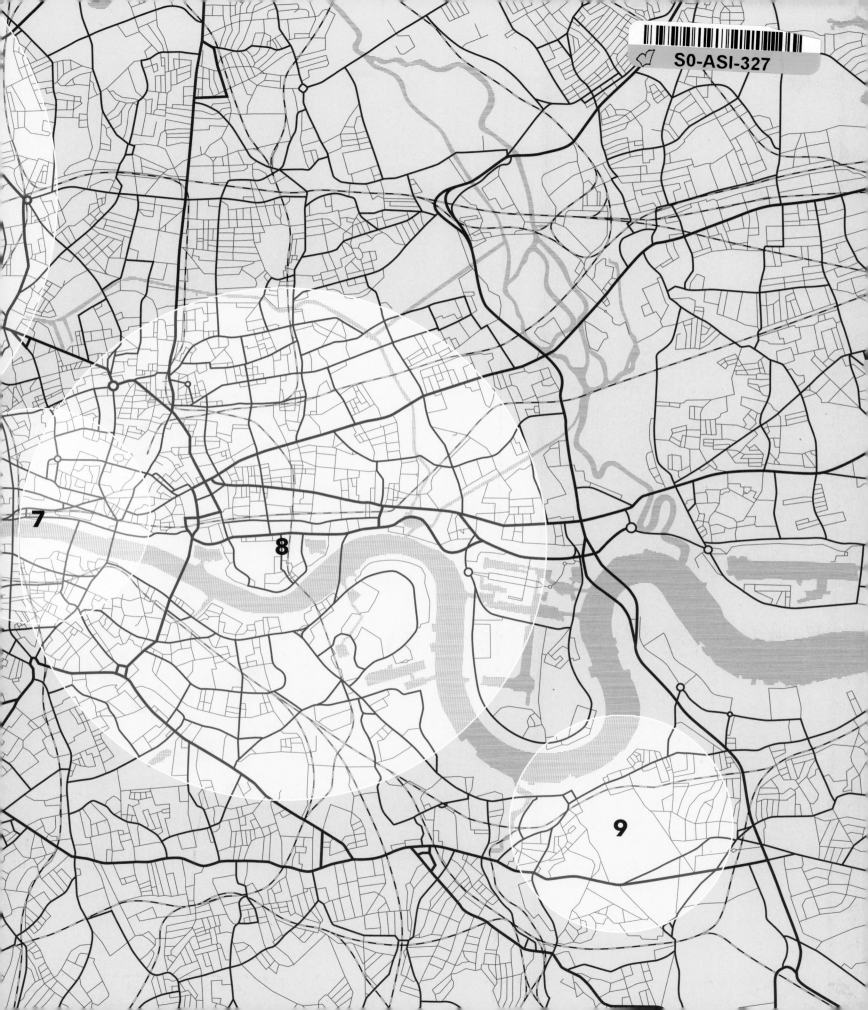

LONDON
IN THE
COMPANY OF
PAINTERS

Published in 2017 by
Laurence King Publishing Ltd
361–373 City Road
London EC1V 1LR
United Kingdom
email: enquiries@laurenceking.com
www.laurenceking.com

A catalogue record for this book is available from the British Library.

ISBN: 978-1-78627-078-8

Design: Masumi Briozzo
Picture research: Peter Kent
Senior editor: Felicity Maunder
Map artwork: Akio Morishima

Printed in China

Overleaf: Feliks Topolski,
Trafalgar Square, 1973. Tate

LONDON
IN THE
COMPANY OF
PAINTERS

RICHARD BLANDFORD

LAURENCE KING PUBLISHING

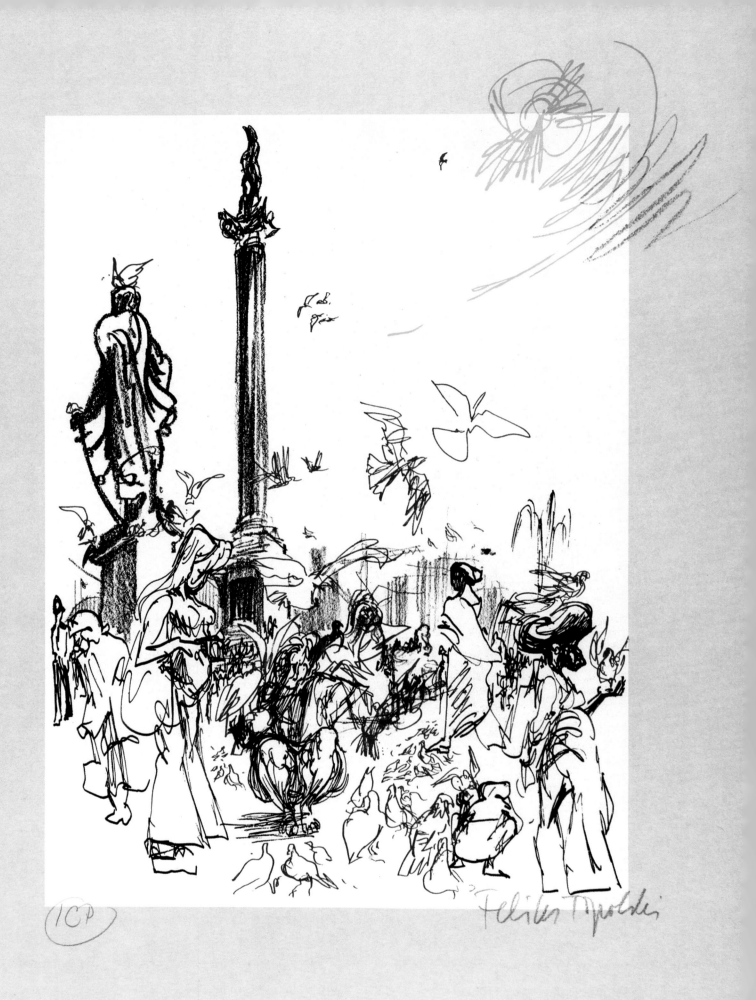

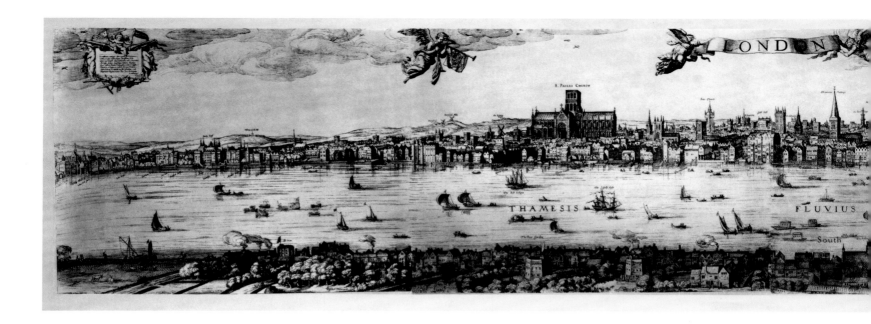

Introduction

'When a man is tired of London,' said Samuel Johnson, 'he is tired of life; for there is in London all that life can afford.' Hyperbole, yes, but containing an essential truth: that London is a vast patchwork – assembled over two millennia, from its origin as the Roman settlement of Londinium – in which so much and its opposite is contained. It has been a city of palaces and slums, of cathedrals and dance halls, of pleasure gardens and prisons. Although any large city would

harbour such dichotomies, there is something distinct about the way the flavours intermingle in London, such as when the street preacher with the sandwich board shares pavement space with the West End pleasure seeker on the way to the hottest nightspot. They have nothing at all in common, except that they both carry the stamp of London. In some way, it binds them together.

Visually as well, London is a city built from contrasts. Plans to knock down and rebuild in

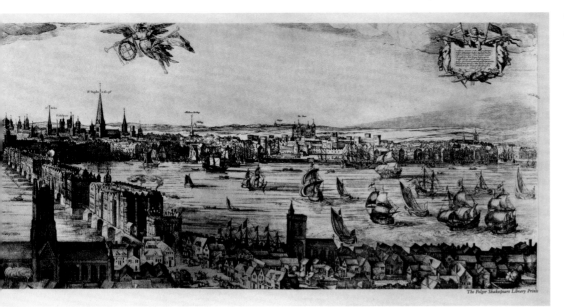

Claes Jansz Visscher,
A Panorama of London, 1616

Robin Reynolds,
Visscher Redrawn, 2016

uniform style, as Haussmann did to Paris, have always been rejected. Instead, the products of architectural movements of different eras neighbour each other, after buildings and areas are erased – by war, fire or simple economics – and replaced. The nineteenth-century mechanics of Tower Bridge stretch across the Thames to the medieval Tower of London, while a remnant of the original Roman city wall still stands by the Brutalist tower blocks of the 1960s Barbican Estate.

To look at London in art is also to see an assembly of differing styles and approaches. London is, variously, a new Rome, an Impressionist bourgeois pleasure garden, or a Romantic outer visualization of inner turmoil. It is grim social reality, the escape of a dream. All these are valid, and all are true, despite the contradictions, for London, in its size, age and mythic stature, can encompass all these different versions of itself.

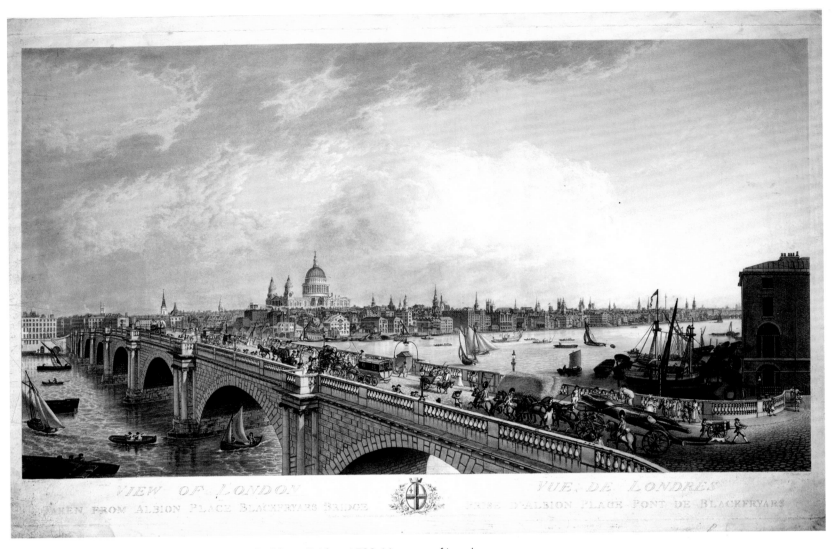

Thomas Black and Thomas Rowlandson (?), *Blackfriars Bridge*, 1798. Museum of London

Indeed, many things that London has once been remain uncaptured in art, at least to our knowledge. For much of its history, London does not appear to have been documented visually. An appearance of Londinium on a Roman medal, Westminster Abbey in the Bayeux Tapestry, the Tower of London in a medieval manuscript illumination – until the sixteenth century, there is not a great deal more than that. As painting subjects turn from the sacred to the secular following the Reformation, London appears sparingly, in the distance of a portrait or a rural scene.

It is not until the seventeenth century that the story of London in art truly begins. The rise of the panoramic city view as a painting genre naturally led to the commissioning of works depicting the capital of England. London had become subject matter for art, and has remained so, with all the stylistic changes of the various mediums,

and historical changes affecting the city, that have followed.

And through it all – the rise and fall of Empire, attacks from above in two world wars, the incredible expansion over centuries that has seen London swallow up its surrounding villages and suburbs – and despite all the contrasts and contradictions, there is something constant, a quality that mysteriously yet unmistakably belongs to London. What is it that makes the works in this book immediately sing of the city, regardless of whether they feature the most easily recognizable landmarks?

I believe that this elusive quality is London's 'rudeness', in the older sense of the word, meaning something rough or crudely built. That is not to say that the city is not capable of sophistication – this is plainly not the case, and much of it is obviously very finely built – but it is

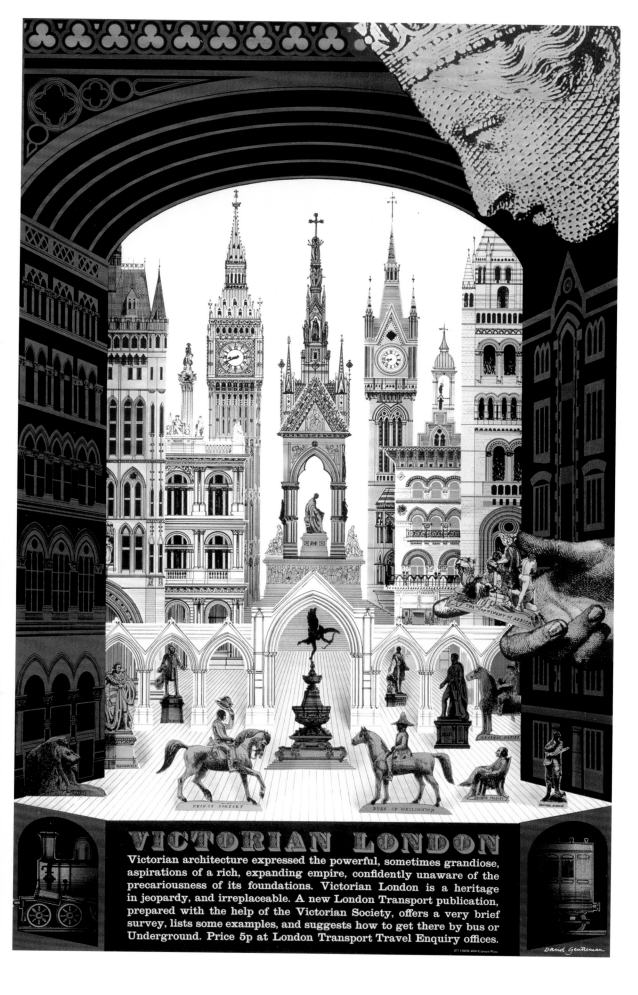

David Gentleman,
Victorian London (poster), 1973.
London Transport Museum

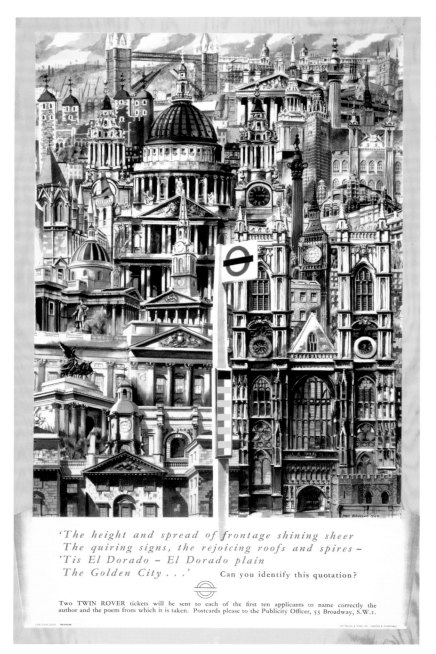

'The height and spread of frontage shining sheer
The quiring signs, the rejoicing roofs and spires –
'Tis El Dorado – El Dorado plain
The Golden City . . .' Can you identify this quotation?

Two TWIN ROVER tickets will be sent to each of the first ten applicants to name correctly the
author and the poem from which it is taken. Postcards please to the Publicity Officer, 55 Broadway, S.W.1.

Peter Roberson,
London Rovers (poster), 1958.
London Transport Museum

OPPOSITE:
Montague B. Black,
*London 2026 AD – this is all in
the air* (poster), 1926. London
Transport Museum

never genteel. There is a coarseness to even its grandest views. Canaletto may present London as if it were Venice, but the comparison can only ever be temporary. There is a disruptive force in the details of such city scenes, and it is the people of London themselves.

For however much power may be centred in London – be it that of state, Church, monarchy or finance – it cannot be said that any of these institutions own London, regardless of what they may on paper possess or control. The folk memory of a publicly beheaded king lingers, perhaps, reminding the crowd that rulers are only ever temporary, encouraging them in their own

particular brand of wilfulness. For to be and act in London is in some way to define it, and possess it. Just as London owns every Londoner, London also belongs to them. The wear of millions of lives lived exuberantly gives London its coarse edge, and it is this coarseness that makes London itself. (Whether this relationship between London and its people can continue into the future, when the luxury apartments of skyscrapers sit empty, bought not to be lived in, but as investments, and the prices of property and rents push many out of the city itself, remains to be seen.) London is also often beautiful. More so, it can be sublime, inspiring awe in the visitor and resident

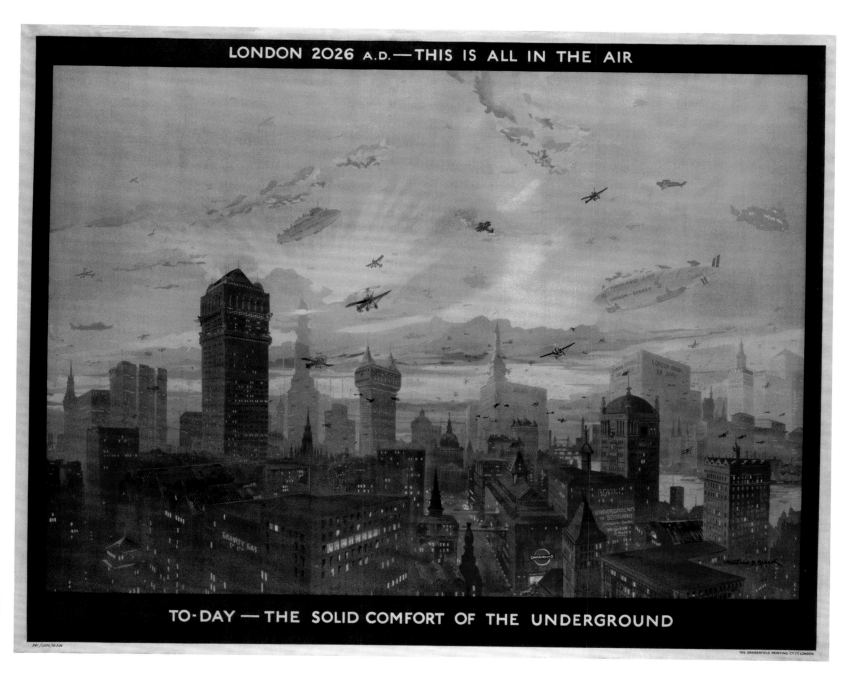

alike. There is camaraderie to be found in the communities of London. Its loneliness is also renowned.

In this collection, London in many of its states, as captured by artists from the past four centuries, can be seen. It is presented as a journey from west to east along the Thames, going some way inland on both the north and south banks to take in some of the most famous sites, along with some more obscure locations along the way. Although the journey is one you could potentially make in space, in time it is only possible through the medium of art. A century's worth of changes to Buckingham Palace will unfold over the turning of a few pages, while a long view of the frozen Serpentine from the 1960s will lead you to an ice-skating scene painted nearly 200 years before. You will see great buildings reduced to nothing, and grand monuments arise out of the ruins. Along the way, there will be coronations and riots, summer days and frost fairs. Scenes of London at play, and London at war. Works by some of the world's most renowned artists – Turner, Monet and Canaletto, as well as some whose name history hasn't even captured. All of it, however, is filled with the unmistakable spirit of London.

And of course, it all starts on the Thames …

1 Thomas Girtin, *The White House at Chelsea*, 1800. Tate

Chelsea, Battersea & Kensington

THE THAMES AT CHELSEA AND BATTERSEA, VAUXHALL GARDENS, KENSINGTON PALACE, KENSINGTON GARDENS, THE ALBERT MEMORIAL, THE ROYAL ALBERT HALL, HYDE PARK

Pale light falls on Chelsea in the late eighteenth century (1). The bank of the River Thames is still only partly built upon, spotted with windmills and occasional dwellings. A hundred years pass, and much changes. Chelsea is now a highly desirable area, transformed from village to town by the building of Battersea Bridge across the Thames (5), with the well-to-do strolling along the Embankment (the bank of the Thames artificially raised in order to provide London with a modern sewerage system), past the retired soldiers known as Chelsea Pensioners sitting on a bench (3).

A quick trip across the Thames via the bridge takes us to Battersea, visiting the park there (8), and the old Vauxhall Pleasure Gardens (10), as they once were, and then back across the river, this time to visit the area beyond Chelsea, Kensington.

Here we find the royal residence of Kensington Palace and the surrounding Kensington Gardens, the deer that were once hunted there immortalized in paint (11). Moving along, we pass two monuments to Queen Victoria's consort Prince Albert, the Albert Memorial (15) and the Royal Albert Hall (16). The latter is part of the collection of cultural and educational establishments to be found in Kensington known as the Albertopolis, which also includes the Natural History and Science Museums, the Victoria and Albert Museum, the Royal Colleges of Art and Music, and Imperial College London.

Our journey around Kensington and Chelsea ends in Hyde Park, where the artificial Serpentine lake, reputed home of fairies (13), continues from Kensington Gardens, frozen in the winter chill while skaters from 200 years narrowly avoid a tumble (22). Onlookers wait for royalty to pass the Grand Entrance (18), while the fashionable promenade along its paths and children play on the grass (17).

OPPOSITE:
2 English School,
View of the Thames, c.1870.
Compton Verney, Warwickshire

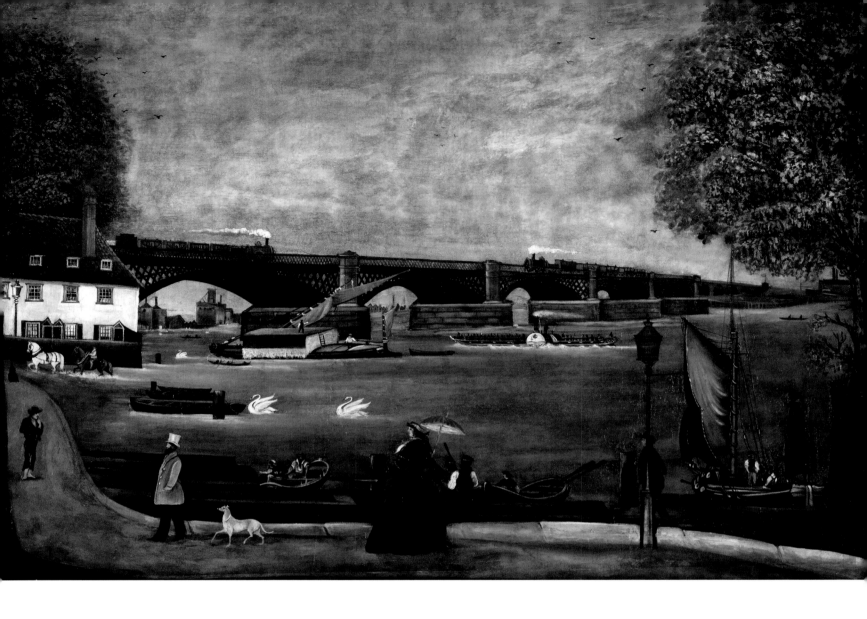

The Thames

The River Thames flows through London, dividing the city between north and south. It was the Thames that allowed London to become a large and important city, providing access to the sea and enabling it to function as an inland port. London is located at a point where the river is deep and easily navigable by ship, just before the river ceases to be tidal at Ham (now located in south-west London and marked by Teddington Lock).

The Thames is the second longest waterway in the United Kingdom, and the longest solely in England. Its source is at Thames Head in Gloucestershire, and the river flows through the counties of Wiltshire, Oxfordshire, Buckinghamshire, Berkshire and Surrey, the city of Oxford and the towns of Reading and Windsor before reaching Greater London. From there it passes through Kent and Essex before meeting the sea at the Thames Estuary.

The building of the settlement on the banks of the Thames would prove to be a significant event, not just for Great Britain, but for the world. It is, as the politician John Burns said, 'liquid history'.

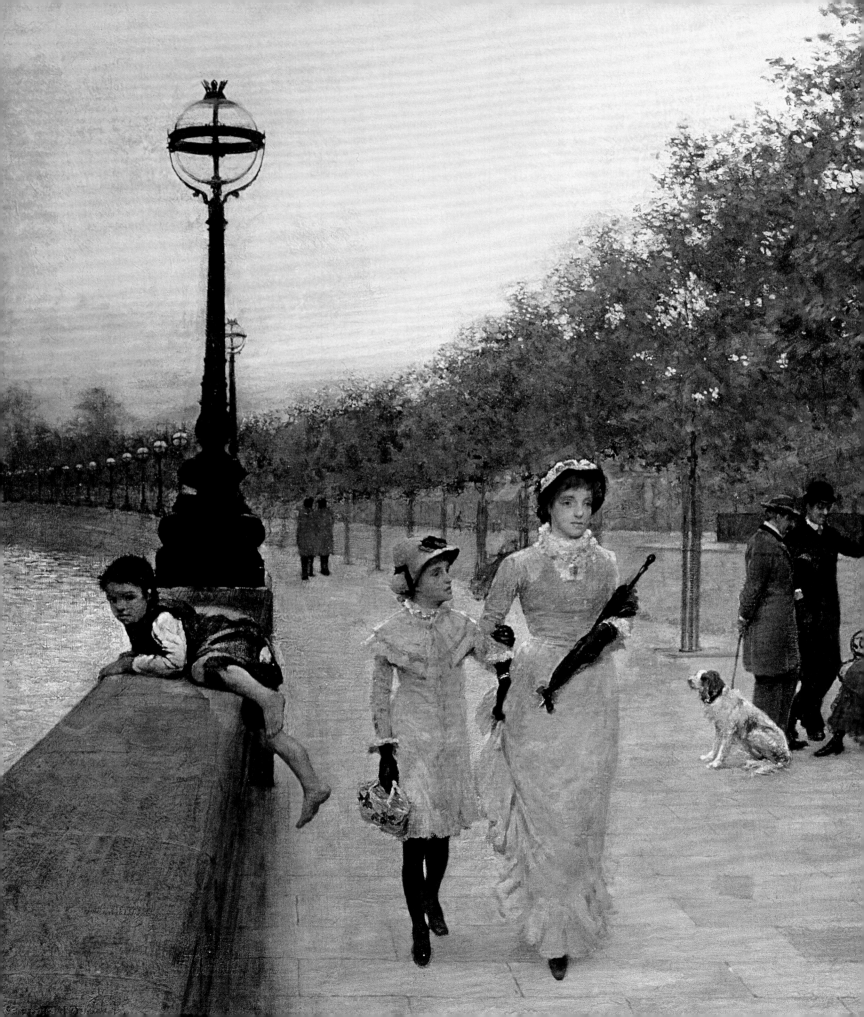

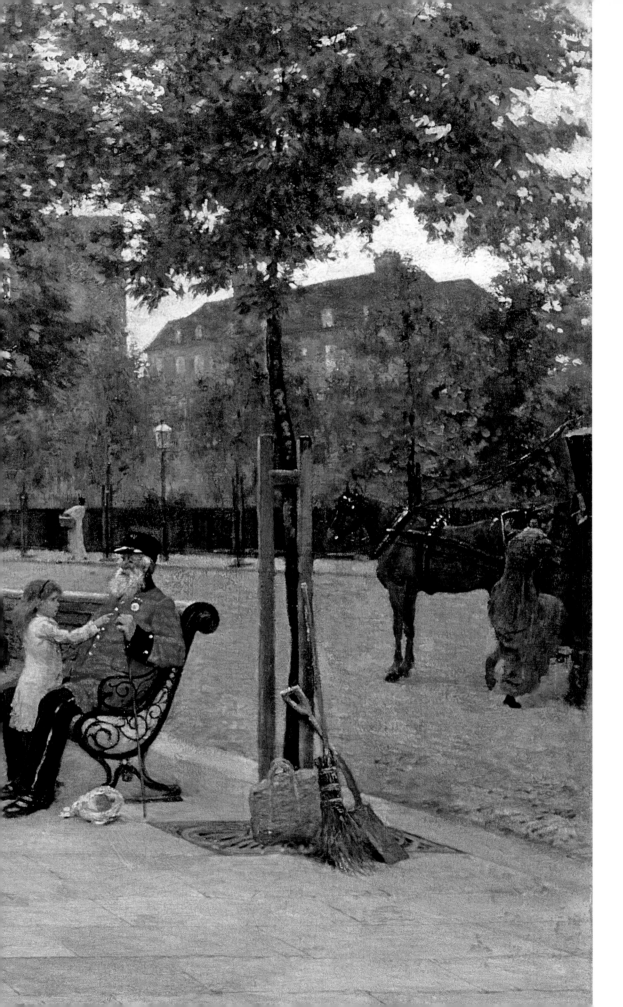

Chelsea Pensioners

Chelsea Pensioners are residents of the Royal Hospital Chelsea, a retirement home for former army servicemen (and since 2009, servicewomen), founded in 1682 by Charles II. The Pensioners are easily recognizable from the uniforms they are encouraged to wear – a blue uniform for when they are in the hospital grounds, and a scarlet coat for outside, along with a peaked cap (**3**; a tricorn hat is worn on ceremonial occasions). Medals won in service and insignia of rank obtained are often worn on the breast of the coat. Chelsea Pensioners can still be spotted easily in the crowd at Chelsea Football Club matches at the Stamford Bridge ground, and provided a guard of honour for the team in 2005 and 2010 when they won the Premier League title.

3 Frederick Brown, *Walk along the Embankment at Chelsea*, late 19th/early 20th century. Private collection

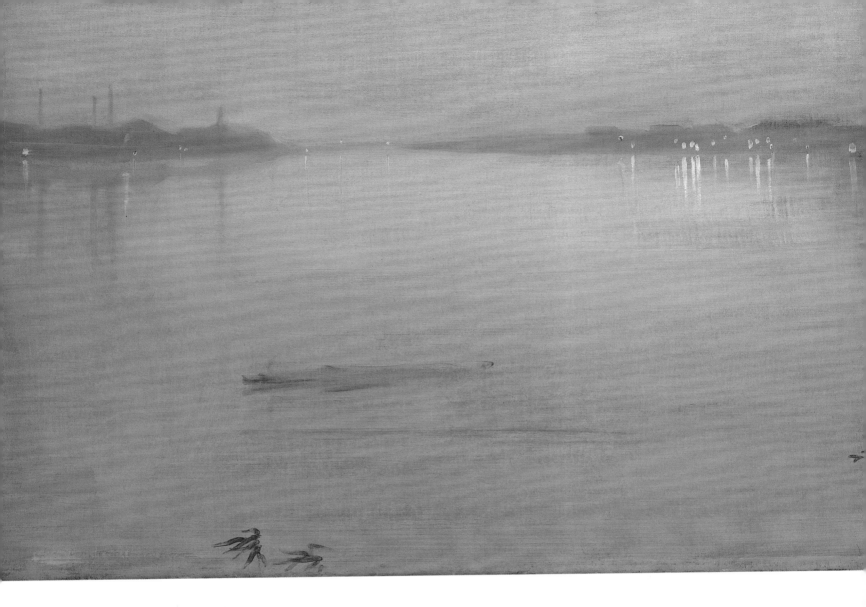

Whistler at Chelsea

American artist James Abbott McNeill Whistler, having already spent some time in London, settled in Chelsea in 1863. His adopted home often served as his subject matter, and he produced numerous paintings of locations in Chelsea, such as the Cremorne Pleasure Gardens (**4**), the Thames, Battersea Bridge (**5**) and, viewed across the water, Battersea itself. The paintings often showed their subject at night or in fading light, the artist calling these paintings 'nocturnes'. A circle of like-minded artists surrounding Whistler, including Theodore Roussel and Paul Maitland (**7**), painted similar scenes.

Whistler viewed his paintings as primarily arrangements of shape and colour, and less about the subject matter itself. This belief in 'art for art's sake' put him in a position of sympathy with his friend, the poet, playwright and author Oscar Wilde, and made an enemy of the critic John Ruskin, who believed that art had a moral dimension, embodied in a truth to nature. This clash of ideas would ultimately result in a court case, with Whistler suing for libel over Ruskin's claim that *Nocturne in Black and Gold – The Falling Rocket*, a painting of the fireworks at Cremorne Gardens, amounted to 'flinging a pot of paint in the public's face'. Whistler won the case, and was awarded a farthing.

ABOVE:
4 James Abbott McNeill Whistler, *Nocturne: Blue and Silver – Cremorne Lights*, 1872. Tate

OPPOSITE:
5 James Abbott McNeill Whistler, *Nocturne: Blue and Gold – Old Battersea Bridge*, c.1872–75. Tate

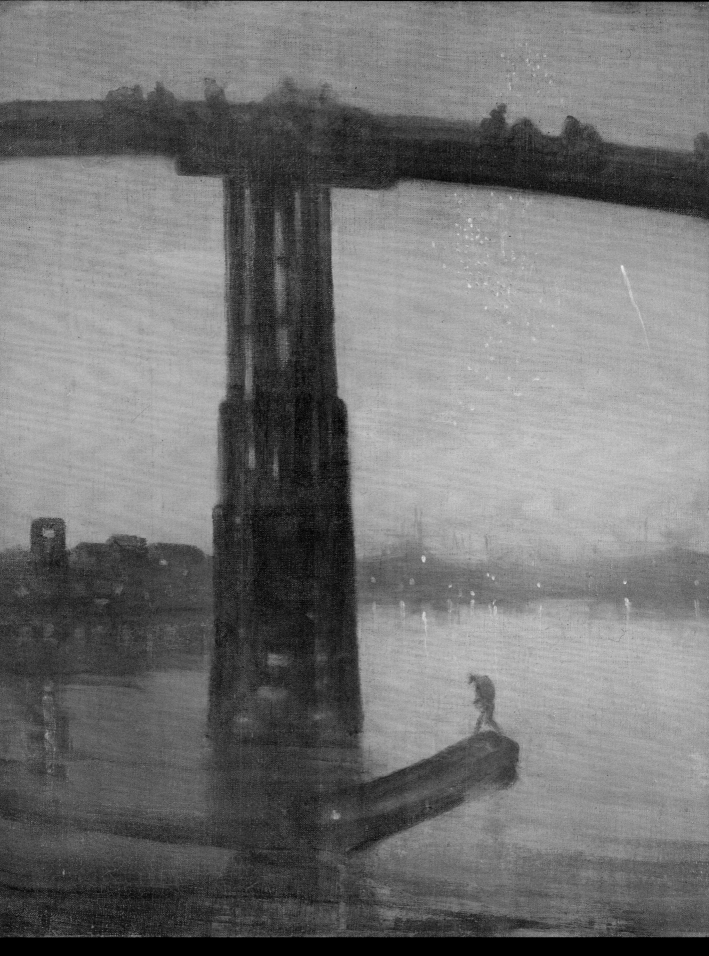

7 Paul Maitland,
Battersea Reach, c.1885–1909.
Walker Art Gallery, Liverpool

Battersea

On the south bank of the River Thames, facing Chelsea (with Chelsea Bridge, Albert Bridge, Battersea Bridge and Battersea Railway Bridge joining the two), the district of Battersea contains several sites of particular significance to London's infrastructure. Clapham Junction is one of the busiest train stations in Europe, with many changes between services taking place there, and with routes beginning at both Victoria and Waterloo stations passing through.

Battersea Power Station (**9**), with its iconic four chimneys each at the corner of a brick 'cathedral' design, operated as a coal-fired power station from 1933 to 1983. The fourth largest brick building in Europe, it is world-famous for appearing on the cover of Pink Floyd's *Animals* LP, with an inflatable pig floating above between two chimneys.

Battersea Park (built on the site where one Colonel Blood attempted to assassinate Charles II, and the Duke of Wellington once fought a duel) is a popular location (**8**), notable for its bandstand, boating lake and the London Peace Pagoda, a Buddhist structure intended to promote thoughts of unity and peace.

Battersea Dogs and Cats Home has housed and rehomed unwanted or stray dogs since 1871, and cats since 1883. The home looks after 9,000 animals a year, with an average of 14 dogs and 8 cats admitted daily.

8 Christopher Wood,
Battersea Park, London,
early 20th century.
Dorset County Museum

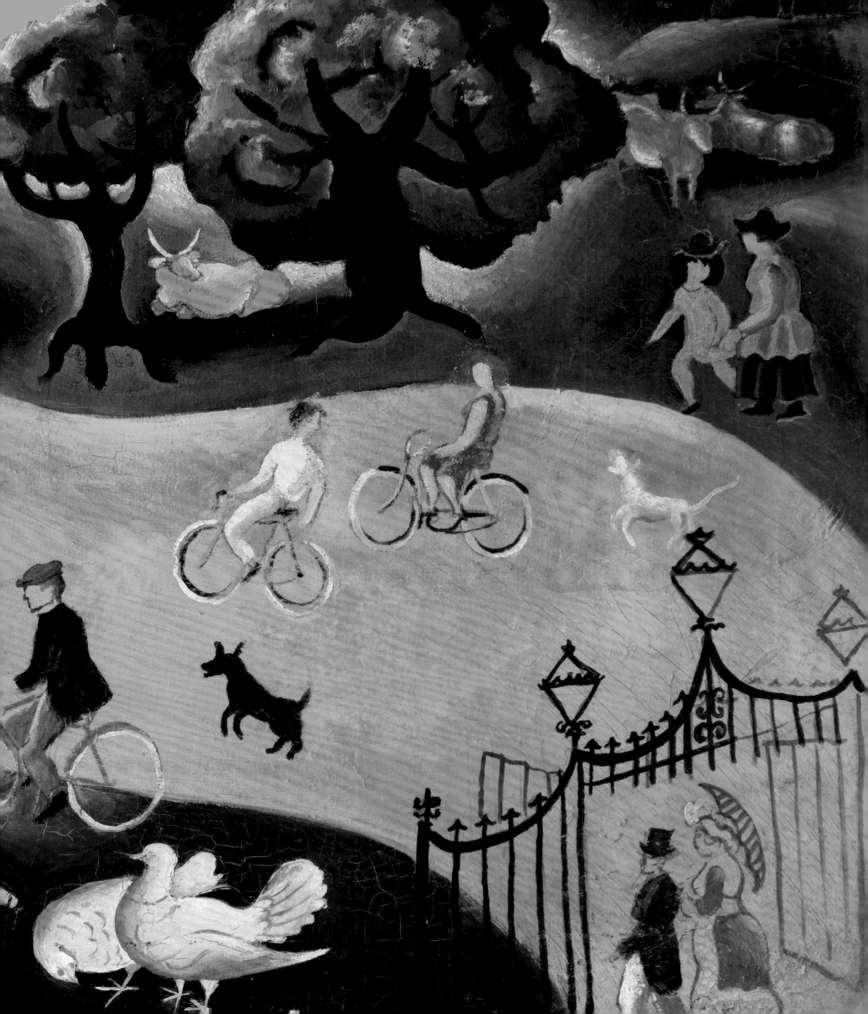

9 Charles Ginner,
*Battersea Power Station
from Chelsea Embankment,*
early 20th century

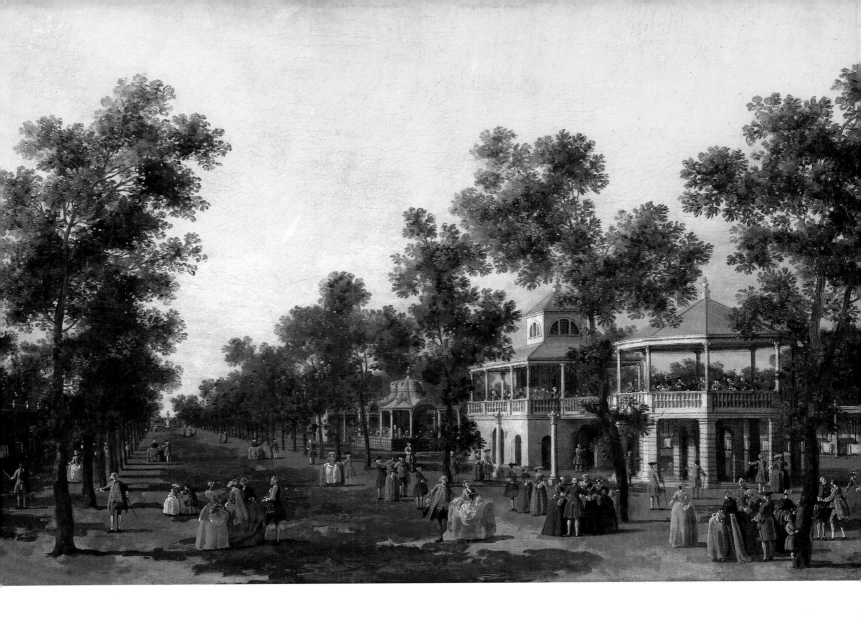

Vauxhall Gardens

The Vauxhall Pleasure Gardens (**10**), originally known as the New Spring Gardens, opened at some point in the mid-seventeenth century, their first known mention found in the diaries of Samuel Pepys. Becoming Vauxhall Gardens in 1785, the acres of tree-lined paths became known for entertainments including hot-air balloon rides, tightrope walkers, fireworks and performances, musical and otherwise – including a re-enactment of the Battle of Waterloo featuring 1,000 soldiers in 1817 – and as a location for romantic meetings. A 'Turkish tent' with a notable rotunda in the Rococo style was a popular attraction. The gardens were originally accessed via boat from across the Thames, the area around it yet to be absorbed by the city, until the opening of Vauxhall Bridge in 1810.

The gardens closed in 1859 and the land was built on. As part of the Festival of Britain, Battersea Park was transformed into a Vauxhall-style pleasure garden. Some of the original site became a park again following slum clearance in the late twentieth century, with a near repeat of history when its name changed from Spring Gardens to Vauxhall Pleasure Gardens in 2012.

10 Canaletto,
The Grand Walk, Vauxhall Gardens, c.1751. Compton Verney, Warwickshire

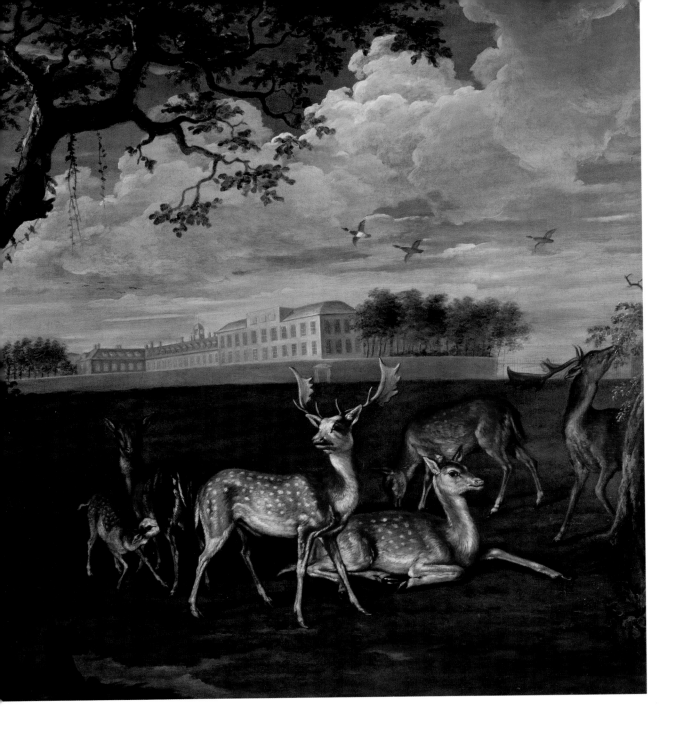

Kensington Palace

Kensington Palace (**11**) is currently the residence of the Duke and Duchess of Cambridge, William and Catherine, and their children, George and Charlotte. Prince Harry also maintains an apartment there. Their attachment to the palace is understandable, as both princes grew up there.

Originally erected in 1605, the mansion then known as Nottingham House became a royal residence in 1689 when purchased by the joint monarchs William and Mary, with Sir Christopher Wren commissioned to enlarge the building. Features of Kensington Palace include the King's Gallery, which houses some of the finest works from the Royal Collection, such as Van Dyck's portrait of Charles I on horseback, and the Orangery, designed by Nicholas Hawksmoor for Queen Anne.

The last reigning monarch to live at Kensington Palace was George II, who died there in 1760, but since then it has been often used by heirs to the throne and other royalty. Queen Victoria was born and spent her childhood there, and it later served as home to Princess Margaret, as well as to Charles and Diana, the Prince and Princess of Wales. It remained Diana's official place of residence until her death in 1997, her coffin travelling from Kensington Palace to Westminster Abbey on the day of her funeral.

Kensington Gardens

One of the Royal Parks, green space owned by the Crown but open to the public, and originally part of Hyde Park, Kensington Gardens was sectioned off in 1728 for the benefit of Queen Caroline, and landscaped into a garden (**12**) following the designs of Henry Wise and Charles Bridgeman. The gardens contain the part of the Serpentine, an artificial lake created by Bridgeman, known as the Long Water (**13**).

Other notable sites in Kensington Gardens include the Albert Memorial, the Serpentine art gallery and the Round Pond (actually rectangular), which is popular with model yacht enthusiasts (**14**).

The Elfin Oak, a 900-year-old tree stump, carved by Ivor Innes in 1928–30 so as to appear to be inhabited by a witch, elves, gnomes and other small creatures, is also housed in the gardens.

OPPOSITE:
11 British or Dutch School, *Kensington Palace*, 1695. Historic Royal Palaces

BELOW:
12 William Dobell, *Kensington Gardens*, 1935. National Gallery of Victoria, Melbourne

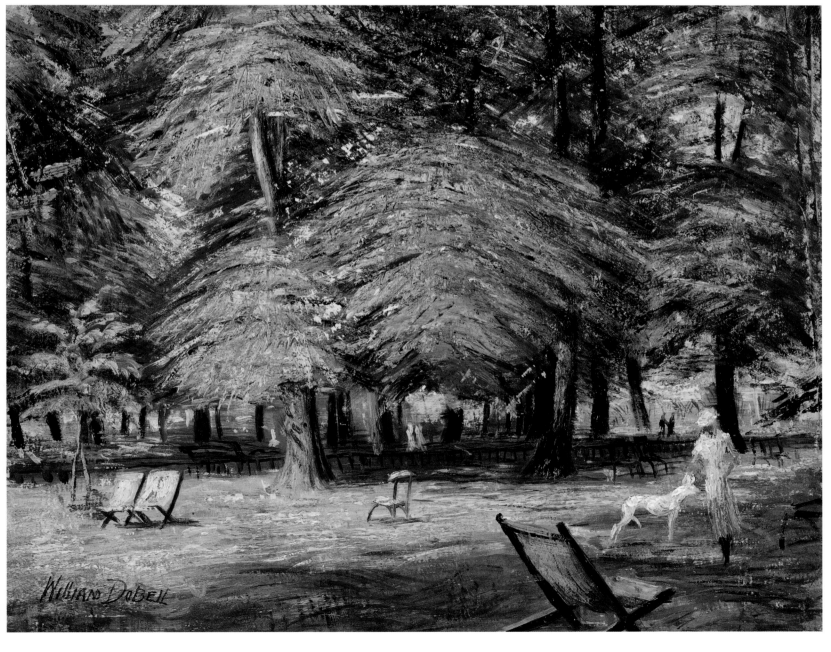

Peter Pan in Kensington Gardens

For J.M. Barrie's novel of 1906, *Peter Pan in Kensington Gardens*, the celebrated illustrator Arthur Rackham produced 49 watercolours, reproduced as engraved plates. The story is that of Peter Pan as a baby, who one day flies out the window of his home and makes his way to Kensington Gardens. There he sails on the Serpentine in a thrush's nest, and makes friends with the fairies who live there (**13**), playing the pan pipes at fairy dances.

A statue of Peter by George Frampton, marking the exact spot where he landed in Kensington Gardens, near the bank of the Serpentine, was erected in 1912. Fairies and small animals surround him as he plays the pan pipes.

13 Arthur Rackham, *Fairies in Kensington Gardens*, 1906

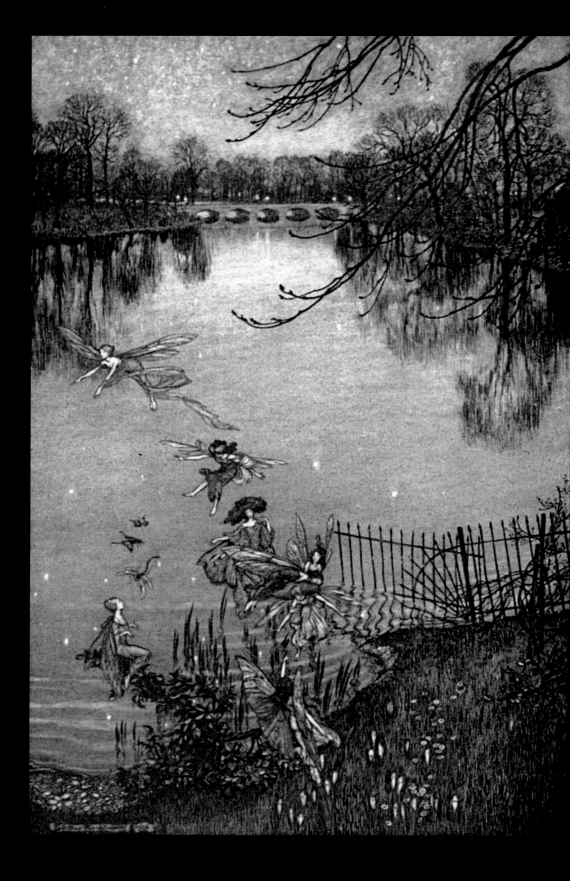

14 Arthur Temple Felix Clay,
Boating at Kensington Gardens,
late 19th/early 20th century.
Private collection

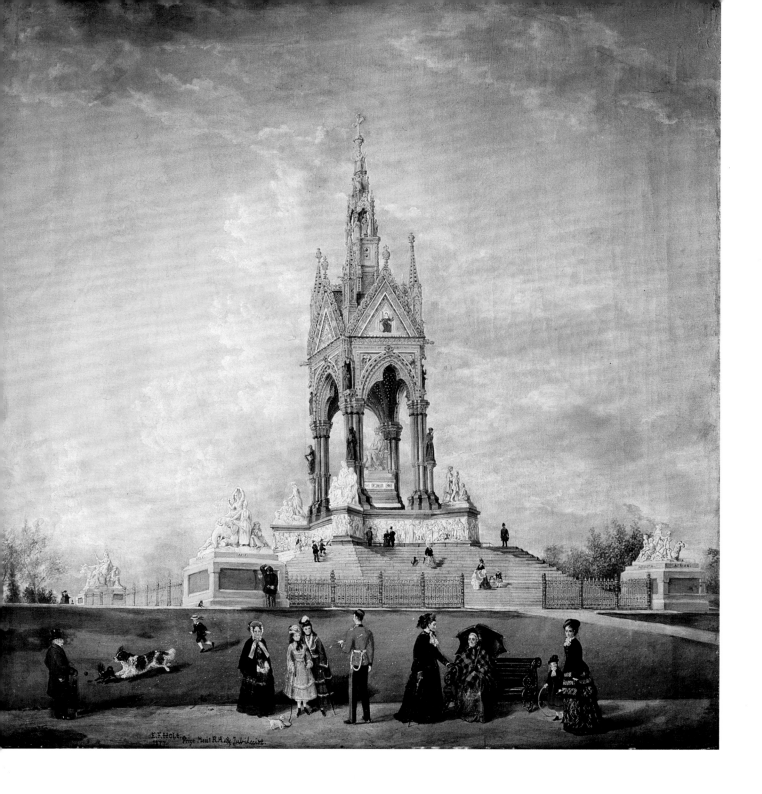

The Albert Memorial

Following the death of her husband, Prince Albert, in 1861, the mourning Queen Victoria commissioned a monument in his memory. Designed by Sir George Gilbert Scott, the Prince Consort National Memorial (**15**), situated in Kensington Gardens, is rich with imagery representing Albert's interests, achievements and significance as consort to the monarch of the British Empire.

A seated statue of Albert holds the catalogue of the Great Exhibition of 1851, which he helped organize. Surrounding him are four groups of sculptures representing the continents of Europe, Asia, America and Africa, and a further four representing the industrial activities of Commerce, Engineering, Manufacturing and Agriculture. The canopy contains representations of the arts and sciences, as well as the Christian virtues of Faith, Hope, Charity, Humility, Prudence, Justice, Temperance and Fortitude. Angels raise their arms and lead the eye to the gold cross at the top of the memorial's tower.

The Royal Albert Hall

The Royal Albert Hall of Arts and Sciences (**16**) is a concert hall, opened in 1871 and named in memory of Queen Victoria's consort, Albert, who had died six years earlier.

The hall recalls a Roman amphitheatre, its circular shape topped by a wrought iron dome. This construction resulted in the problem of a strong echo, about which it was joked that the hall was the only place a British composer could be sure of hearing his work twice. This was not fully resolved until 1969 when fibreglass discs, said to resemble mushrooms or flying saucers, were installed beneath the ceiling.

The Albert Hall is the venue for the BBC Promenade Concerts, or Proms, an eight-week season of concerts held there since 1941. The Proms are held in high affection, not least by the 'Prommers', who stand at a much cheaper price than those with seats. The Last Night of the Proms features popular classics, patriotic songs such as 'Jerusalem', and a final rendition of 'Auld Lang Syne'.

Hyde Park

Hyde Park (**17**), one of the Royal Parks, was created in 1536 as a hunting ground for Henry VIII, before being partially opened to the public (or at least, 'gentlefolk') by James I.

Of particular interest is the Grand Entrance (**18**), also known as Apsley Gate, and Rotten Row (**19**), formerly the King's private road, which became a fashionable site for the wealthy to ride on horseback in the nineteenth century. The majority of the Serpentine, the artificial lake created for Queen Caroline in 1730 (and site of a recreation of the Battle of Trafalgar in 1814), is found here (**23**), while the Diana, Princess of Wales Memorial Fountain opened in the park in 2004. A Victorian dogs' cemetery is hidden within the park, while an Edwardian tea house is now the Serpentine art gallery.

The Crystal Palace, an iron and glass structure, was built at the park to house the Great Exhibition of 1851, before being moved to Sydenham Hill in south-east London in 1854 and burning down in 1936.

Hyde Park is renowned as a site of free speech and protest. Orators including Karl Marx, Vladimir Lenin, William Morris, George Orwell and Marcus Garvey have all braved the hecklers at Speakers' Corner, while mass demonstrations are often held there. The park has also hosted concerts for the Rolling Stones, Bruce Springsteen, Taylor Swift and other household names.

17 André Derain,
Hyde Park, c.1906.
Musée d'Art Moderne, Troyes

BELOW:
18 Rose Maynard Barton,
Hyde Park: Waiting for Royalty,
late 19th/early 20th century.
Private collection

OPPOSITE:
19 Yoshio Markino,
In the Rotten Row One Evening,
1928. Museum of London

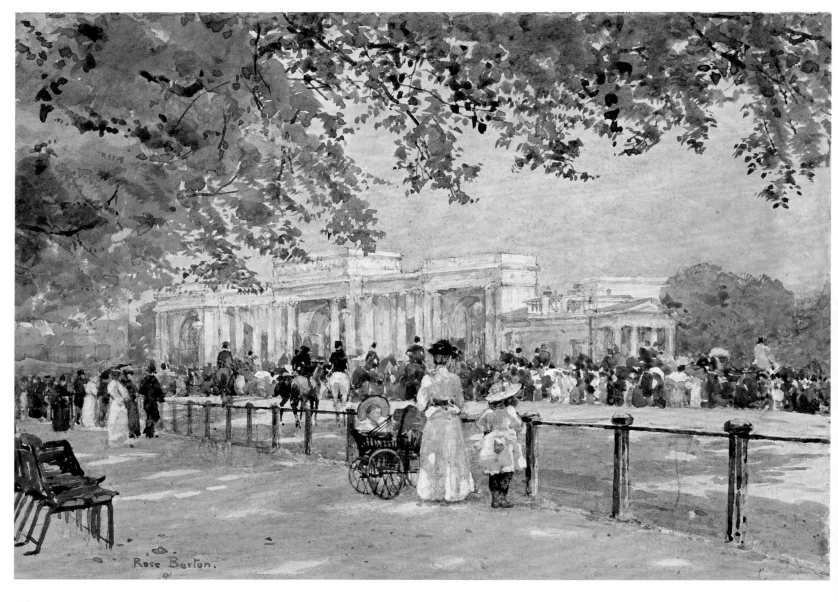

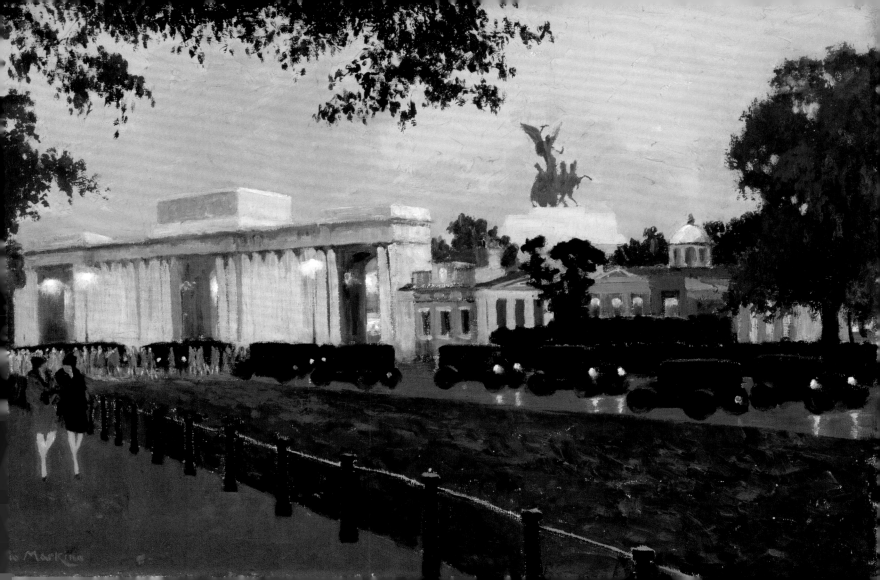

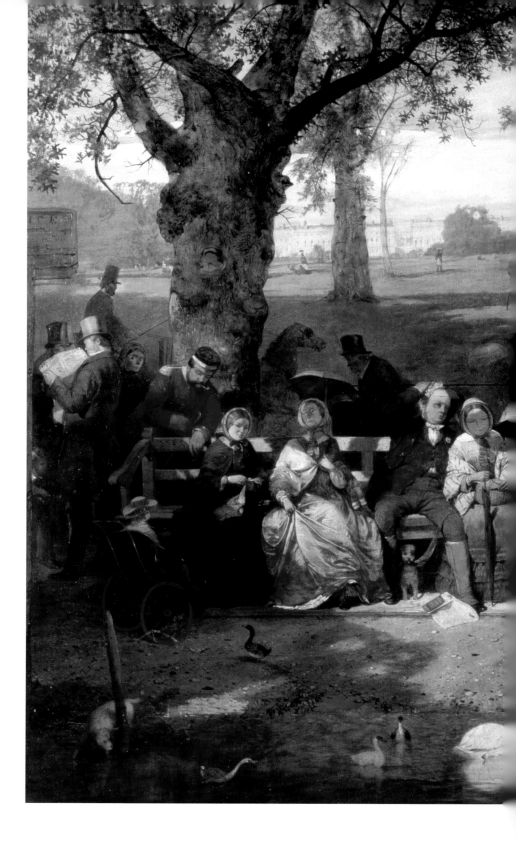

'The citizens of London are universally held up for admiration and renown for the elegance of their manners and dress, and the delights of their tables.'

WILLIAM FITZSTEPHEN, MONK (c.1141–91)

20 John Ritchie, *Summer Day in Hyde Park*, 1858. Museum of London

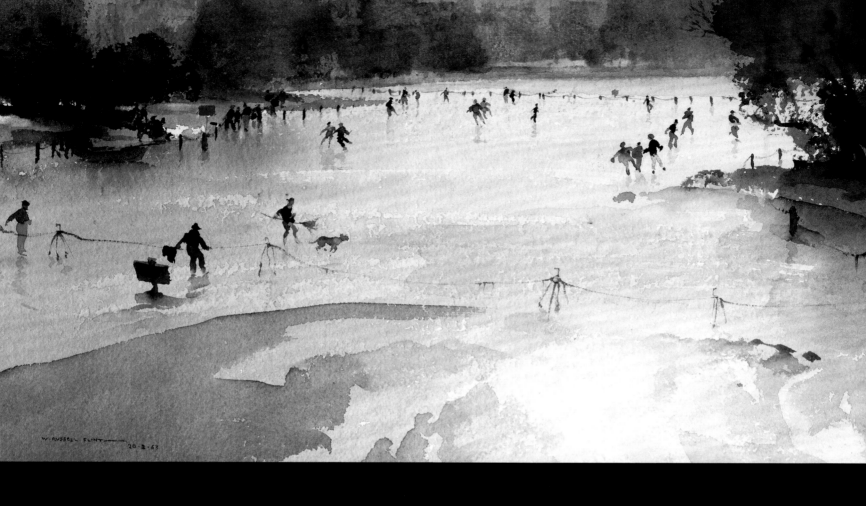

21 William Russell Flint,
The Frozen Serpentine, 1963.
Private collection

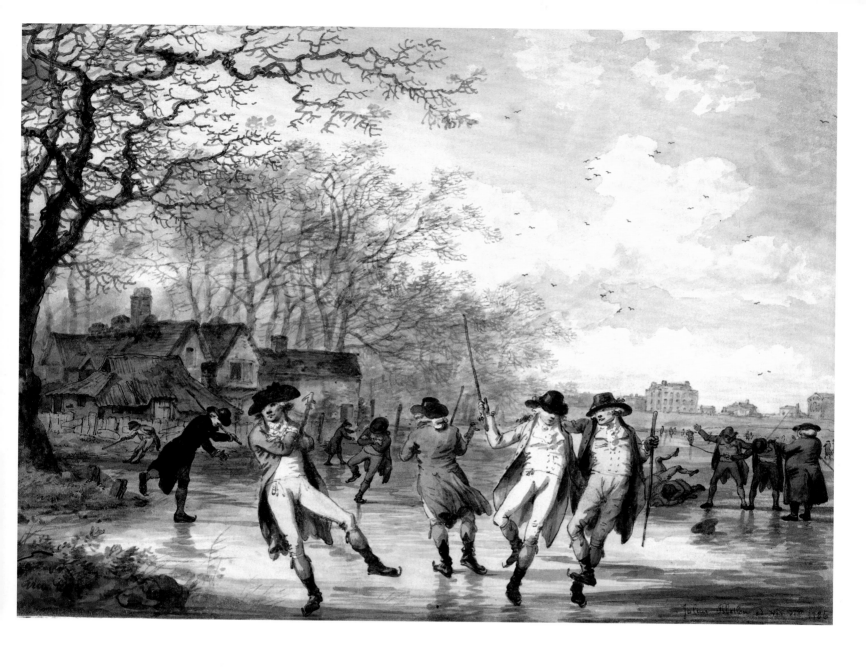

22 Julius Caesar Ibbetson,
*Skaters on the Serpentine in
Hyde Park*, 1786. National
Gallery of Art, Washington

'One must be in London
to see the spring.'

GEORGE MOORE,
NOVELIST (1852–1933)

23 John Martin,
A View of the Serpentine, 1815.
Yale Center for British Art,
Paul Mellon Collection

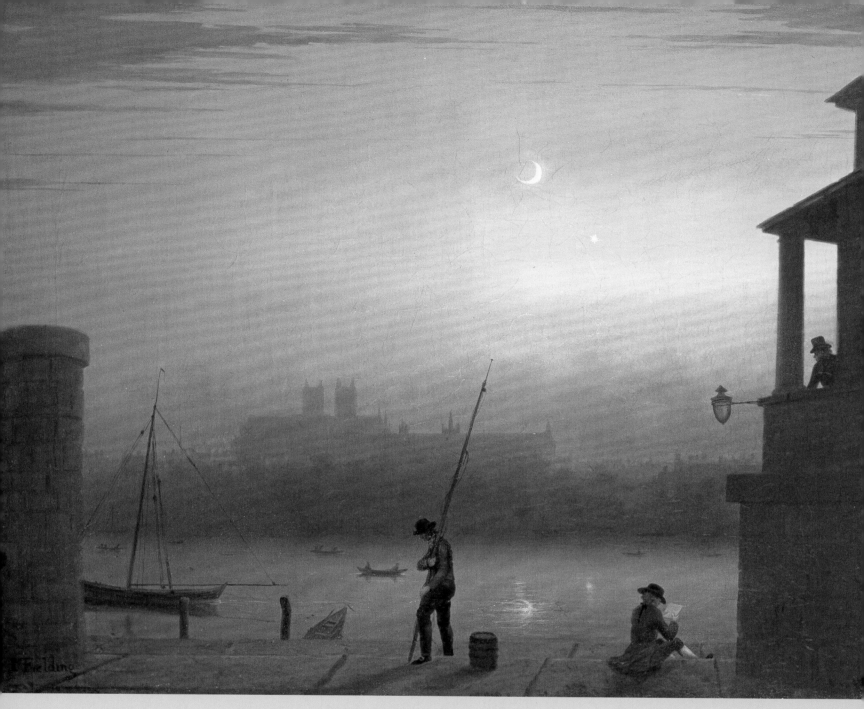

24 Thales Fielding, *The Thames by Moonlight*, 19th century. Private collection

Westminster & Buckingham Palace

WESTMINSTER BRIDGE, WESTMINSTER ABBEY, THE PALACE OF WESTMINSTER, THE LONDON EYE, WHITEHALL, 10 DOWNING STREET, BUCKINGHAM PALACE, ST JAMES'S PARK AND GREEN PARK

Further along the Thames, we come to Westminster (**24**), a cluster of British power with state, Church and monarchy all near neighbours. It is the mid-eighteenth century, and a bridge is constructed across the water (**26**), leading us to the abbey that has stood there since medieval times. A procession of the Knights of the Bath, an order of chivalry made up of senior military officers and civil servants, enters the abbey (**27**). Nearly a hundred years pass, and a pair of women gaze at the abbey, barely changed, from their window balcony (**29**).

Around this time, the nearby Palace of Westminster, home to the Houses of Parliament, burns to the ground (**32**). It re-emerges out of the ashes, a new building famous the world over, housing the bell of Big Ben within its tower (**34**).

There is more state power in Westminster, at 10 Downing Street, home of the Prime Minister (**42**), and Whitehall (**41**), where many government offices are situated. Within easy walking distance is Buckingham Palace (**46**), home of a power that long predates the United Kingdom's democratically elected Parliament. This is the official residence of the monarch. We see the palace change over the years, with its Marble Arch (**44**) replaced by the Victoria Memorial, and its East Front reworked (**43**), but through it all it is a site of commemoration, of battles won and lives lost, and also of celebration. Crowds throng The Mall outside on the day of coronation of Queen Elizabeth II, the current monarch (**48**).

The Mall leads us back in time to when ladies of fashion promenaded there (**51**), while on either side the Royal Parks of St James's Park and Green Park show us once again London at leisure. Visitors wear white on a lazy summer's day (**53**), while in winter it is best to wrap up warm as you feed the ducks by the lake (**52**).

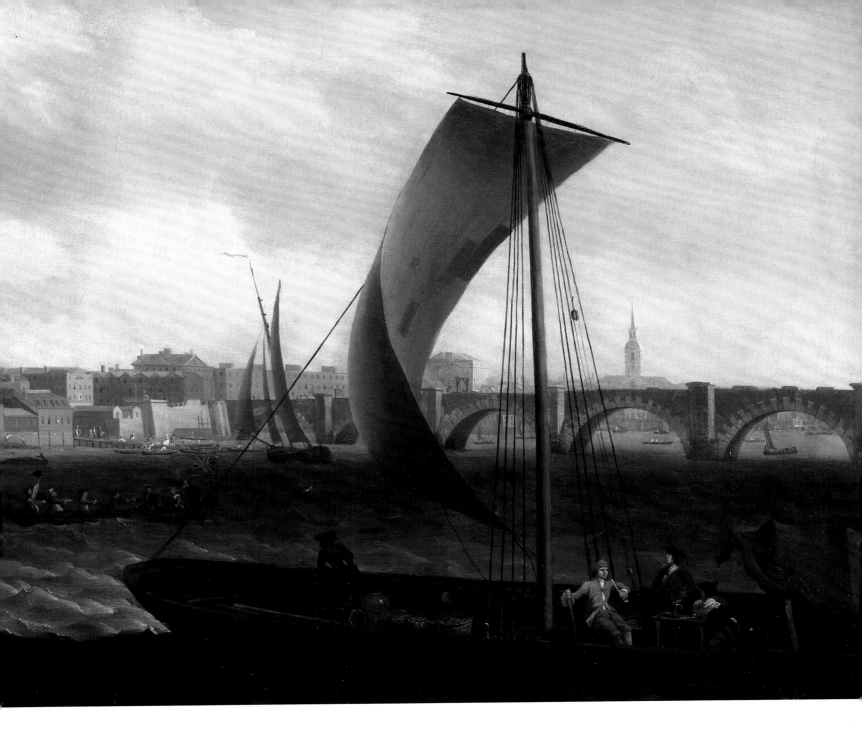

Westminster Bridge

The first Westminster Bridge, linking Westminster with Lambeth, was erected between 1739 and 1750 (**26**), part of a larger movement of bridge-building in London as the city expanded and London Bridge, then handling the entirety of the traffic for the city, became increasingly unsuitable.

By the mid-nineteenth century, however, the bridge was suffering from subsidence. A replacement bridge was opened in 1862, designed by Thomas Page and with detailing by Charles Barry, the architect of the Palace of Westminster, in the Gothic style. This replacement bridge is now the oldest road bridge crossing the Thames in central London.

The bridge has been painted green since 1970 in reference to the colour of the leather seats in the House of Commons, while the next bridge along the Thames, Lambeth Bridge, is painted red to reflect the seats of the House of Lords.

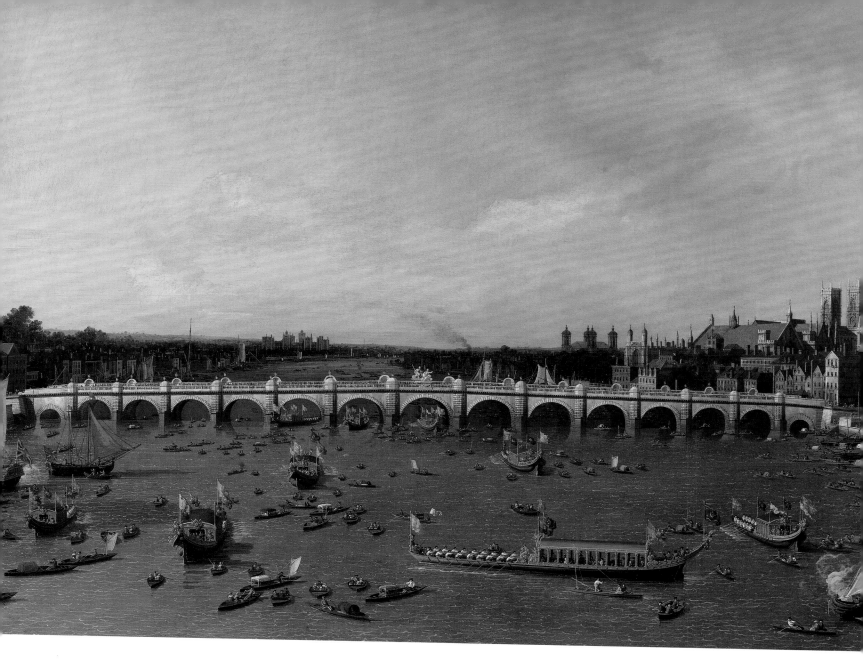

Canaletto in London

Giovanni Antonio Canal, known as Canaletto (1697–1768), was already established as a painter of cityscapes of his home of Venice, works that were often sold to British visitors on the Grand Tour, when the War of the Austrian Succession led to a decline in those willing to take such a trip. Consequently, Canaletto relocated to London in 1746. There he painted many views of his adopted city, including Westminster Bridge (**26**), Westminster Abbey (**27**), Vauxhall Gardens (**10**) and St Paul's Cathedral (**115**).

Although his paintings continued to feature the architectural exactitude to and radiance of sunlight for which he was famed, his stay in England was ultimately felt to have had a deadening effect on his work, becoming repetitive to the point that art critic George Vertue suggested that the Canaletto resident in London was in fact an impostor. Canaletto felt forced to publicly demonstrate his painting prowess in order to refute this, before returning to Venice in 1755.

'Stone seems, by winning labour of the chisel, to have been robbed of its density, suspended aloft, as if by magic.'

WASHINGTON IRVING,
WRITER (1783-1859)

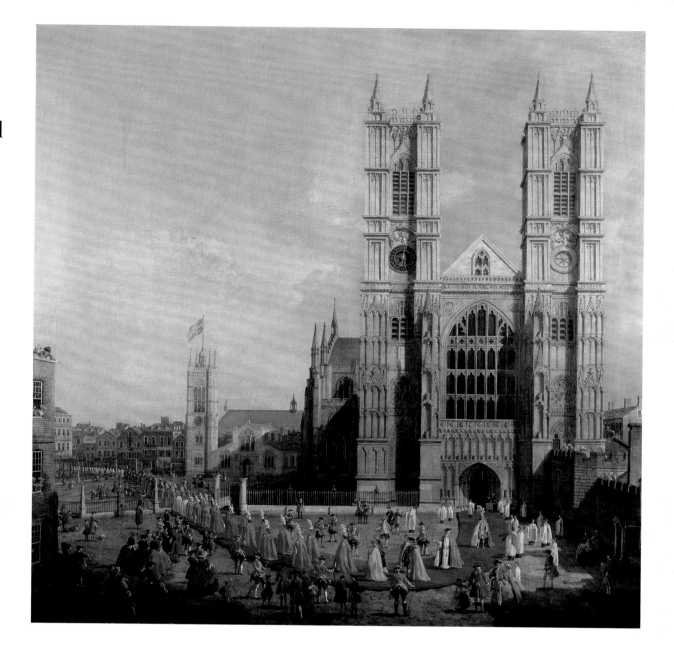

Westminster Abbey

There has reportedly been a church on the site of Westminster Abbey since the seventh century, with coronations of the English monarch taking place there since 1066 – first that of Harold, and very soon after, William the Conqueror. Construction of the Gothic cathedral that now stands was begun in 1245 under the orders of Henry III, and it is this building that has become the resting place of many monarchs and notable Britons, including Isaac Newton, Charles Darwin, Charles Dickens and Laurence Olivier, to name just a few.

There have been some additions to the original Gothic building over the years. A chapel dedicated to the Virgin Mary, or 'Lady Chapel', was ordered by Henry VII to be replaced in 1502 with a new chapel in the late Gothic Perpendicular style of the period. Two towers were added on the western front of the cathedral between 1722 and 1745, designed by Nicholas Hawksmoor, with the original Gothic style maintained (**27**).

Westminster Abbey was spared the vandalism being carried out on other abbeys following Henry VIII's declaration of himself as Supreme Head of the Church of England, as he

made it a cathedral in 1540, which it remained until 1556. While Puritans objecting to religious iconography caused damage in the 1640s, Oliver Cromwell, the Puritan ruler of England, Ireland and Scotland during the Commonwealth (the period in which the country had no monarch following the beheading of Charles I), was himself buried in Westminster Abbey, only for his corpse to be dug up and hung in chains following the re-establishment of the monarchy. His head was put on a spike outside Westminster Hall, where it stayed for some years before finally coming down in a storm.

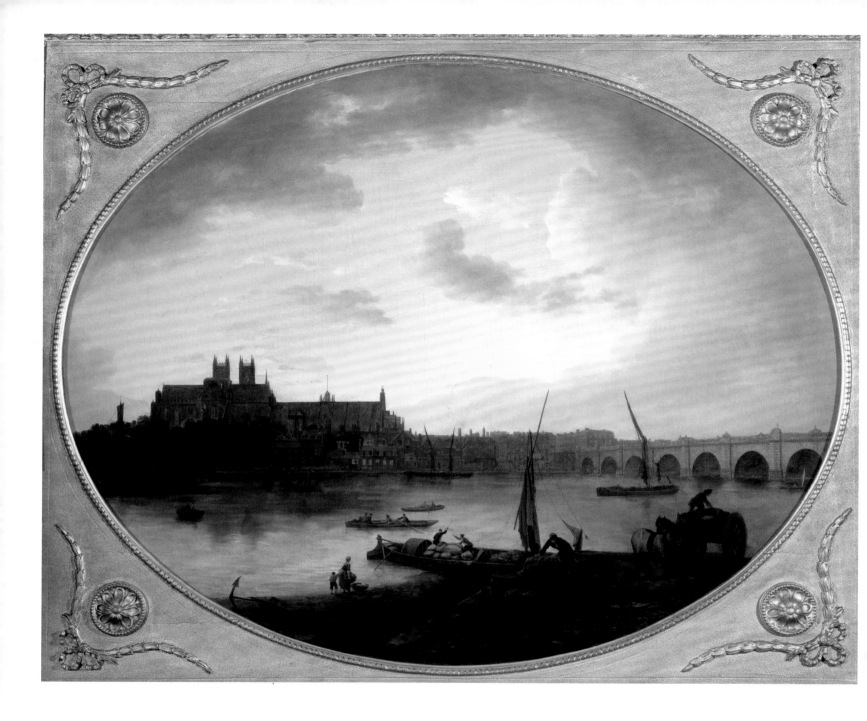

ABOVE:
28 William Marlow,
*A View of Westminster Abbey
and Old Westminster Bridge*,
c.1774. Guildhall Art Gallery,
London

OPPOSITE:
29 Louis Pierre Spindler,
London Interior, c.1834–36.
Musée des Beaux-Arts,
Strasbourg

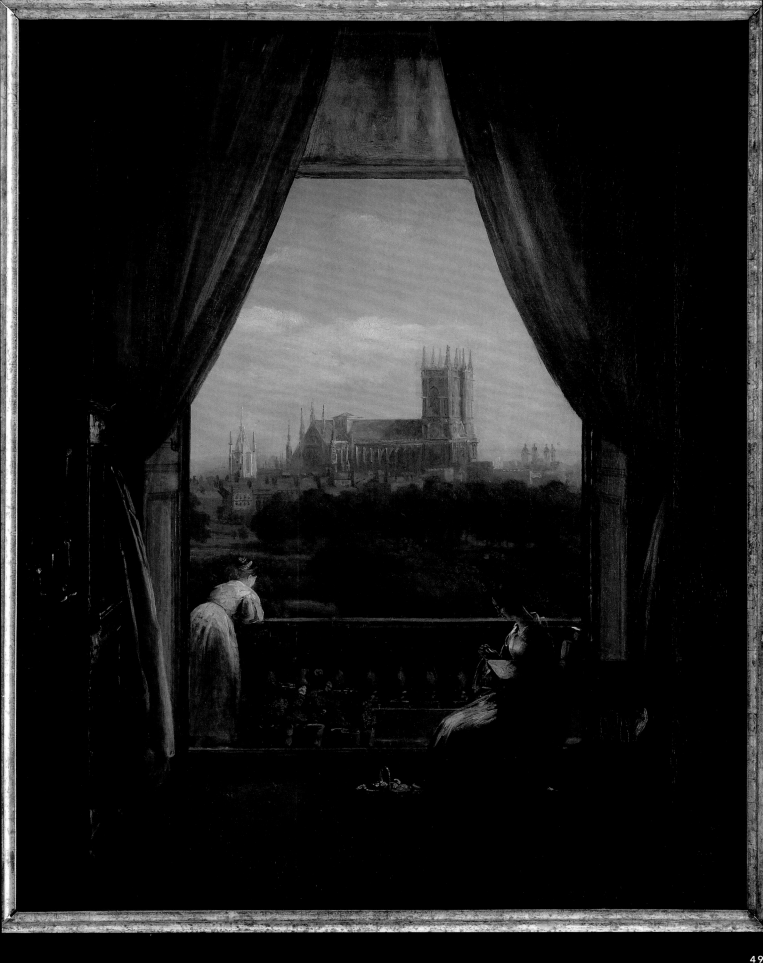

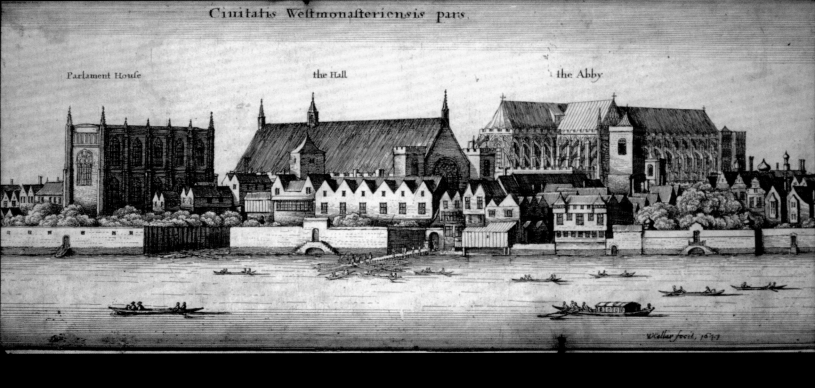

Parlament Houſe the Hall the Abby

Ciuitatis Weſtmonaſterienſis pars.

W.Hollar fecit, 1647

The Burning of the Houses of Parliament

The original Palace of Westminster (**30**) survived an attempt to blow it up in 1605, when a group of English Catholics attempted to assassinate King James I by placing 36 barrels of gunpowder under the House of Lords, with the intention of detonating them during the State Opening of Parliament. The plot was foiled when conspirator Guy Fawkes was discovered with the barrels. He and eight other plotters were hung, drawn and quartered, with the event commemorated annually on 5 November up to the present day, with effigies of Fawkes still burned on bonfires across the country.

The palace was not so lucky in 1834, when carelessly discarded tally sticks started a chimney fire that spread throughout the building. Its consumption by fire was recorded on the spot by a number of artists, including John Constable, who sketched it from a hansom cab on Westminster Bridge (**31**).

It is not known whether a series of nine watercolour sketches by Joseph Mallord William Turner now owned by the Tate were made as the scene unfolded (and there is some speculation that they actually document a later fire at the Tower of London). Nevertheless, the artist produced two finished oil paintings of the event in 1835, one showing the view from the Lambeth side of Westminster Bridge (**32**), the other further along the Thames, with the fire and Westminster Bridge seen in the distance (**33**). Westminster Abbey can be seen perilously close to the blaze in both paintings.

OPPOSITE:
30 Wenceslaus Hollar,
The Palace of Westminster,
c.1643

BELOW:
31 John Constable,
Fire sketch, 1834. Clark Art
Institute, Williamstown

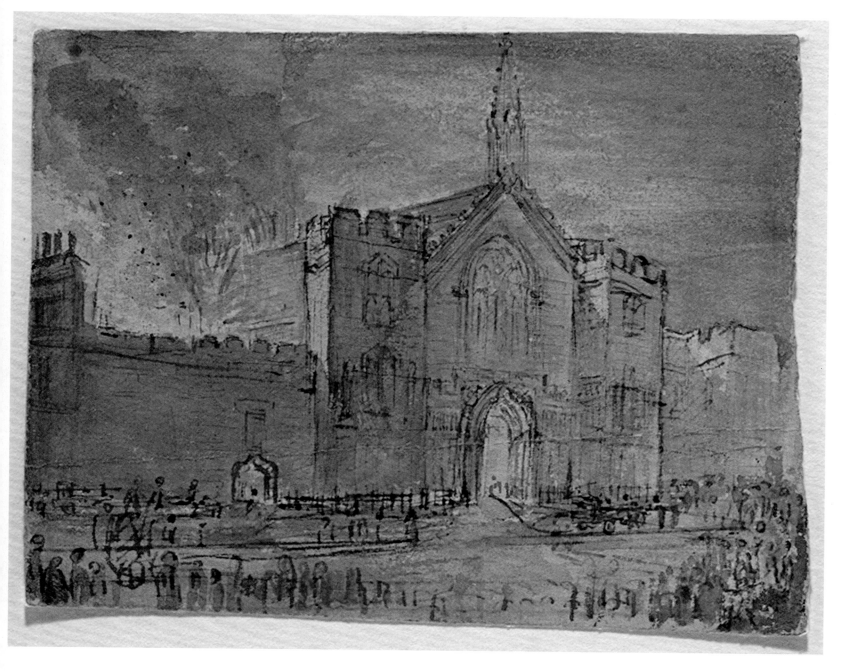

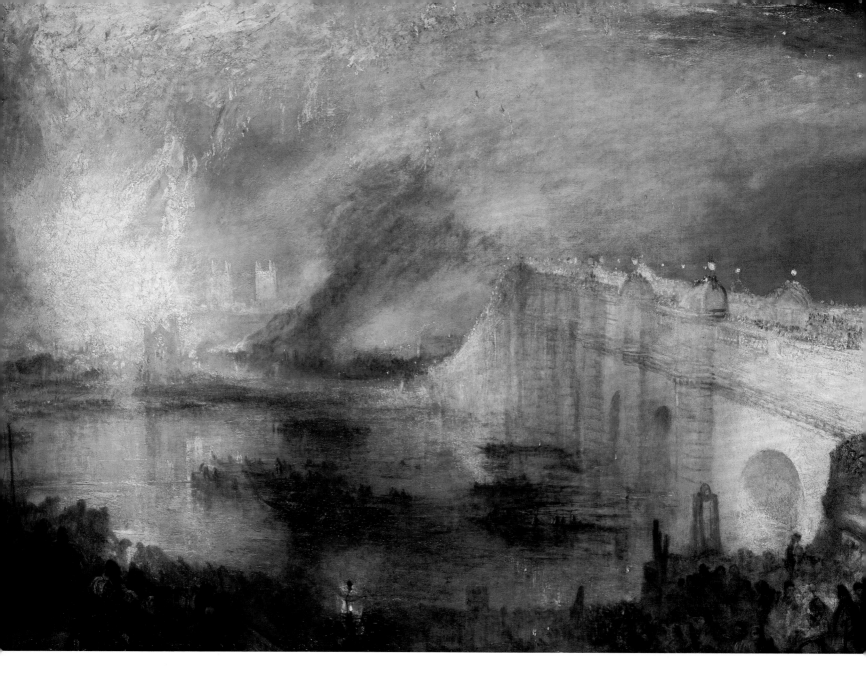

32 J.M.W. Turner,
*The Burning of the Houses
of Lords and Commons,
16 October 1834*, 1835.
Philadelphia Museum of Art

33 J.M.W. Turner,
*The Burning of the Houses
of Lords and Commons,
16 October 1834*, 1835.
The Cleveland Museum of Art

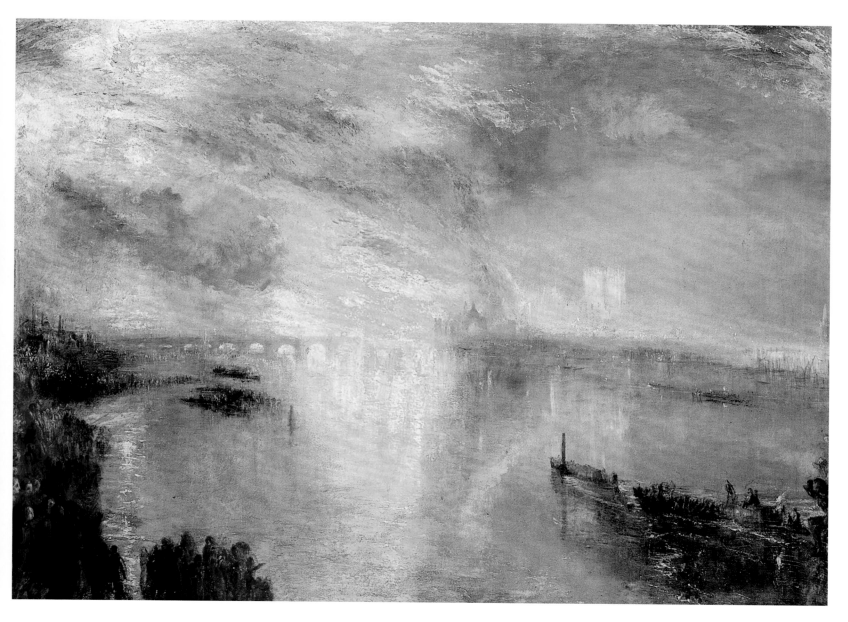

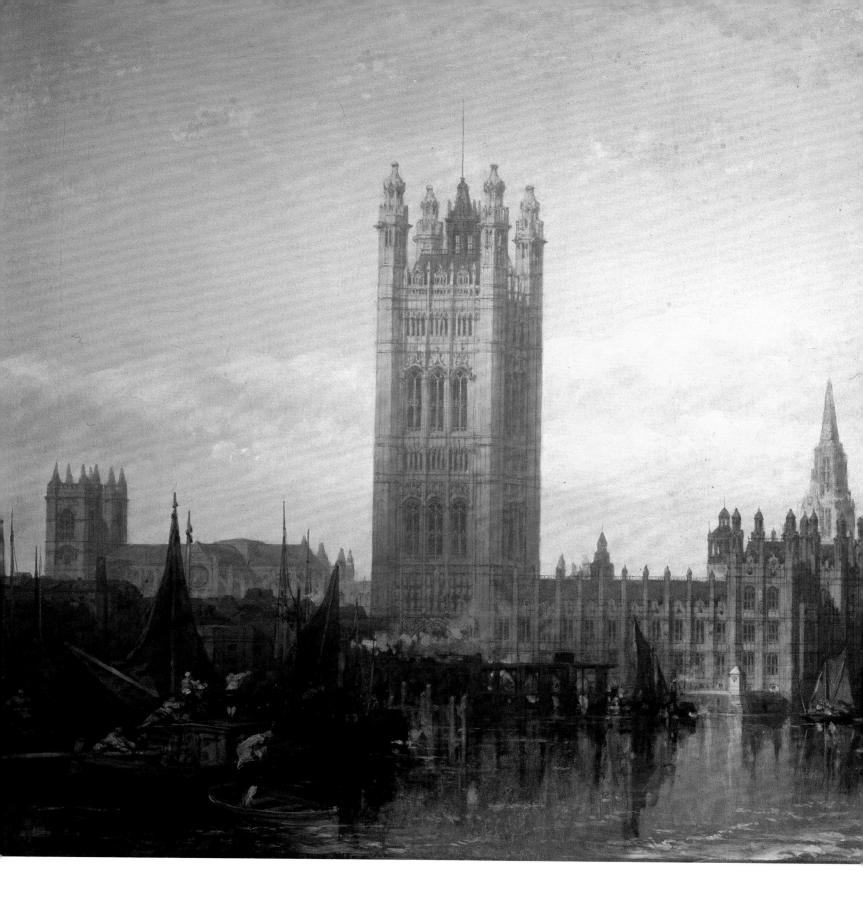

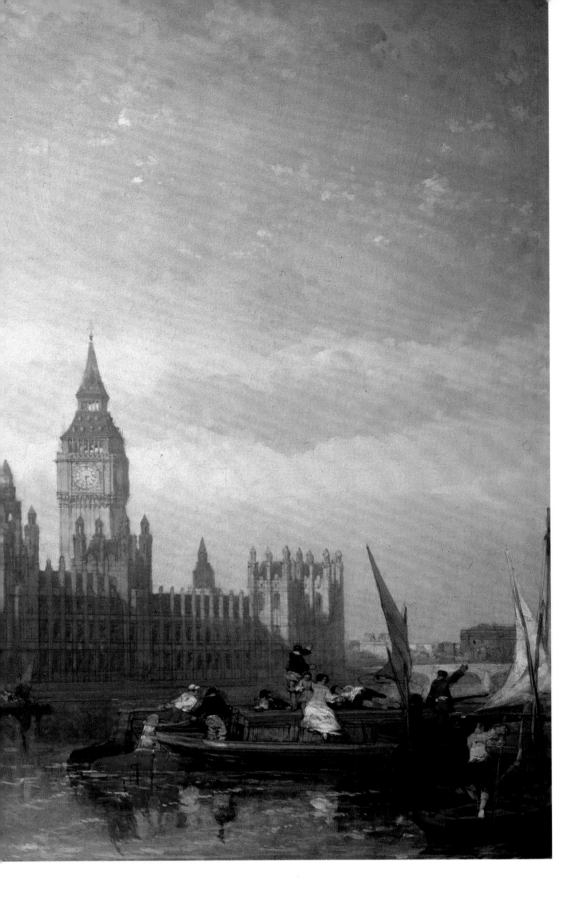

The Palace of Westminster

The Palace of Westminster, or the Houses of Parliament as it is more commonly known, is the meeting place of the House of Commons and the House of Lords, the elected and non-elected sections respectively of the British government. The building that we know is not the original, however. The Old Palace (**30**), established as a residence for the king during medieval times, held meetings of government from the thirteenth century on. Surviving the Gunpowder Plot of 1605, and extensively remodelled over the years, this palace finally burned down in 1834 (**32**).

The new Palace of Westminster, its distinctive exterior by Charles Barry in the Neo-Gothic style complemented by interior ornamentation by Augustus Pugin, was completed in 1870 (**34**). Its tower – erroneously known as Big Ben – was until 2012 simply known as the Clock Tower, and is now the Elizabeth Tower. Big Ben is in fact the largest of the five bells it contains, and is the largest chiming bell in the world. When first installed, the clock's accuracy was checked twice a day by a telegram to Greenwich Observatory, a practice that continued until the line was bombed in World War II. The Palace of Westminster was itself hit during the War, with the Commons Chamber totally destroyed and the Lords Chamber damaged. A new Commons Chamber came into use in 1950.

34 David Roberts,
New Palace of Westminster from the River Thames, 19th century.
City Club, London

‘A completely honest
answer always gives
you the advantage
of surprise in the
House of Commons.’

JONATHAN LYNN AND SIR
ANTONY JAY, *YES, PRIME MINISTER*
(BROADCAST 1986-87)

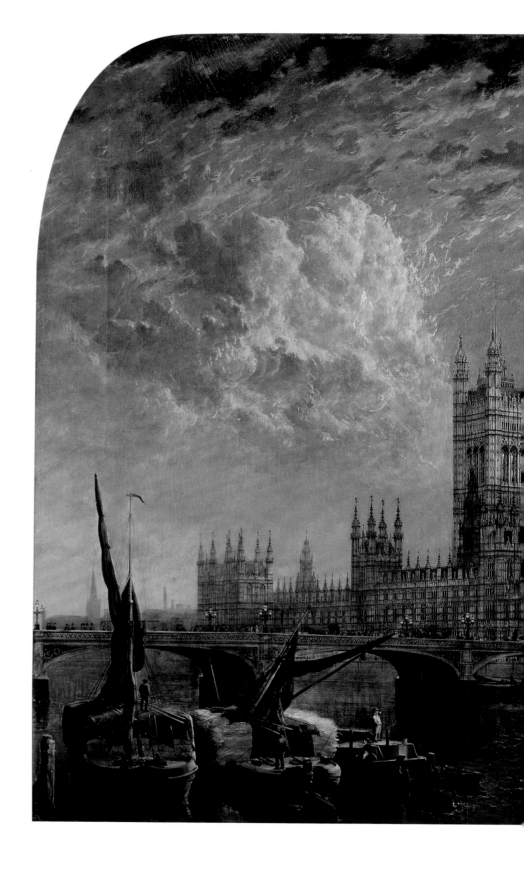

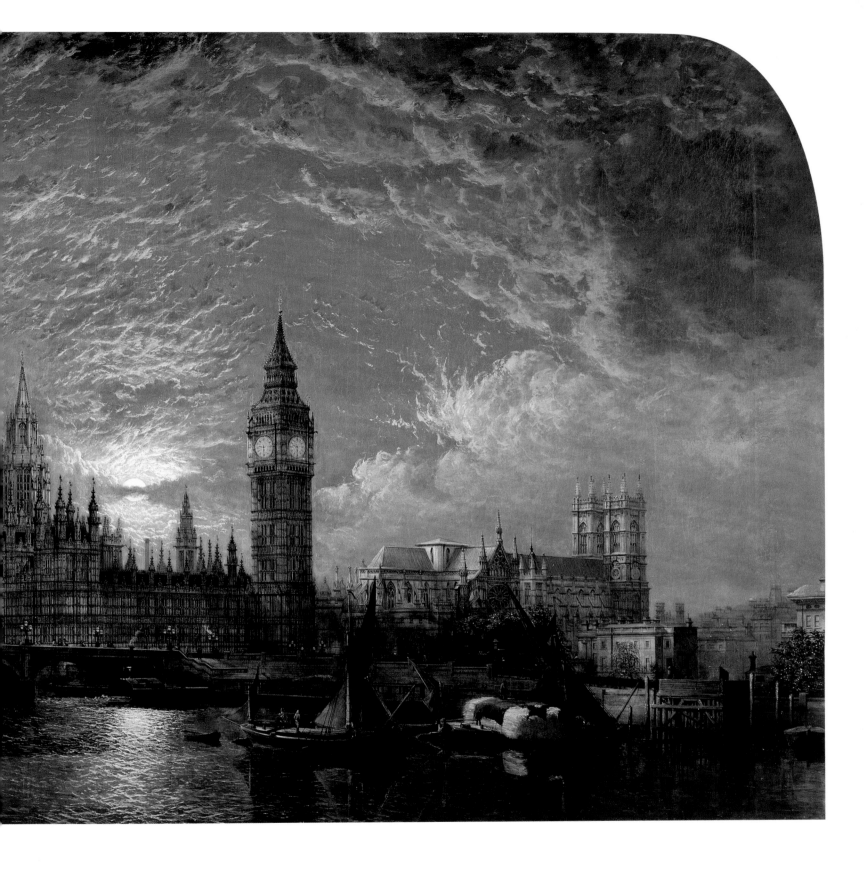

35 John Anderson,
*The Houses of Parliament with
Westminster Bridge and Abbey,
seen from the South Side of the
Thames*, 1872. Museum of London

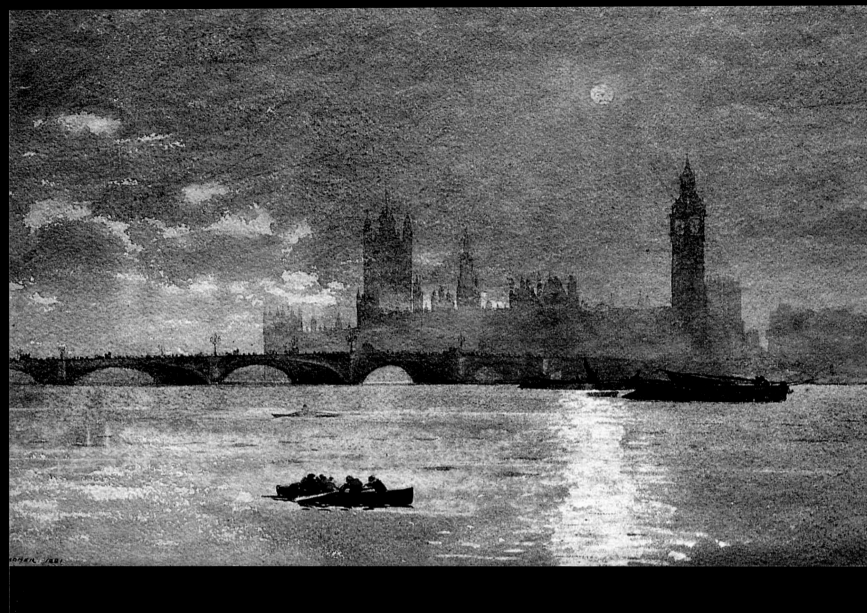

36 Winslow Homer,
The Houses of Parliament, 1881.
Hirshhorn Museum and Sculpture
Garden, Washington

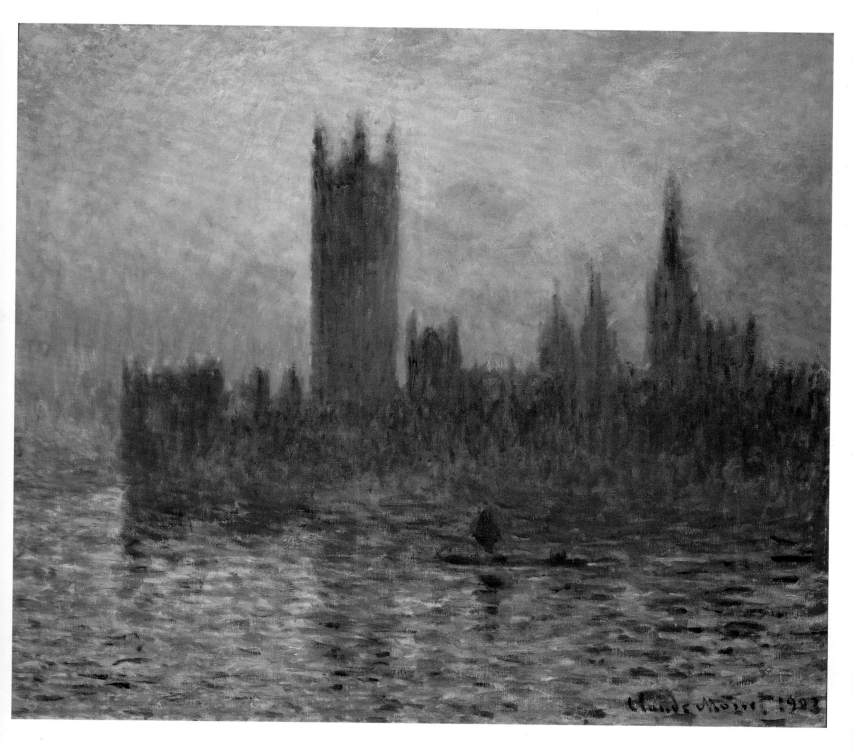

ABOVE:
38 William Coldstream,
Westminster II, 1974.
UK Government Art Collection

OPPOSITE:
39 Peter Blake,
Thames Regatta, 2012

Peter Blake and the Regatta

Numerous rowing competitions, or regattas, take place on the Thames every year. The events commonly occur upstream from central London, however. The scene pop artist Peter Blake presents here (**39**) is a fantastic one, more reminiscent of the Thames Diamond Jubilee Pageant of 2012, in which many vessels, both military and commercial, journeyed the Thames in celebration of 60 years of Queen Elizabeth's reign, in an event inspired by Canaletto's painting *The River Thames with St Paul's Cathedral on Lord Mayor's Day* (1747–48; **116**).

Blake includes not just rowing boats but airships and hot-air balloons in his regatta. The work is part of a larger series of prints, 'The London Suite', which includes other unlikely scenes such as Westminster Abbey besieged by zoo animals, runaway donkeys in Hyde Park, and superheroes in Piccadilly Circus.

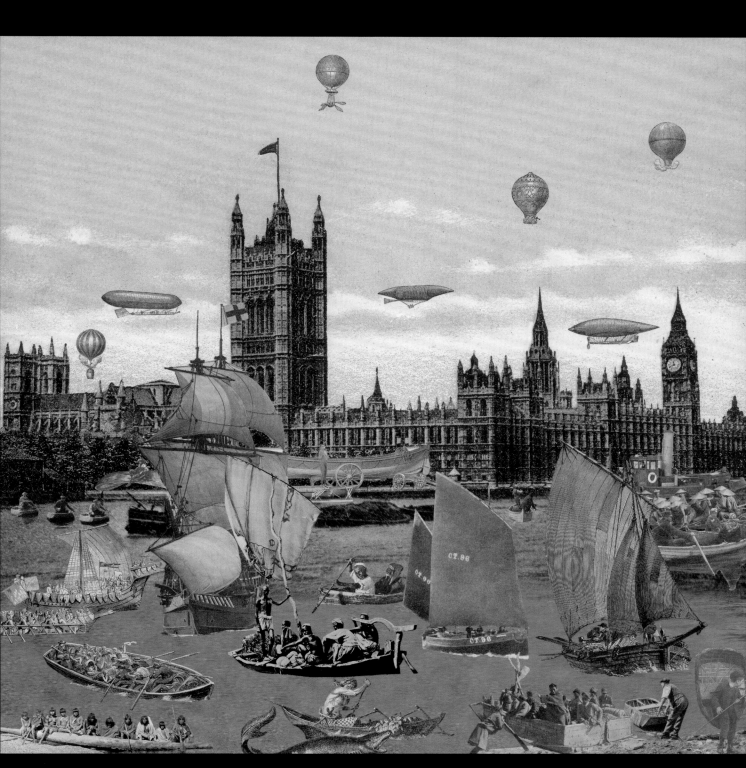

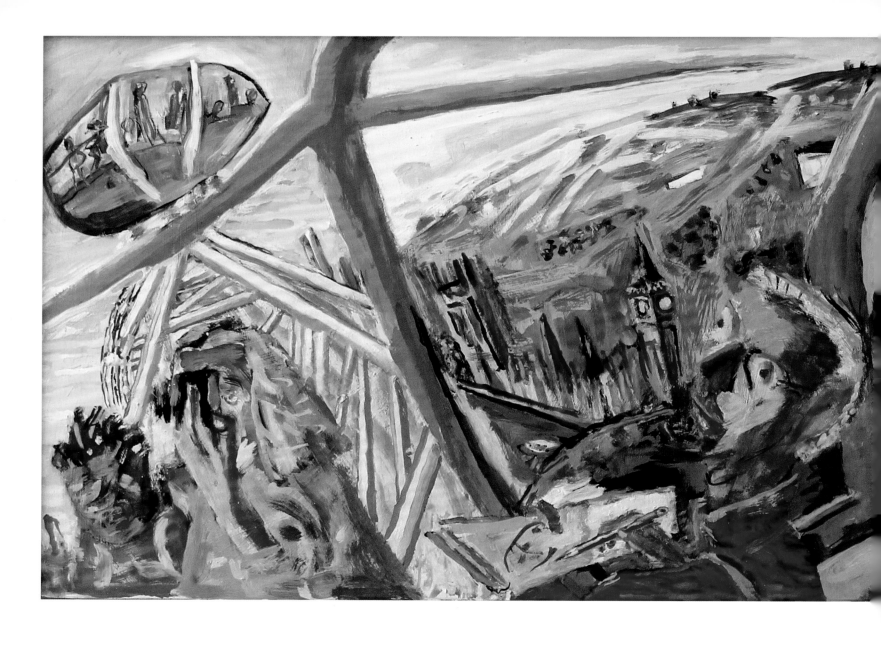

40 Timothy Hyman,
Drawing on the Eye, 2004–10

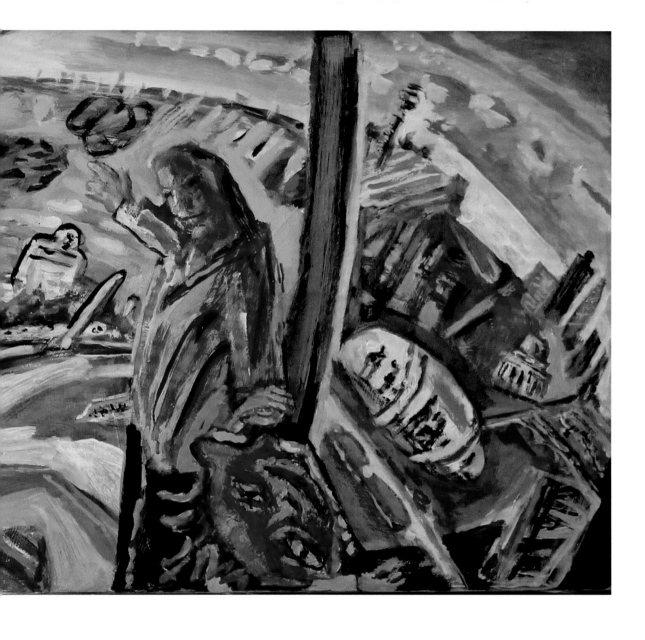

The London Eye

The London Eye, or Millennium Wheel, is a 443 foot (135 metre) tall Ferris wheel on the south bank of the River Thames. Opened as part of the millennium celebrations in 2000, the Eye was only intended to be in London for five years but has remained there owing to its popularity. Offering an excellent view of the Houses of Parliament and Westminster on the opposite bank, the Eye was the highest public viewing point in London until 2013. It was also the biggest Ferris wheel in the world until 2006, and is still the largest in Europe.

The Eye has 32 passenger capsules with room for 25 people in each. Timothy Hyman's painting *Drawing on the Eye* (**40**) shows the view from one of these capsules. Each revolution takes about 30 minutes, with the wheel continually moving, its speed slow enough for passengers to embark and disembark as it goes round.

Whitehall

Whitehall (named after the Palace of Whitehall, which occupied the site until it burned down in 1698) is a road running from Trafalgar Square to Parliament Square, and is the location for many government buildings, housing HM Treasury, HM Revenue and Customs, the Ministries of Defence and Health and the Foreign and Commonwealth Office, among others.

The road also provides access to the Horse Guards, headquarters of the London District and Household Cavalry army commands. The building has a central archway under which only the queen and holders of a special permit are allowed to pass.

At the centre of Whitehall is the Cenotaph (**41**), the country's primary war memorial, erected in 1920, where a National Service of Remembrance is held every year on Remembrance Sunday, the Sunday closest to Armistice Day (11 November).

The Banqueting House, the only surviving part of the old palace, was the backdrop to the execution of Charles I, beheaded on the scaffold in 1649 after having been found guilty of high treason.

ABOVE:
41 J. Hartley,
The Cenotaph, 1921

OPPOSITE:
42 Philip Norman,
Garden of No. 10 Downing Street, 1888

10 Downing Street

No. 10 Downing Street is the official residence of the British Prime Minister, and location of the Prime Minister's Office. In fact three houses joined together, 10 Downing Street was a gift made in 1732 by George II to the office of the First Lord of the Treasury, a position which is generally held by the Prime Minister, and consistently so since 1905.

The original Downing Street buildings were designed by Sir Christopher Wren and erected in 1682-84. Also incorporated into the property was 'the House at the Back', a sixteenth-century mansion that had become property of the Crown. At the back of the property is a terrace and half-acre garden, close to St James's Park (**42**). The numbering of the houses in Downing Street has changed throughout the years, until no. 5 became no. 10 in 1787.

10 Downing Street has not always been in favour as a place of residence, however. Owing to its then dilapidated state, and the perception that as a house it was actually unimpressive, it was used simply as offices or for meetings from 1834 to 1877. More recently, Tony Blair lived at no. 11 Downing Street when Prime Minister in order to accommodate his large family, while Chancellor of the Exchequer Gordon Brown lived at no. 10. Nevertheless, the door of no. 10 is iconic, with no visit by foreign dignitaries or VIPs complete without their being photographed outside, shaking hands with the Prime Minister.

Buckingham Palace

Buckingham Palace is the home of the British monarch. It has over 775 rooms, although only a small number of these are used by the royal household personally. Originally a townhouse for the Duke of Buckingham when erected in 1703, it became a royal residence in 1761, and the official residence of the British monarch when Queen Victoria ascended to the throne in 1837.

There have been some changes to the palace over the years. John Buckler shows the palace with the Marble Arch (**44**), intended as the state entrance to the courtyard by architect John Nash. It was moved to the West End in 1851, however, where it still stands, on a traffic island. Later, in 1913, the East Front of the palace was redesigned by Sir Aston Webb (**43**), and it is this that has become the iconic face of Buckingham Palace known the world over, the backdrop for military parades and the regular Changing of the Guard.

The East Front also features the famous balcony from which the Royal Family appear and wave to the crowds on days of celebration, a tradition beginning with Queen Victoria in commemoration of the opening of the Great Exhibition, and continuing up to the present day, notably on the annual Trooping the Colour celebration of the queen's official birthday. It is also from the East Front that the flag known as the Royal Standard, which is raised when the queen is in residence, can best be observed.

43 Charles Ernest Cundall, *Royal Air Force Parade at Buckingham Palace: Battle of Britain Anniversary*, 1943. Imperial War Museum, London

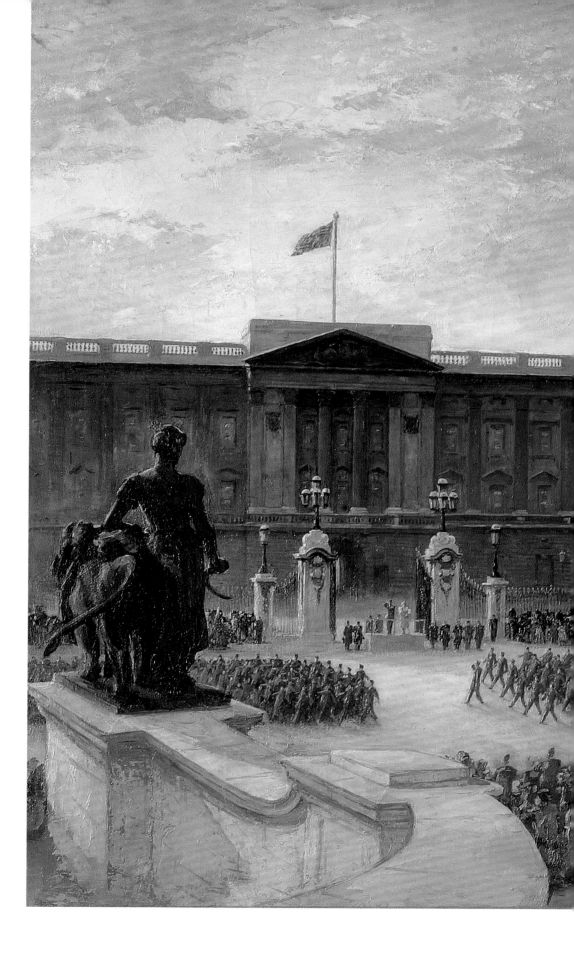

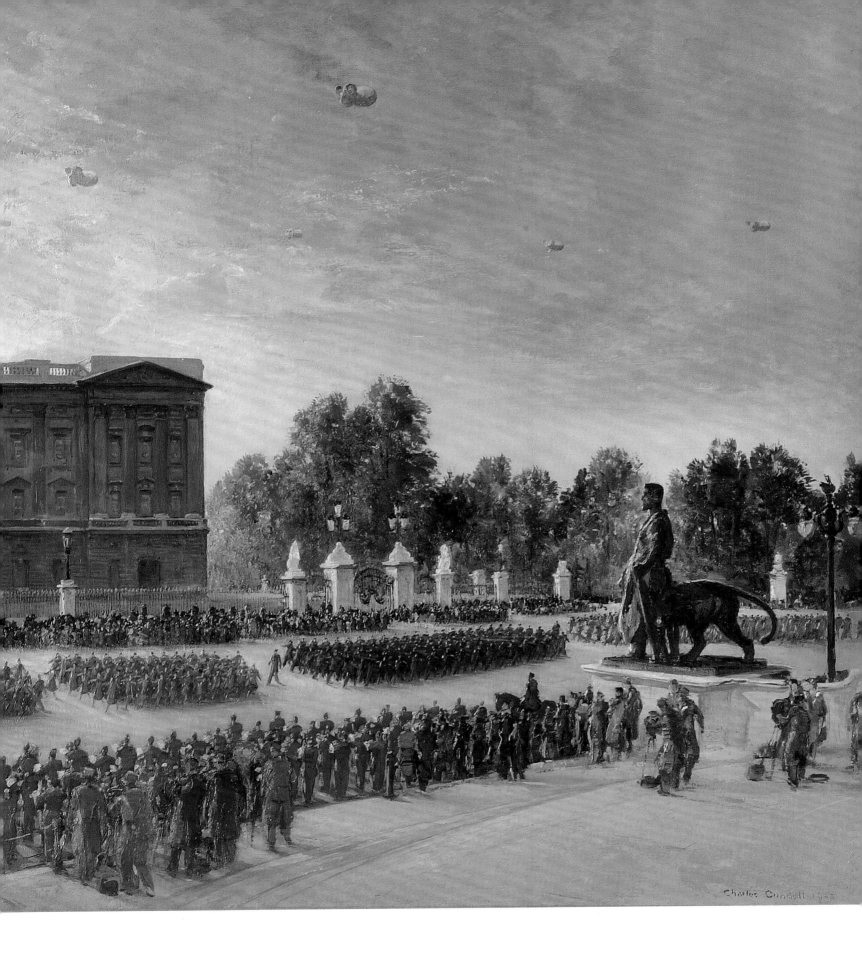

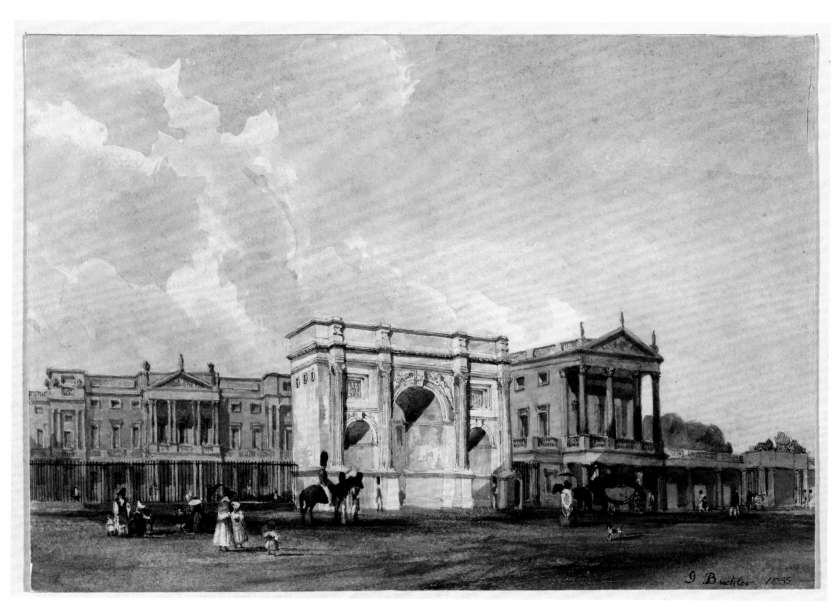

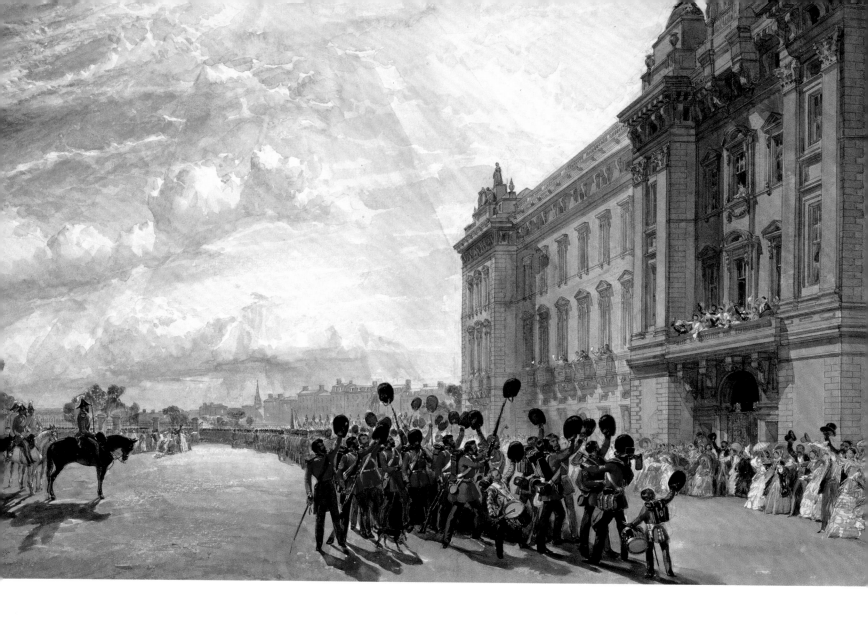

45 William Simpson,
The Return of the Guards from the Crimea, outside Buckingham Palace, 9 July 1856, 1856.
Royal Collection

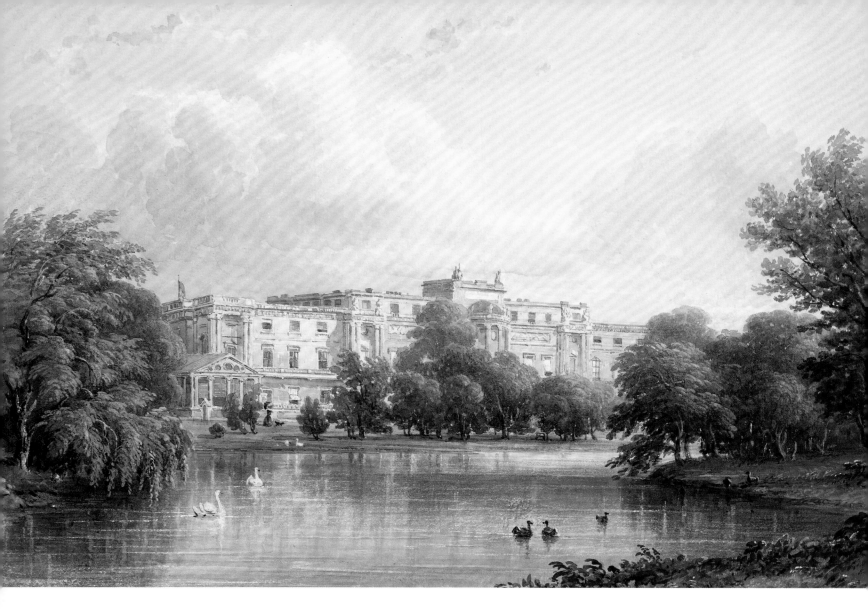

'This isn't ours.
It's a tied cottage.'

PRINCE PHILIP, DUKE OF
EDINBURGH (B. 1921)

46 Caleb Robert Stanley,
*Buckingham Palace: Garden
Front from across the Lake*,
c.1845. Royal Collection

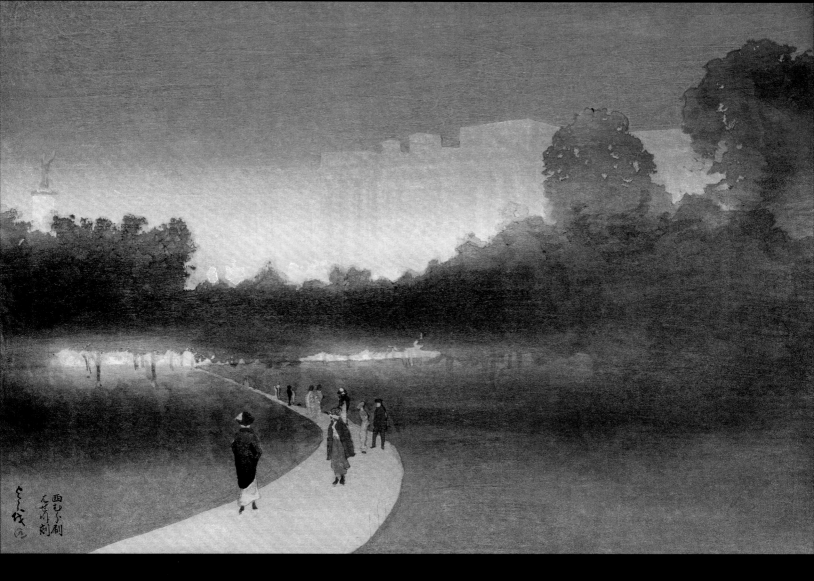

西むら 制
乙芳川刻

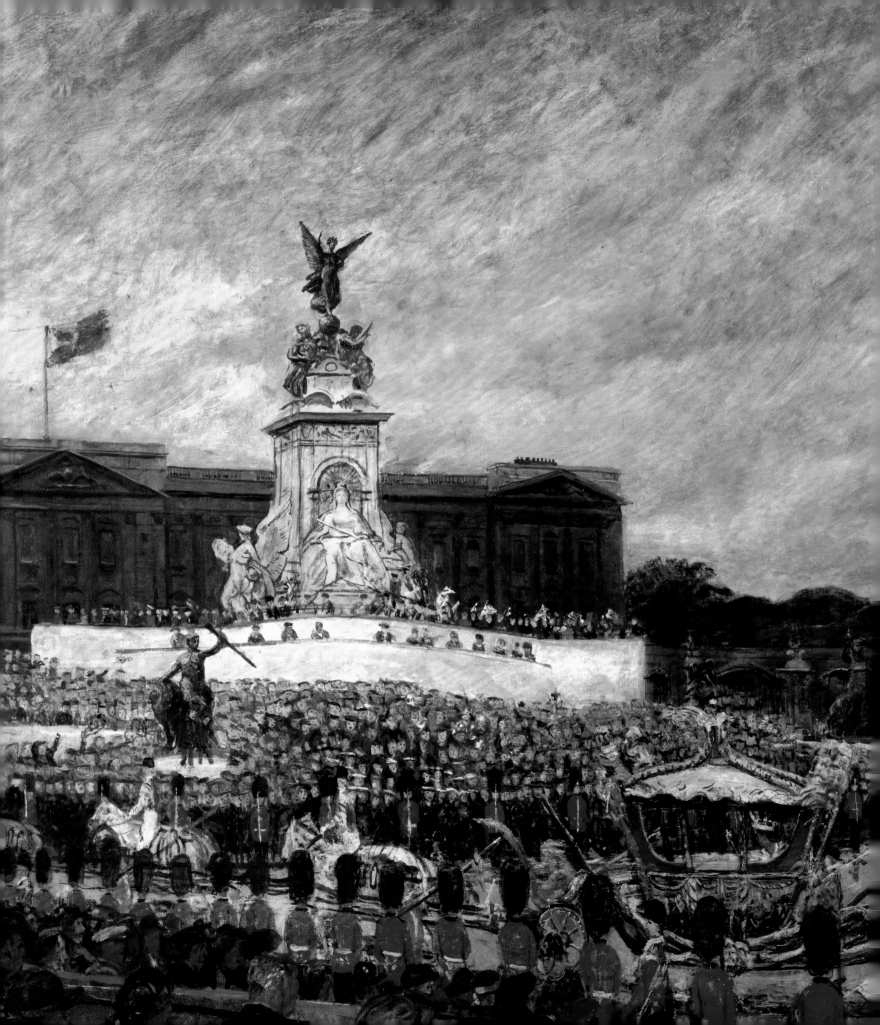

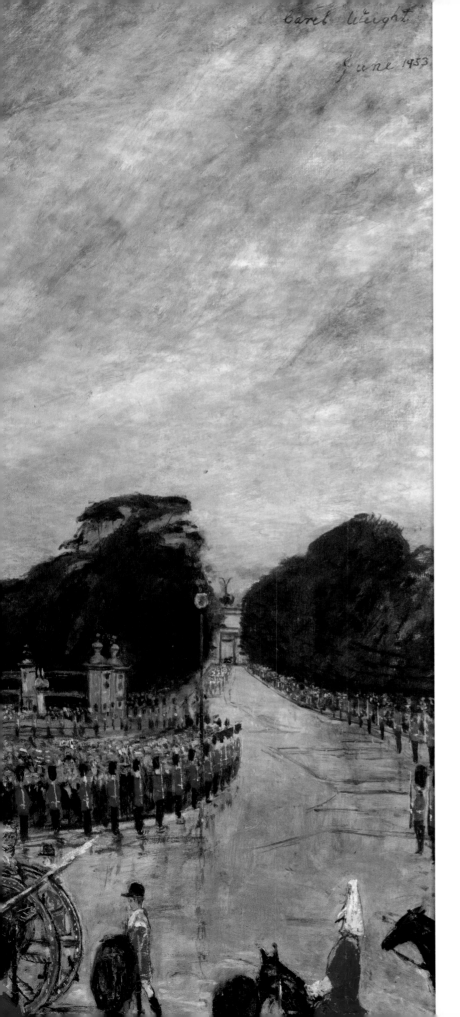

The Coronation of Queen Elizabeth II

Queen Elizabeth II was made monarch of the United Kingdom and Commonwealth on 2 June 1953 at a ceremony in Westminster Abbey, following the death of her father, George VI. The first coronation of a British monarch to be televized, the day was one of celebration, marked with street parties throughout the land.

Following the ceremony, the queen travelled in the Gold State Coach (**48**), with a military escort of thousands, to Buckingham Palace (**49**), where she appeared on the balcony and waved to the gathered crowds that stretched down The Mall (**50**). Were all three artists whose work appears here in The Mall that day, each moving among the crowd, making sketches for their paintings? It is tempting to think so.

48 Carel Weight,
Coronation Procession Returning to Buckingham Palace, 1953.
UK Government Art Collection

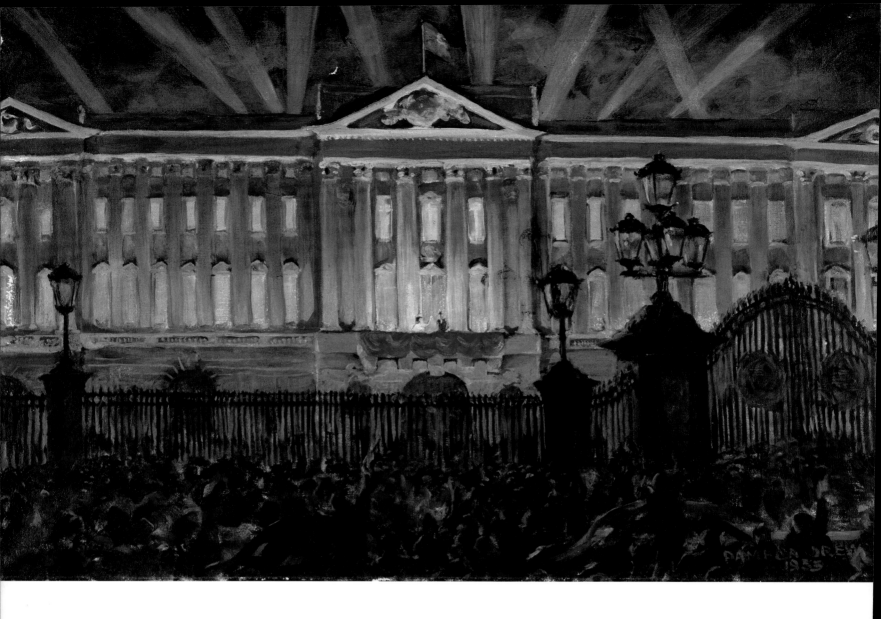

ABOVE:
49 Pamela Drew,
Coronation Night, Buckingham Palace, 1953. UK Government Art Collection

OPPOSITE:
50 Stanley Clare Grayson,
Coronation Night, The Mall, 1953. UK Government Art Collection

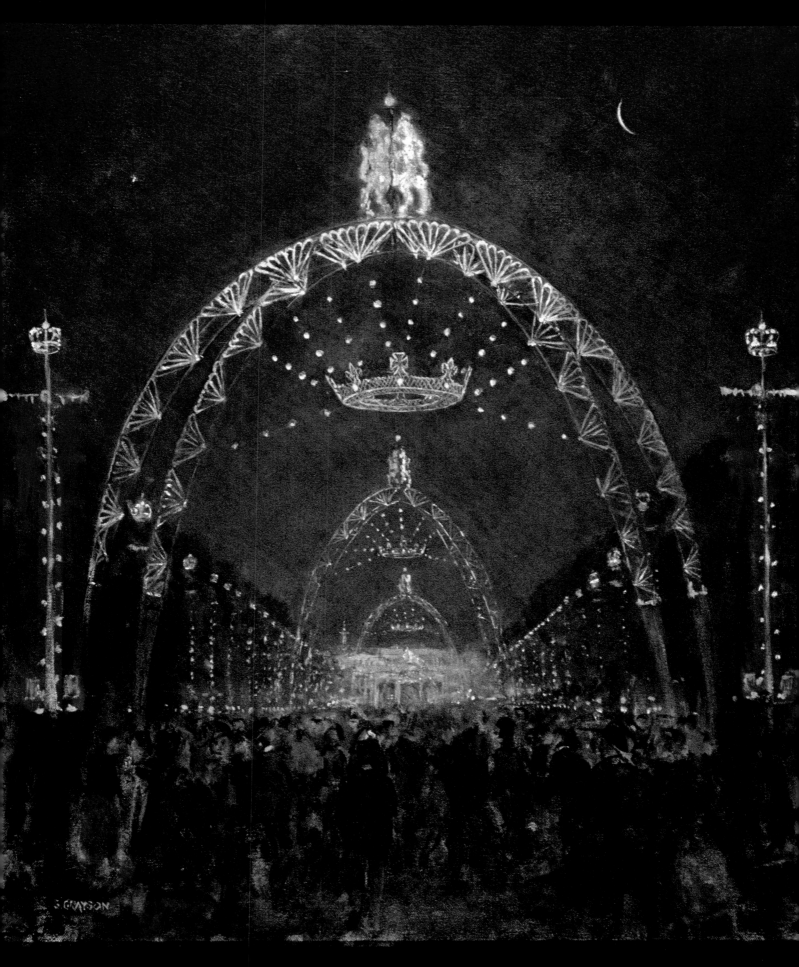

'The ladies of St James's!
They're painted to the eyes;
Their white it stays for ever,
Their red it never dies:'

AUSTIN DOBSON,
'THE LADIES OF ST JAMES'S' (1885)

St James's Park and Green Park

Leading from Buckingham Palace to Trafalgar Square is The Mall, originally an alley for the playing of the lawn game pall-mall, and becoming a place for the fashionable to promenade in the seventeenth and eighteenth centuries (**51**). Either side are two Royal Parks, St James's Park and Green Park.

St James's Park (**52**) was developed by James I in the early years of the seventeenth century on land purchased by Henry VIII. Once drained, it became a home for exotic animals such as crocodiles, camels and an elephant, along with an aviary and, at one point, a crane with a wooden leg. Charles II had the park developed further and opened it up to the public, at which point it gained a reputation as a location for immoral behaviour. A canal was refashioned into a lake by landscape artist John Nash in 1826–27, and avenues into winding pathways.

Green Park (**53**) is perhaps the least well known of the Royal Parks in central London, containing fewer features of note than its more famous neighbours. It has had its share of notable incidents over the years, however. Apparently built on a lepers' burial ground, the park was plagued by highwaymen in the eighteenth century, and was a popular site for duels. Handel composed his famous 'Music for the Royal Fireworks' for a display at Green Park in 1749, while there was an assassination attempt on the life of Queen Victoria in 1840, when one Edward Oxford unsuccessfully fired on her with two pistols while she was out in her carriage on Constitution Hill, an avenue in the park. (She would go on to survive another seven failed assassination attempts, two of them again on Constitution Hill.)

51 Thomas Gainsborough, *The Mall in St James's Park*, c.1783. Frick Collection, New York

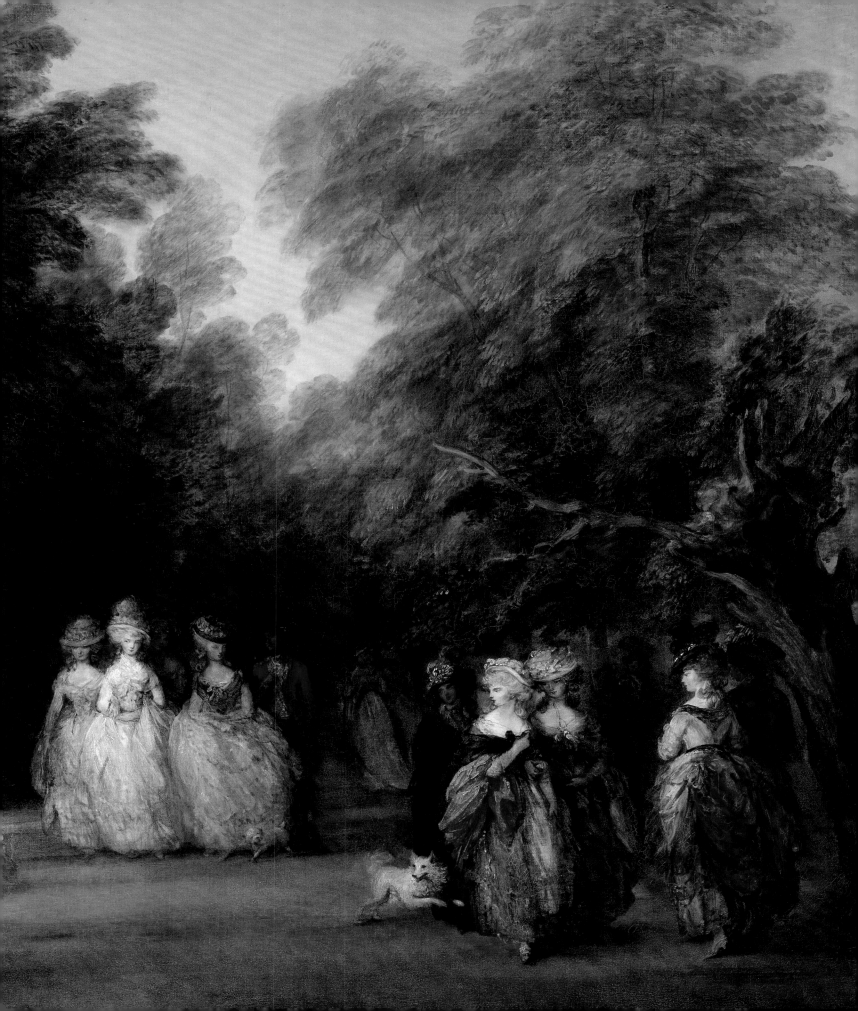

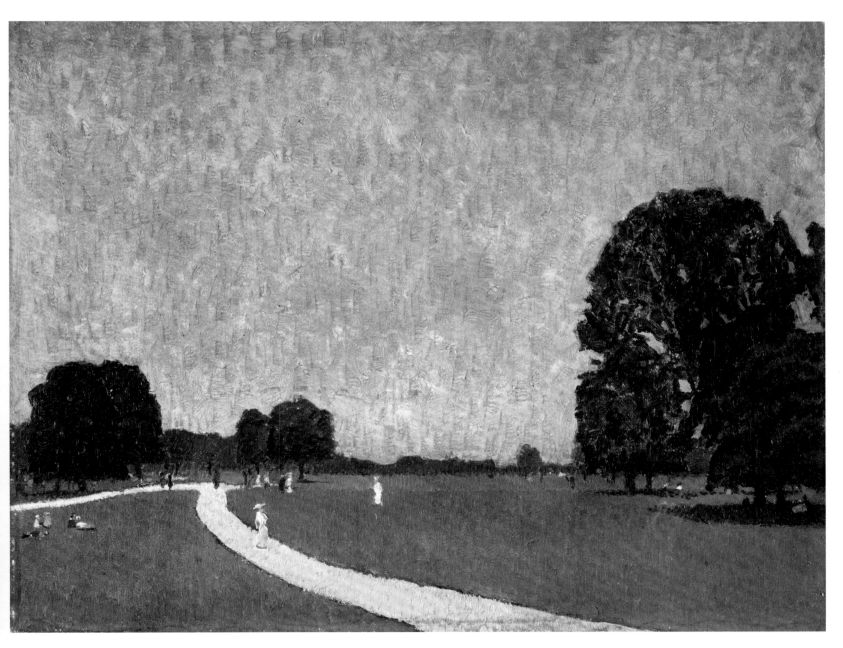

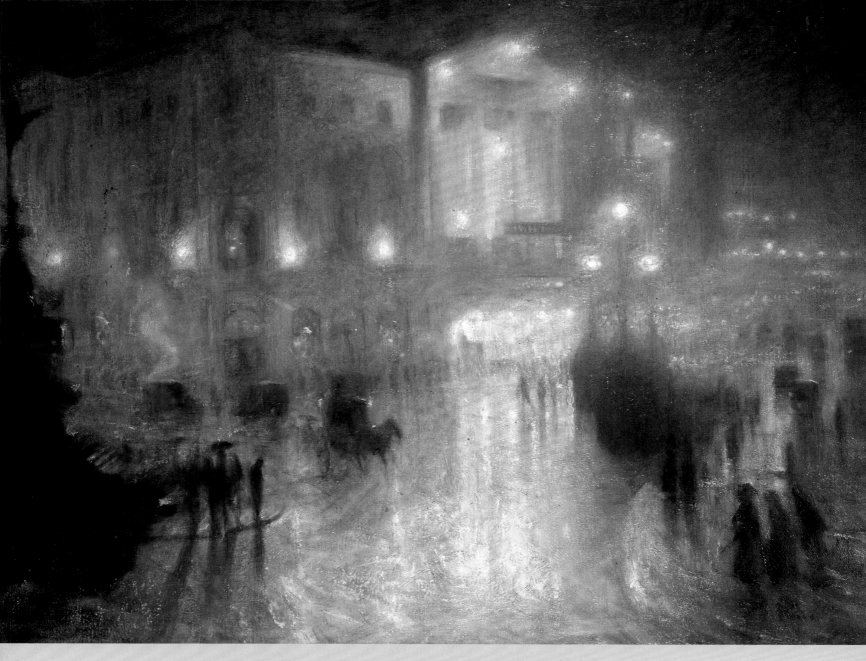

54 Arthur Hacker, *Wet Night at Piccadilly Circus*, 1910. Royal Academy of Arts, London

Piccadilly

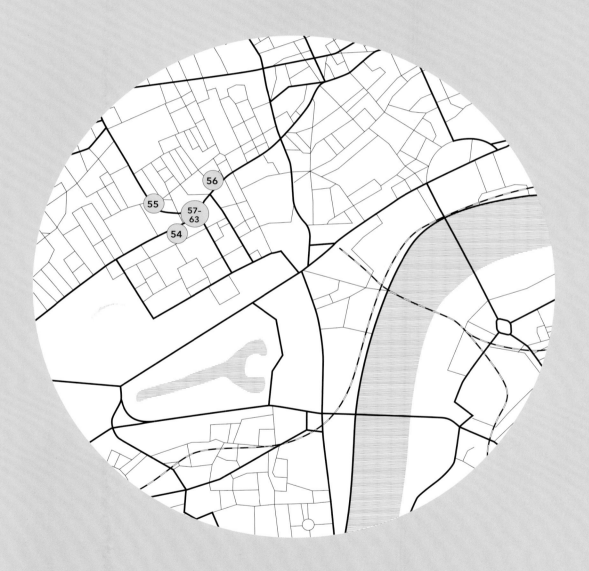

REGENT STREET, THEATRELAND, PICCADILLY CIRCUS

A trip down the premier shopping location of Regent Street (**55**) leads us to Piccadilly Circus (**54**). Gaining its name from long-gone country house Pikadilly Hall, belonging to a tailor who had made his fortune from 'piccadil' collars, it is now one of the most famous road junctions in the world. Piccadilly Circus has long been known for its illuminated signs (**60**) – once made from light bulbs, then neon, and now video displays. At the centre is the Shaftesbury Memorial Fountain, atop which stands the statue by Alfred Gilbert commonly known as 'Eros' (although actually depicting the Greek god's brother, Anteros; **57**). Here in the heart of 'Theatreland' (**56**), flower-sellers and newspaper boys sell their wares to the immaculately dressed patrons (**61**), while during the day, traffic and people jostle for space at this busy junction (**58**). And as the end of war is announced in 1945 (**62**), the crowds throng to this popular public space and bring Piccadilly Circus to a standstill …

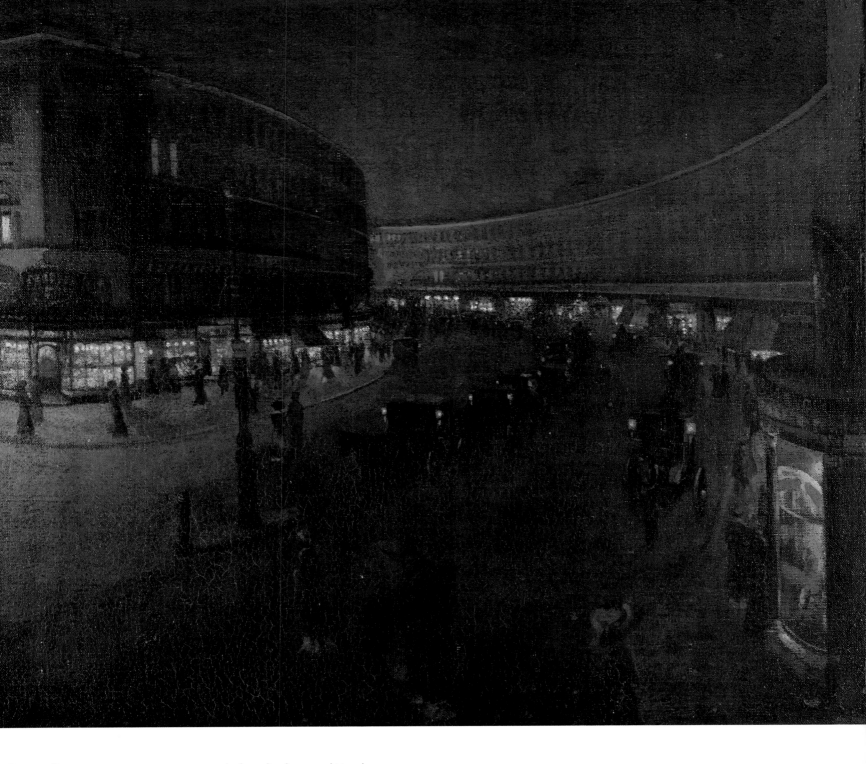

Regent Street

One of the primary streets for shopping in London's West End, Regent Street (**55**) was completed in 1825. Designed by the architect John Nash (although all but one of his original buildings have since been replaced), it was named in honour of the then Prince Regent, who would become George IV.

Notable shops on Regent Street include the Liberty department store, seller of luxury goods and known for its Christmas window displays, and Hamleys, the oldest toy shop in the world. First opening as 'Noah's Ark' in High Holborn in 1760, the toy shop moved to Regent Street in 1881, before moving again to another Regent Street address 100 years later, at which point it became the biggest toy shop anywhere, covering seven floors.

Regent Street is also known for its spectacular Christmas light display, a tradition dating back to 1953.

'Nothing is certain in London but expense.'

WILLIAM SHENSTONE,
POET (1714-63)

'Theatreland'

London's relationship with theatre was at one point a rocky one. The theatres in which Shakespeare's plays were originally performed, including the Globe, were ultimately closed by the Puritans in 1649. The art of theatre gradually revived following the restoration of the monarchy in 1660, and by the early nineteenth century, a number of new theatres opened in the West End in order to present melodramas, stories acted out with musical accompaniment. The number of these grew, particularly in the Victorian and Edwardian eras, and now the West End theatre district is equal to New York's Broadway in terms of prestige in the theatrical industry.

'Theatreland' (**56**) in the West End now consists of about 40 theatres. Historical theatres from the early years still surviving include the Theatre Royal (first opened in 1660, current building opening in 1812), the Adelphi (opened by John Scott in 1806 in order to launch his daughter's acting career), the Lyceum (originally opening in 1765, rebuilt in 1834), and the Theatre Royal Haymarket (first opened in 1720, relocated to its current site in 1821).

Although the West End has hosted many long-running musical successes, such as *Les Misérables*, *The Phantom of the Opera* and *Cats*, the longest continuous run is of a play, Agatha Christie's *The Mousetrap*. Opening in 1952, it is still performed at St Martin's Theatre, marking its 64th year in 2016.

56 George Hyde Pownall, *London Theatreland*, c.1910. Private collection

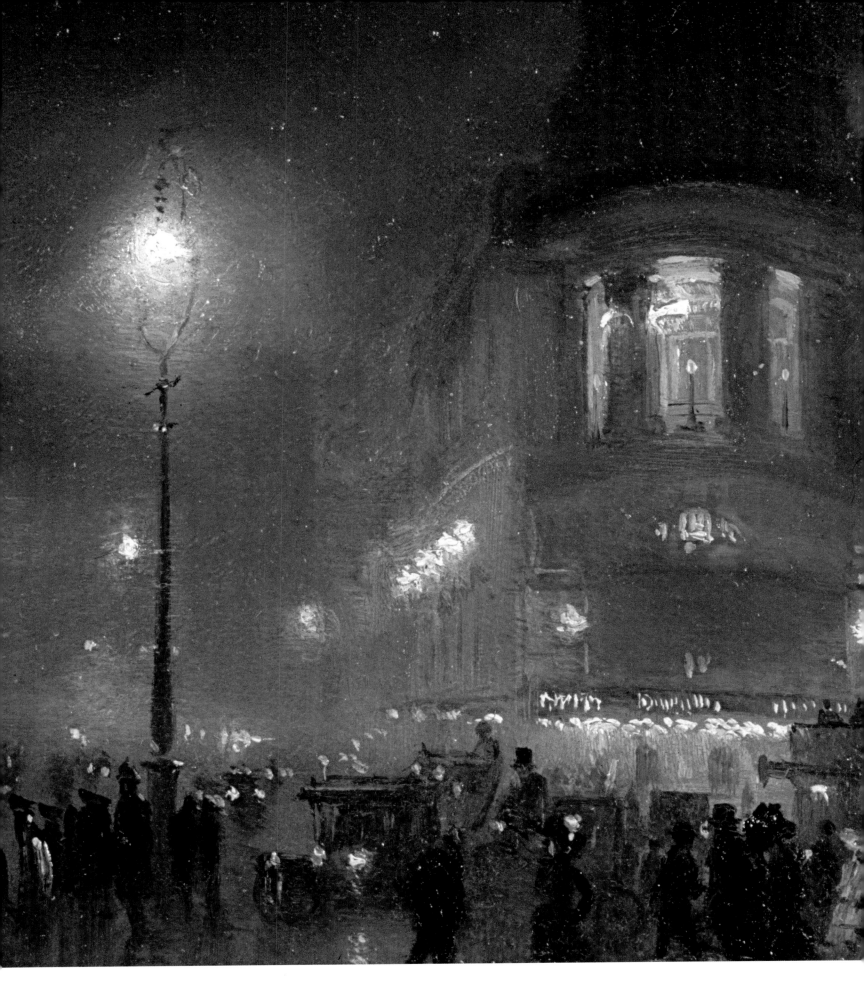

'Eros'

The statue showing a winged figure armed with a bow on the south-eastern side of Piccadilly Circus, known as 'Eros', stands atop the Shaftesbury Memorial Fountain (**57**), and is in fact not of the mythical figure of Eros at all, but his brother, Anteros.

The fountain commemorates the politician, social reformer and philanthropist Lord Shaftesbury (1801–85), and was unveiled in 1893. The figure of Anteros was chosen as in Greek mythology he is 'the god of selfless love' (as opposed to Eros, the 'frivolous tyrant' according to Gilbert), and was seen to embody Shaftesbury's concern for the welfare of others.

The memorial originally occupied the centre of Piccadilly Circus, but was removed twice – first from 1922 to 1931 when Piccadilly underground station was being excavated, and then during World War II – and relocated in its current position on its return. While the fountain is made from bronze, 'Eros' was the first statue in the world to be cast in aluminium.

57 Ernest Dudley Heath, *Piccadilly Circus at Night*, 1893. Museum of London

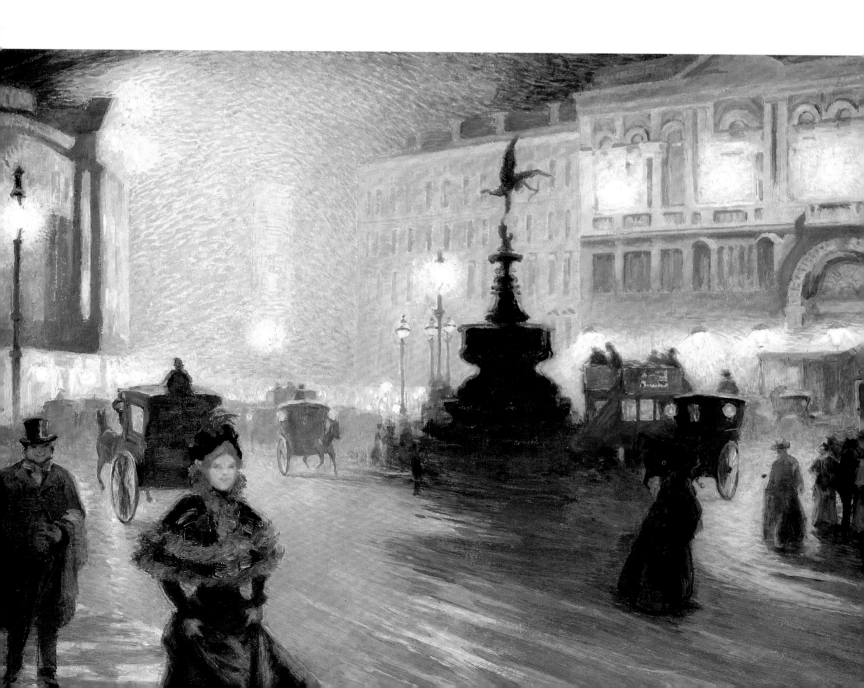

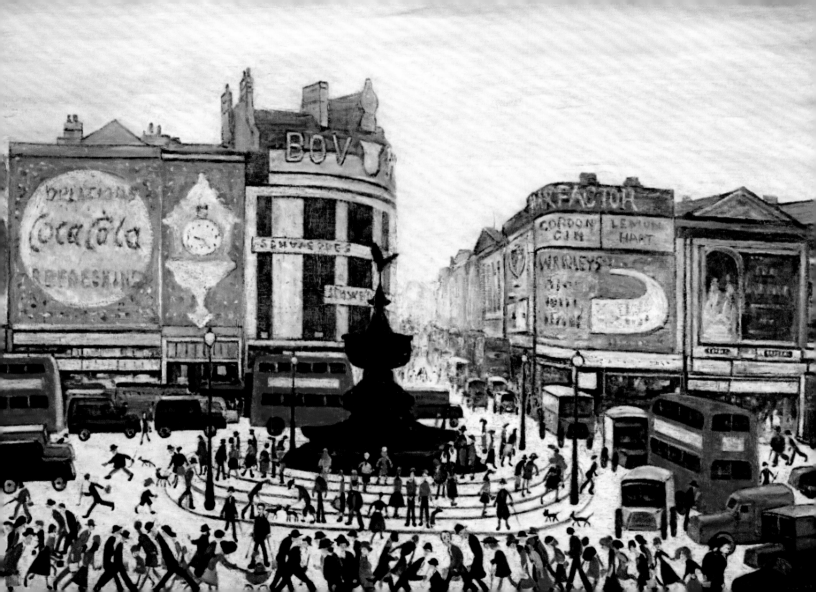

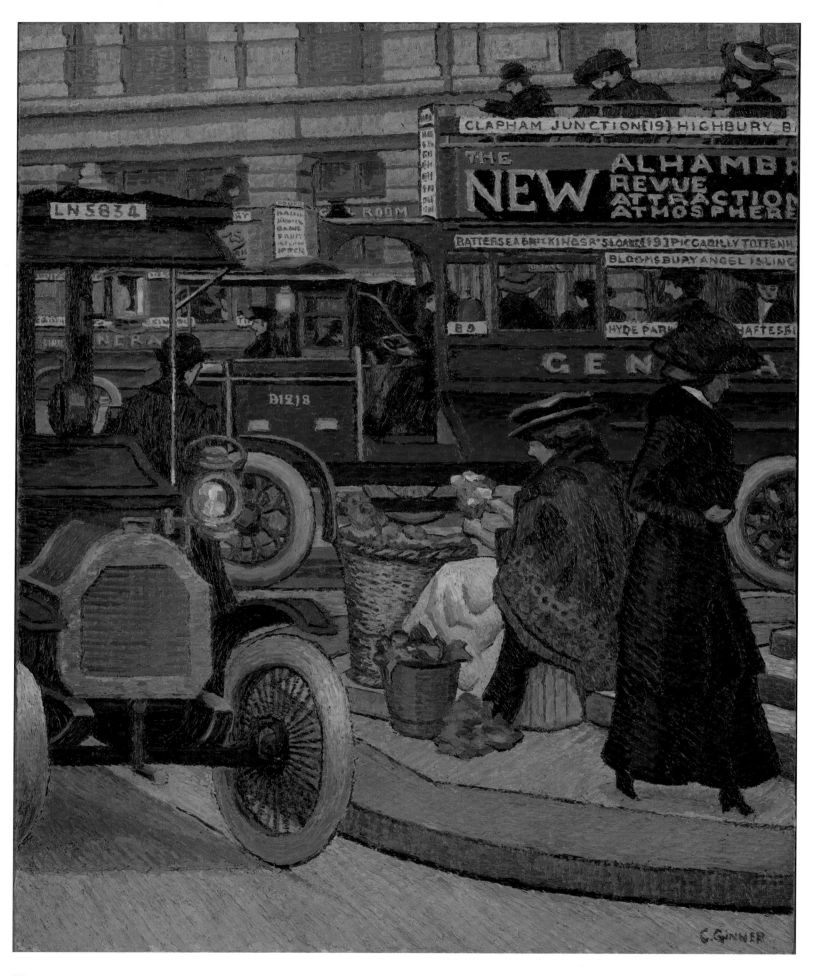

'London is only a huge shop, with a hotel on the upper storeys.'

GEORGE GISSING,
NEW GRUB STREET (1891)

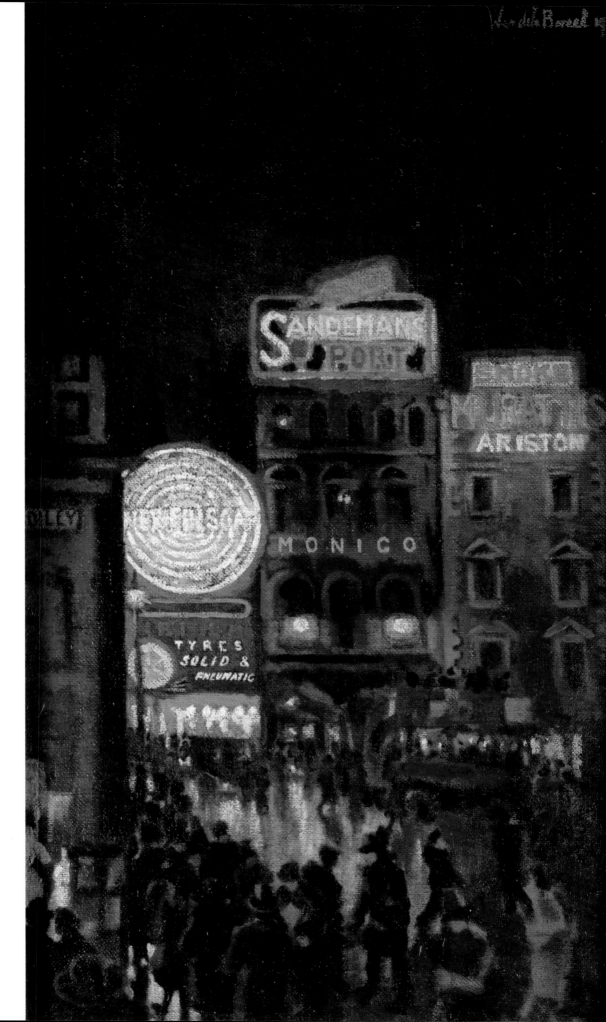

OPPOSITE:
59 Charles Ginner,
Piccadilly Circus, 1912. Tate

RIGHT:
60 Wendela Boreel,
Piccadilly Circus, 1922.
Private collection

VE Day and VJ Day in Piccadilly Circus

At the end of the Second World War, Piccadilly Circus was the site of enormous celebrations on both VE (Victory in Europe) Day and VJ (Victory in Japan) Day.

A BBC radio broadcast on VE Day (8 May 1945) reported sailors from the Royal Navy shimmying up lamp poles and planting the Union Jack at the top, as well as the flags of Britain's wartime allies, the USA and the Soviet Union, and a huge cheer for a Lancaster bomber flying overhead, caught in a spotlight.

The advertising hoardings that replaced the Shaftesbury Memorial Fountain can be seen in Sansalvadore's painting of VJ Day (15 August 1945; **62**), surrounded by the massive crowd celebrating the victory.

Also on this day, the Royal Family waved from the balcony at Buckingham Palace to the many gathered there, and Princesses Elizabeth and Margaret went down to mingle with them.

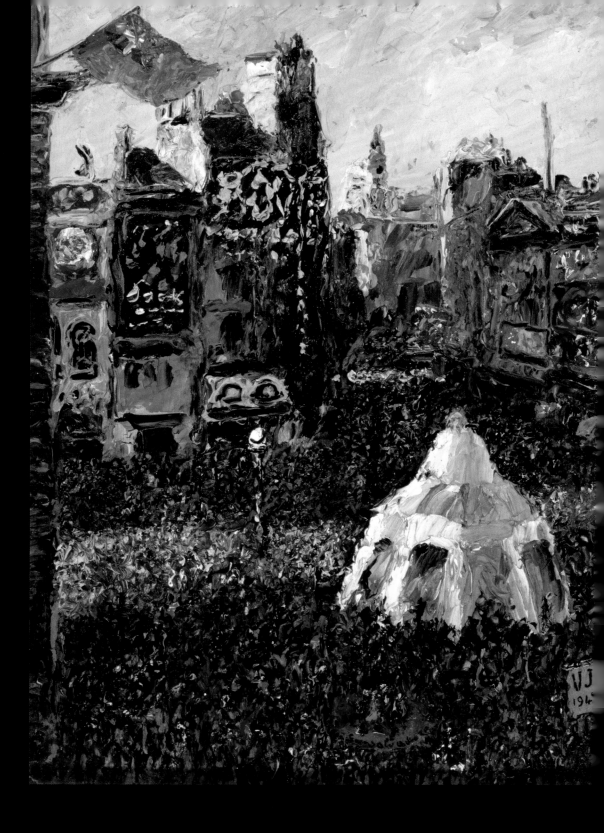

62 Piero Sansalvadore,
London, VJ Day, Piccadilly Circus,
1912, Museum of London

London Underground

Piccadilly Circus is one of 270 stations on the London Underground network (**63**). Beginning in 1863 as the Metropolitan Railway, the world's first underground railway originally employed steam engines, before electric traction trains were introduced in 1890. The Underground now consists of 11 lines, adding up to a total of 402 km (250 miles), the third longest metro system in the world.

The London Underground has long been a patron of the visual arts, commissioning striking graphic posters by renowned artists including Paul Nash and Graham Sutherland, and also incorporating art into the stations themselves, such as a series of mosaics at Tottenham Court Road station by Eduardo Paolozzi installed in 1984 and, more recently, *Labyrinth* by Mark Wallinger, a multi-part work spread across all 270 stations.

The famous London tube map, originally designed by Harry Beck in 1931, is a classic work of graphic art in its own right. Beck did not consider the actual physical location of the stations in relation to each other, instead placing them on straight horizontal, vertical and diagonal lines, so that the journey the traveller must take could be easily worked out. This approach has since been adopted by many underground systems throughout the world.

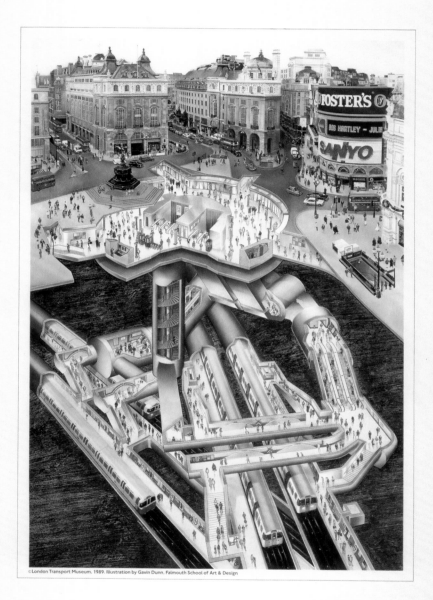

©London Transport Museum, 1989. Illustration by Gavin Dunn, Falmouth School of Art & Design

LONDON TRANSPORT MUSEUM

PICCADILLY CIRCUS
The Heart of London

A Special Exhibition at the
London Transport Museum
The Piazza, Covent Garden
25 May–26 November 1989
Open daily from 10.00 to 18.00
Last admission 17.15

63 Gavin Dunn,
*Piccadilly Circus: The Heart
of London*, 1989. London
Transport Museum

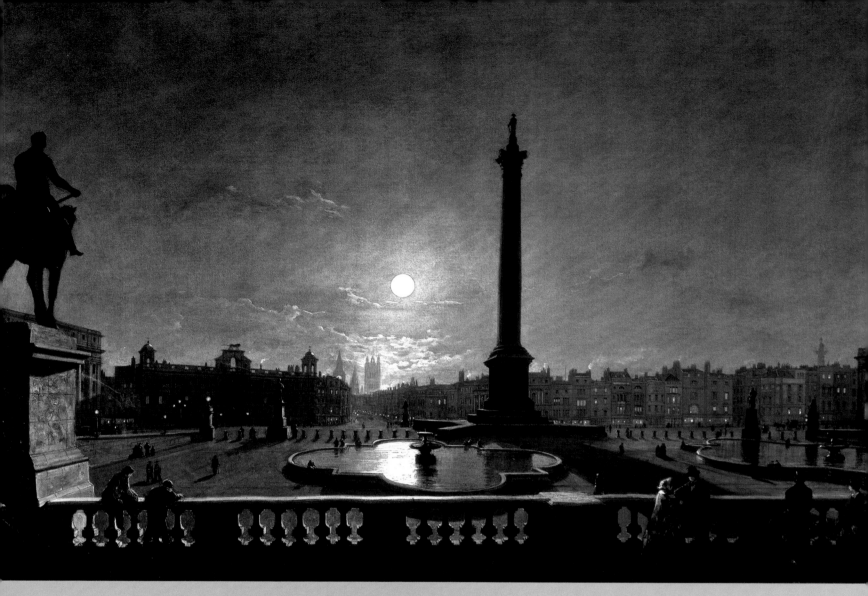

64 Henry Pether, *Trafalgar Square by Moonlight*, c.1862. Museum of London

Trafalgar Square & Leicester Square

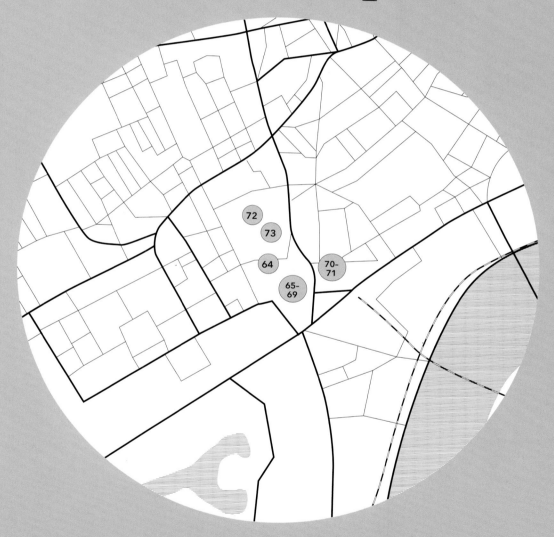

TRAFALGAR SQUARE, NELSON'S COLUMN, ST MARTIN-IN-THE-FIELDS, LEICESTER SQUARE

Moonlight falls on Trafalgar Square (**64**). A public space since 1844, and home to the National Gallery, the church of St Martin-in-the-Fields (**70**), Nelson's Column (**66**) and surrounding lions (**71**), as well as two fountains (**65**) and until recently a flock of pigeons (**68**), the square also has some perhaps less well-known features.

There are four plinths, intended for statues, but only three of these are occupied. The fourth had stood empty since the opening of the square, until finally in 1999 it became an exhibition space for contemporary art, hosting eye-catching works including a giant ship in a bottle (Yinka Shonibare), a similarly oversized blue cockerel (Katharina Fritsch) and, most famously, the work *One & Other* by Antony Gormley, where 2,400 members of the public were given one hour each on the plinth to do whatever they liked.

Also to be found in Trafalgar Square is what was once Britain's smallest police station. Operating from 1926 and disguised as a lamp post, the tiny station was intended for monitoring the demonstrations that often occur in the square. By the time of the Poll Tax riots in 1990 (**69**), however, the station was being used as a broom cupboard for street cleaners.

A short walk from Trafalgar Square is Leicester Square (**73**), now the location for London's major cinemas, and an area known for its entertainments before the art of filmmaking was even born. Claude Monet captures an impression of the magnificent display that would have been seen back in 1901 (**72**).

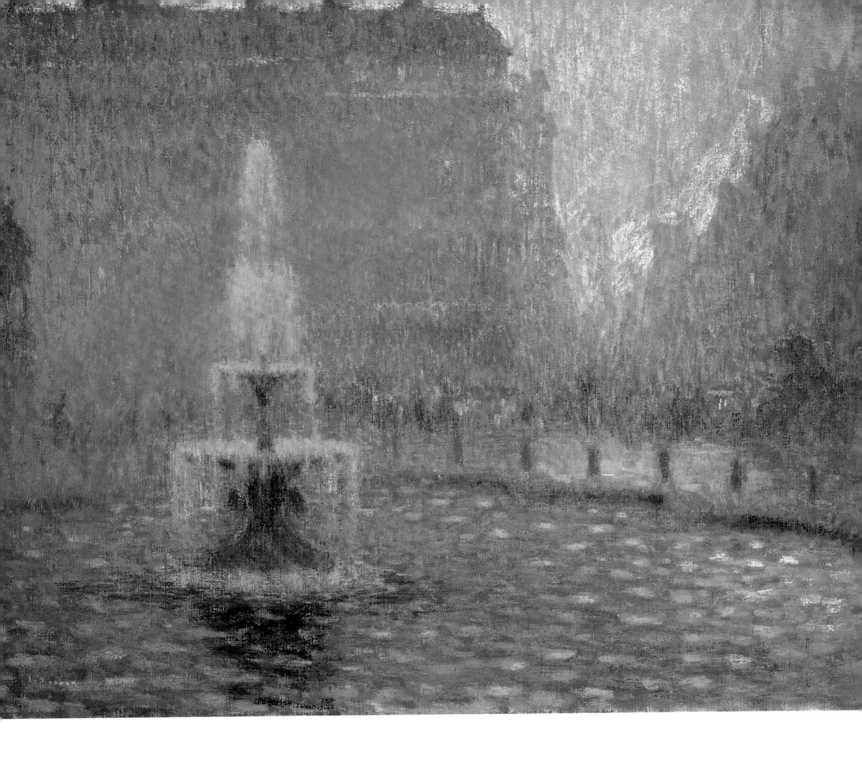

65 Henri Le Sidaner,
Trafalgar Square, c.1908.
Fitzwilliam Museum, Cambridge

Nelson's Column

At the heart of Trafalgar Square is Nelson's Column (**66**). Commemorating Admiral Horatio Nelson's victory at the Battle of Trafalgar in 1805, funds for the monument were raised by public subscription, with the winning design by William Railton chosen by a committee headed by the Duke of Wellington. The column, erected in 1843, stands at 170 feet (52 metres), including the statue of Nelson by E.H. Baily atop it (30 feet shorter than originally planned owing to budgetary constraints). Curiously missing the admiral's famous eyepatch, but wearing a bronze bandage in order to stop his arm dropping off following a lightning strike in 1896, the statue is an iconic figure known the world over.

Nelson was joined by four bronze lions designed by Sir Edwin Landseer at the base of the column in 1867 (their paws somewhat less than fearsome as they were modelled on those of a domestic cat after Landseer's deceased lion model began to decay; **71**). Every day, tourists and Londoners alike enjoy sitting on the lions, and getting caught in the spray of the nearby fountains.

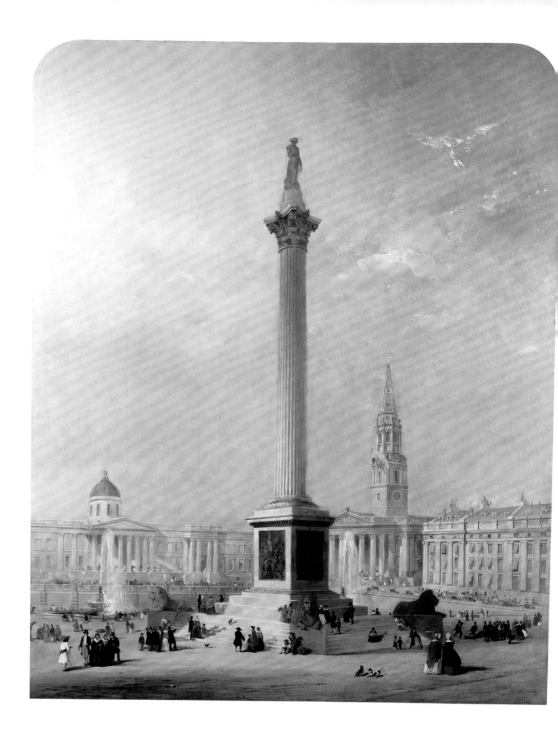

66 George Henry Andrews, *Projected View of Trafalgar Square*, 1844. Private collection

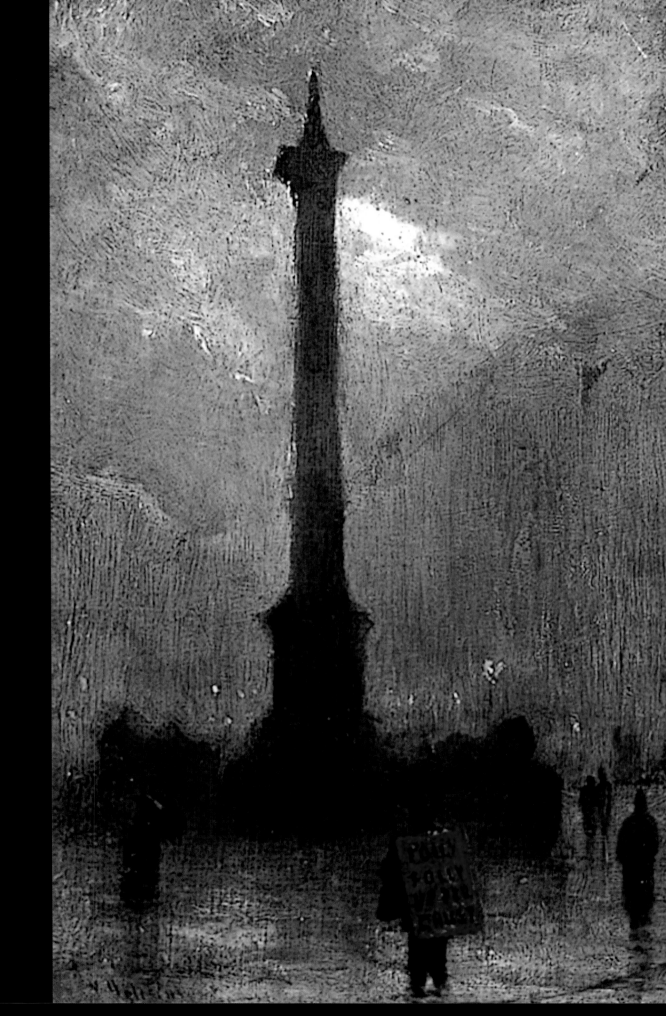

67 Vincent Philip Yglesias,
*Nelson's Column, Trafalgar
Square*, late 19th century.
Museum of London

'London is a roost for every bird.'

BENJAMIN DISRAELI,
UK PRIME MINISTER (1804-91)

Pigeons of Trafalgar Square

Until recently, Trafalgar Square was home to a famous flock of feral pigeons (**68**). Feeding the pigeons had been a popular pastime since the Victorian era, and feed could be bought from sellers in the square. When the jets of the Trafalgar Square fountains were turned on every morning at ten o'clock, they would startle the pigeons into flight. In 2003, however, owing to health concerns, as well as the disfigurement to Nelson's Column and the surrounding monuments from droppings, this was stopped, and the use of birds of prey to keep their numbers down was introduced. The pigeons that once made Trafalgar Square their home are now little more than a memory.

68 Ceri Richards,
Trafalgar Square, London,
1950. Tate

The Poll Tax Riots

In 1990, a new way of funding local councils introduced by the Conservative Party under Margaret Thatcher, the Community Charge or 'Poll Tax', was perceived by many to unfairly penalize the poor and was met with a series of demonstrations, some of which became violent with clashes between demonstrators and police.

The most notable confrontation occurred on 31 March, when at a rally in Trafalgar Square, with attendance far greater than expected and spilling far down into Whitehall, protesters took the charging of police on horseback, followed by the driving of riot squad vans into the crowd, as acts of provocation. In the ensuing violence (**69**), bricks and scaffolding from a construction site were thrown and builders' cabins were set on fire, while demonstrators were pushed into the shopping district of the West End, where windows were smashed and cars overturned.

The strength of feeling against the Community Charge would ultimately be a significant factor in the events leading to Margaret Thatcher's resignation in November that year. The charge itself was abolished in 1992.

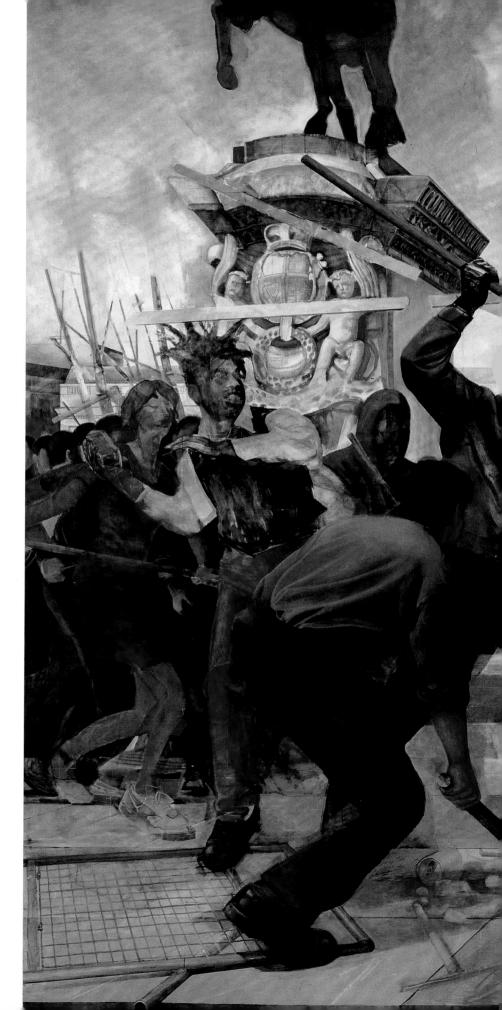

69 John Bartlett,
History Painting, 1993–94.
Museum of London

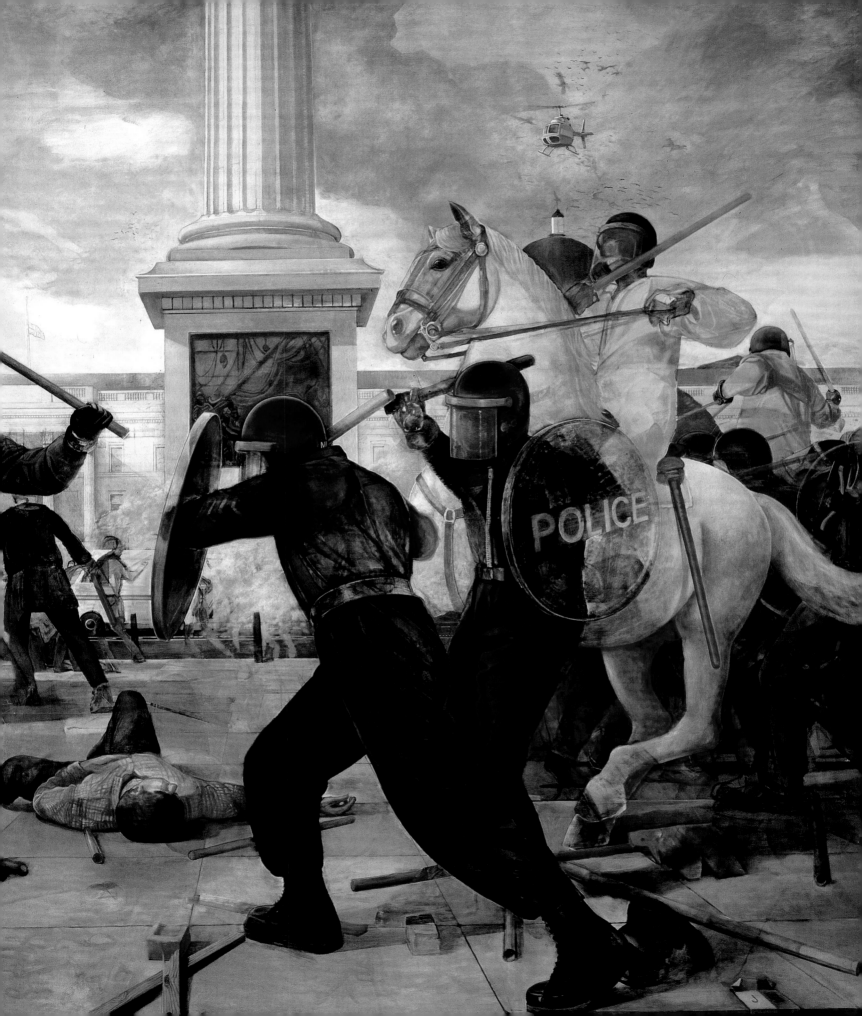

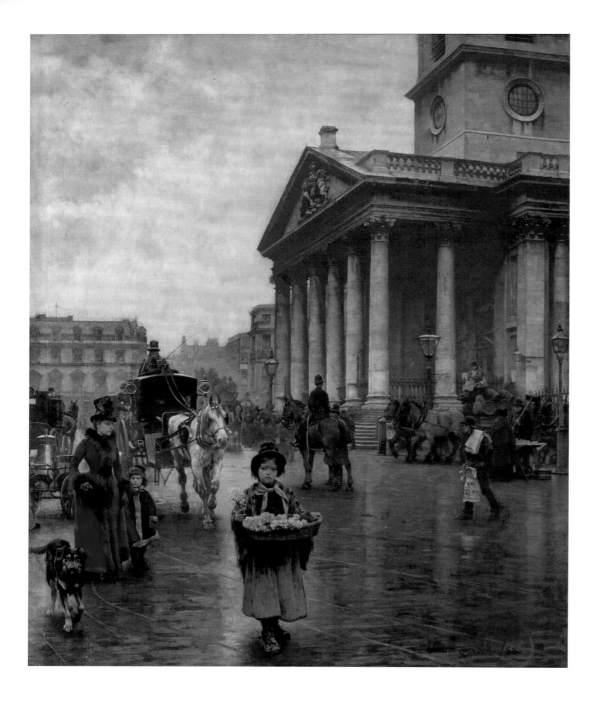

St Martin-in-the-Fields

At the north-eastern corner of Trafalgar Square is St Martin-in-the-Fields (**70**), an Anglican church dating from 1722–26 and designed by James Gibbs in a Neoclassical style inspired by the work of Sir Christopher Wren.

The church gets its unusual name from the fact that an earlier place of worship on that site was literally 'in the fields' – on land between Westminster and the City of London that had yet to be developed.

Furniture maker Thomas Chippendale (1718–79) is buried in the church, while notorious criminal Jack Sheppard (1702–24) was buried in the churchyard, although this was ultimately cleared to make way for Trafalgar Square.

Today, St Martin-in-the-Fields is known for hosting jazz concerts in the crypt, and for its work with the homeless, a practice that dates back to the care of homeless soldiers returning from the battlefields of the First World War.

ABOVE:
70 William Logsdail,
St Martin-in-the-Fields,
1888. Tate

OPPOSITE:
71 Felix Kelly,
St Martin-in-the-Fields from Trafalgar Square, 1951.
Private collection

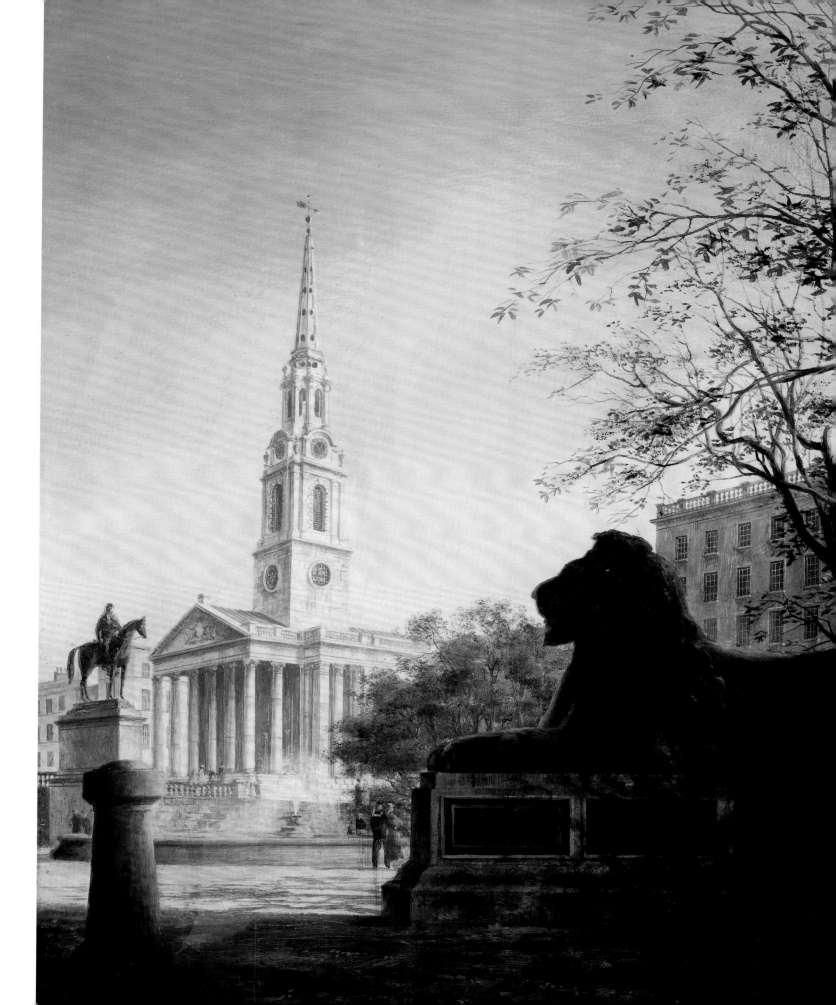

Leicester Square

Situated in the heart of the West End and dating back to the seventeenth century, Leicester Square (**73**) has become a centre for film, with premieres frequently held in one of the several major cinemas located there, along with the annual London Film Festival.

Initially residential, and home to such figures as William Hogarth and Sir Joshua Reynolds, the square's reputation as an entertainment hotspot grew throughout the nineteenth century, with the Alhambra Theatre and Empire Theatre of Varieties both located there (they have since been replaced by cinemas).

A small park has been at the centre of the square since it was built. A statue of William Shakespeare by Giovanni Fontana, surrounded by a fountain, was erected in 1874, and one of Charlie Chaplin, himself a Londoner, in 1981 (relocated to nearby Leicester Place in 2013). The square was pedestrianized in the 1980s.

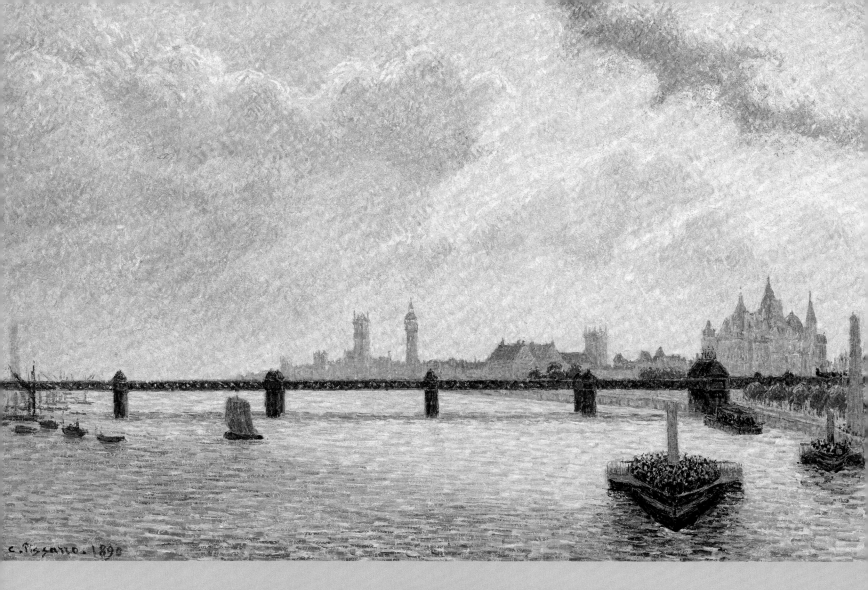

74 Camille Pissarro, *Charing Cross Bridge*, 1890. National Gallery of Art, Washington

Covent Garden

CHARING CROSS BRIDGE AND WATERLOO BRIDGE, CLEOPATRA'S NEEDLE,
THE SOUTH BANK, COVENT GARDEN MARKET

We travel further down the Thames, under the Charing Cross (**74**) and Waterloo Bridges, just in time to catch a real Waterloo sunset, as witnessed by Claude Monet (**77**). Between the bridges on the north side is Cleopatra's Needle (**78**), a sliver of ancient Egypt relocated to the north bank of the Thames, while on the opposite side is the South Bank Centre, an arts complex emerging from the site of the 1951 Festival of Britain (**80**).

Back on dry land we venture into Covent Garden (**81**), a centuries-old marketplace in an area that also houses the Royal Opera House and the legendary Theatre Royal, Drury Lane, which has stood in various incarnations on the site since 1663. As well as high culture, debauchery, criminality and poverty have also had their place in Covent Garden over the years, as shown to us here by William Hogarth (**88**) and Gustave Doré (**93**).

Nevertheless, life in the market is busy, both for the vegetable-seller of the 1720s (**86**) and the floral hall workers of the 1960s (**87**). The market may have now moved on, but its memory remains in Covent Garden through the buildings it left behind.

OPPOSITE:
75 André Derain,
Charing Cross Bridge, London,
1906. National Gallery of Art,
Washington

Charing Cross Bridge and Waterloo Bridge

Further along from Westminster Bridge, seven more bridges cross the Thames before the famous London Bridge.

The first of these, Hungerford Bridge or Charing Cross Bridge (**74**), was originally a suspension footbridge designed by Isambard Kingdom Brunel which opened in 1845. This was replaced by a railway bridge in 1864. In 2002 the two Golden Jubilee Footbridges were added either side, replacing dilapidated footpaths.

Next along the route downriver is Waterloo Bridge. Carrying both pedestrians and traffic, it is considered to provide the best view of London at ground level, with Westminster visible to the west and the City of London to the east.

The first Waterloo Bridge opened in 1817, and it was this that served as the motif for Monet's Waterloo Bridge series at the dawn of the twentieth century (**77**). Less happily, it had by this time gained a reputation as a suicide spot. A second Waterloo Bridge opened in 1945 (**80**), known at the time as 'the Ladies' Bridge' due to much of the construction team being female, with women taking over traditionally male jobs during World War II.

76 Timothy Hyman,
*Utopian Thoughts While Crossing
Waterloo Bridge*, 2005–8.
Collection of David and Anita
Atterbury Thomas

'Even though I knew the Thames is a small river compared with the great ones of the world, I would patriotically make it wider and wider in my mind.'

V.S. PRITCHETT, *A CAB AT THE DOOR* (1968)

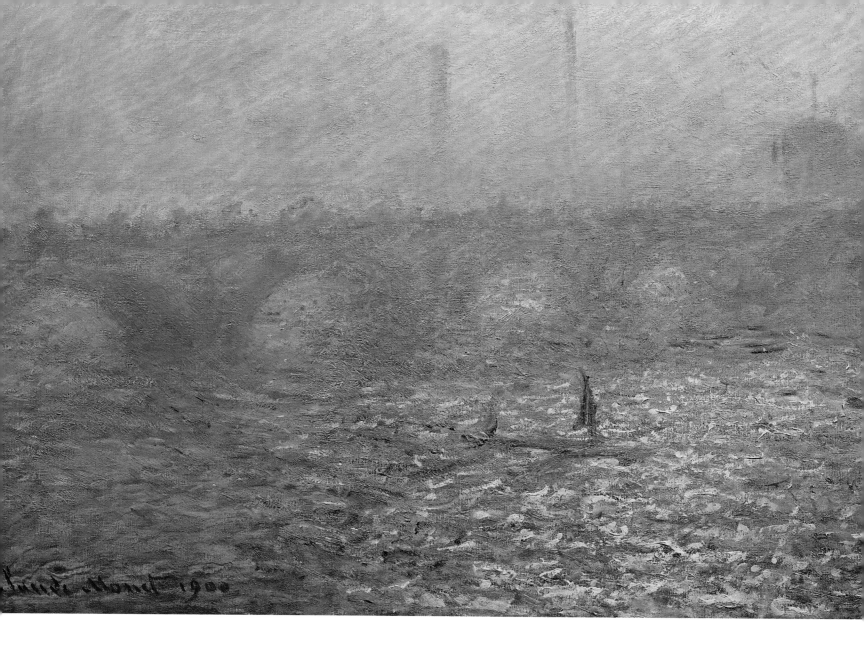

Monet in London

Impressionist painter Claude Monet (1840–1926) first stayed in London in 1870–71, escaping the Franco-Prussian War. During this time, he produced a number of paintings, with subjects such as Green Park, Hyde Park and the Pool of London.

Returning to the city for several trips in the years 1899 to 1901, Monet this time concentrated on several series of works in the manner of his celebrated haystacks paintings and those of Rouen Cathedral, depicting his motif in a range of weather, light and atmospheric conditions. The subjects he chose for these series were the Houses of Parliament (**37**), Waterloo Bridge (**77**) and Charing Cross Bridge. Perhaps especially, however, Monet depicted the London fog, fascinated by the way it 'dematerialized' the motif, thus making it appear insubstantial. By this point Monet was not completing his paintings *en plein air*, instead finishing them in his studio in France and even referring to photographs sent over to him from London. The resulting works are considered significant additions to the canon of a major artist.

Cleopatra's Needle

On the Victoria Embankment, north bank of the Thames, stands Cleopatra's Needle (**78**). A granite ancient Egyptian obelisk dating from 1450 BC, long before the time of Cleopatra, and covered in hieroglyphics describing the military victories of Ramesses II, the Needle was a gift from Muhammad Ali, ruler of Egypt, in 1819. No funds were made available to transport it, however, and so it remained in Alexandria until 1877, when Sir William James Erasmus Wilson arranged for it to be transported to London in a specially designed cylindrical craft, called the *Cleopatra*. Both the craft and the Needle were almost lost in a storm in the Bay of Biscay and went missing for several days, but were eventually recovered and made it to London on 21 January 1878. When installed at its current location, a time capsule was buried beneath the Needle, among its contents photographs of the 12 most attractive Englishwomen of the time.

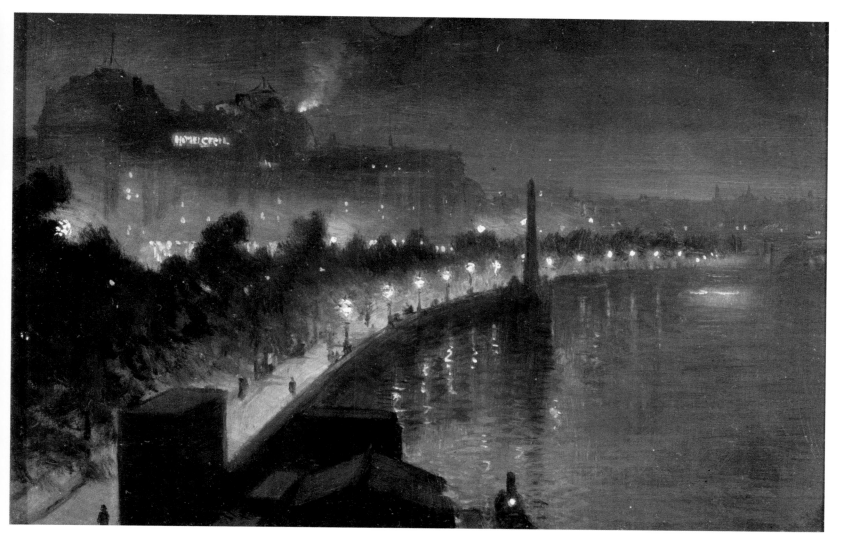

The South Bank

The shallow bank and mud flats on the south side of the River Thames had been employed as docks and for a variety of industrial uses before the building of County Hall in Lambeth in 1922 marked its adoption for public use.

William Townsend's *South Bank* (**79**) shows the old industrial land awaiting redevelopment following extensive bomb damage in World War II. *Somerset House, Waterloo Bridge, South Bank* (**80**) by John Cosmo Clark, meanwhile, gives us a glimpse of what was done with the land. The main

site of the Festival of Britain in 1951, where it played host to such attractions as the Dome of Discovery and a futuristic steel tower supported with cables called the Skylon, the South Bank was then developed into a cultural centre, including the Royal Festival Hall, the Queen Elizabeth Hall and the Hayward Gallery. Clark's painting shows the walkway in front of the Royal Festival Hall, along with Rodney Pier, specially built for the festival, providing access by boat, and elevated decks giving riverside views – all long since removed.

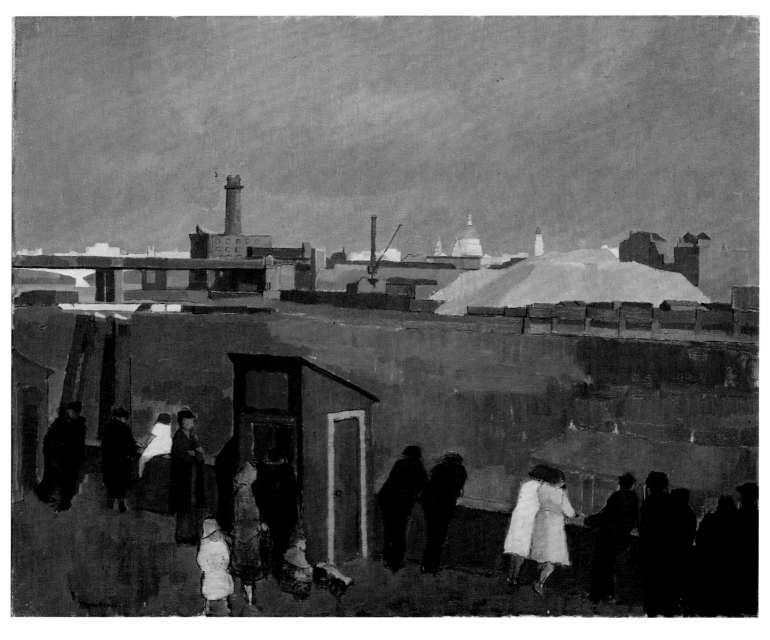

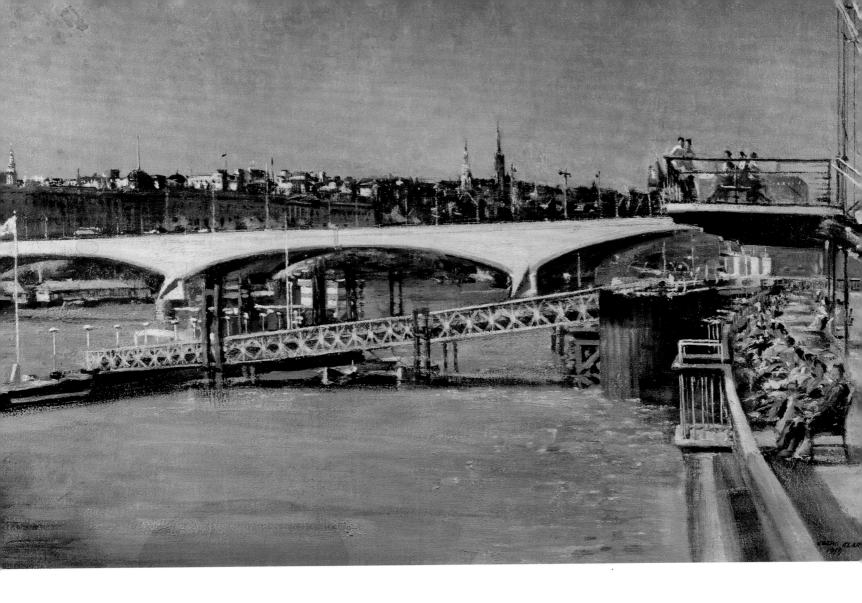

OPPOSITE:
79 William Townsend,
South Bank, 1948. Tate

ABOVE:
80 John Cosmo Clark,
*Somerset House, Waterloo Bridge,
South Bank*, c.1961. Royal West
of England Academy, Bristol

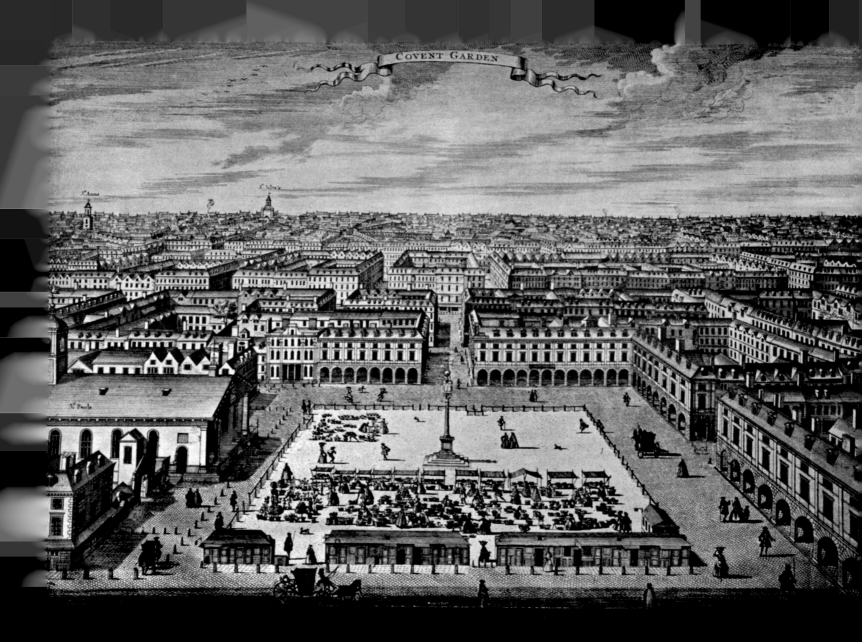

COVENT GARDEN

Covent Garden Market

Covent Garden was once land belonging to Westminster Abbey and 'the garden of the Abbey and the Convent'. It developed into a square designed by Inigo Jones in 1630 (**81**), with a market established on its south side by the mid-seventeenth century (**82**). The wealthy tenants of the square moved out as the market grew, replaced by more disreputable residents, and it was a renowned red-light district by the eighteenth century.

The erecting of a market hall helped to restore Covent Garden's good name, with further halls – the Floral Hall (**87**), the Charter Market and the Jubilee Market (for imported flowers) – added over the years.

By the 1960s, however, congestion was making the market untenable, and it relocated to New Covent Garden Market in 1974. The old market hall is now a shopping centre, while the Floral Hall spent some time as a scenery store for the adjoining Royal Opera House before becoming an events room. The square is now famed for its outdoor performances of classical music, as well as magic and circus acts.

ABOVE:
81 Sutton Nicholls,
Covent Garden, 1730–32

OPPOSITE:
82 Joseph Van Aken,
*Covent Garden Piazza
and Market*, 1725–30

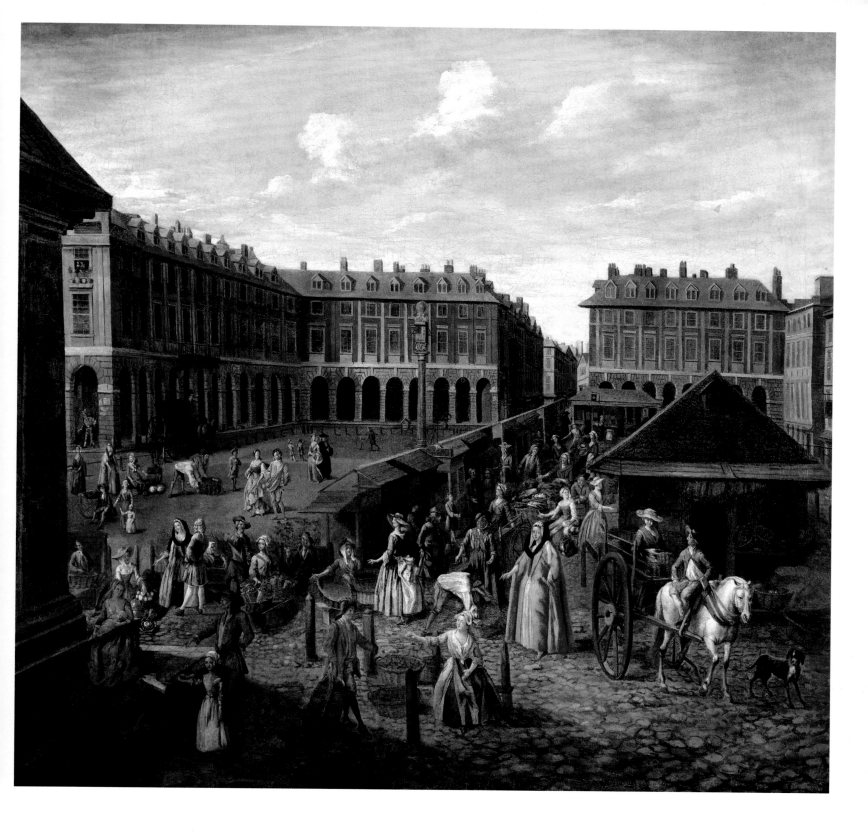

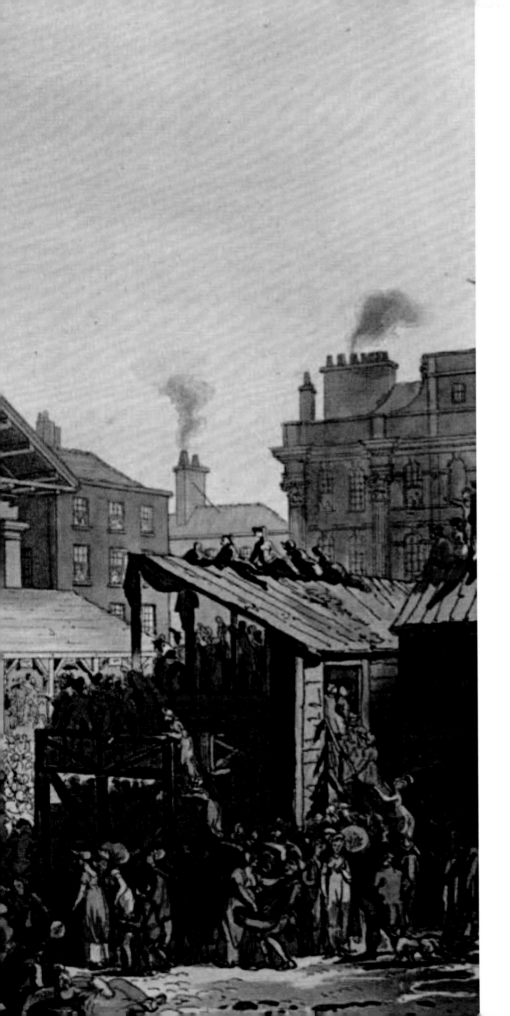

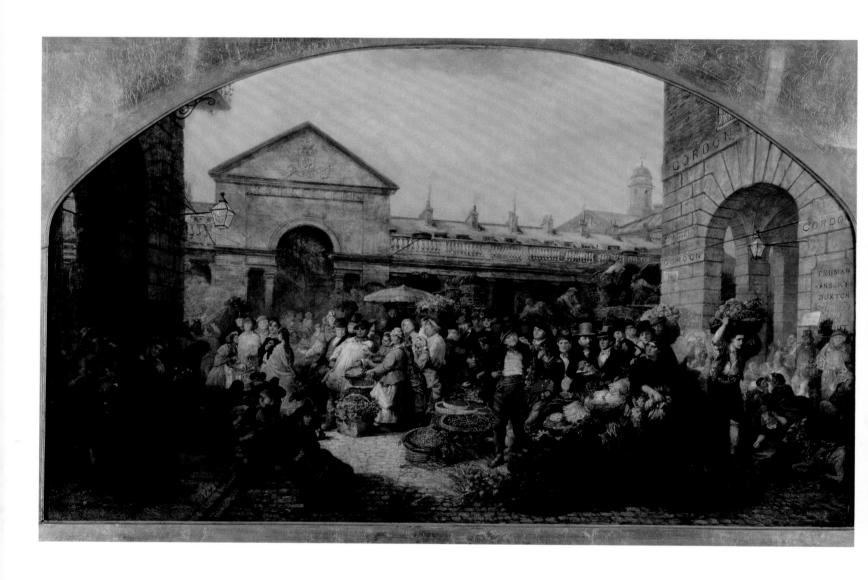

ABOVE:
84 Phoebus Levin,
Covent Garden Market, London,
1864. Museum of London

OPPOSITE:
85 Donald Chisholm Towner,
Covent Garden, 1934.
Tullie House Museum
and Art Gallery

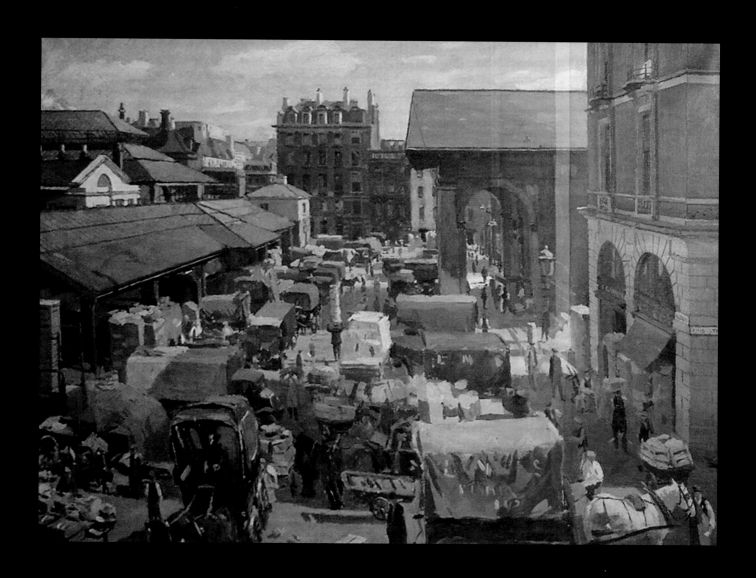

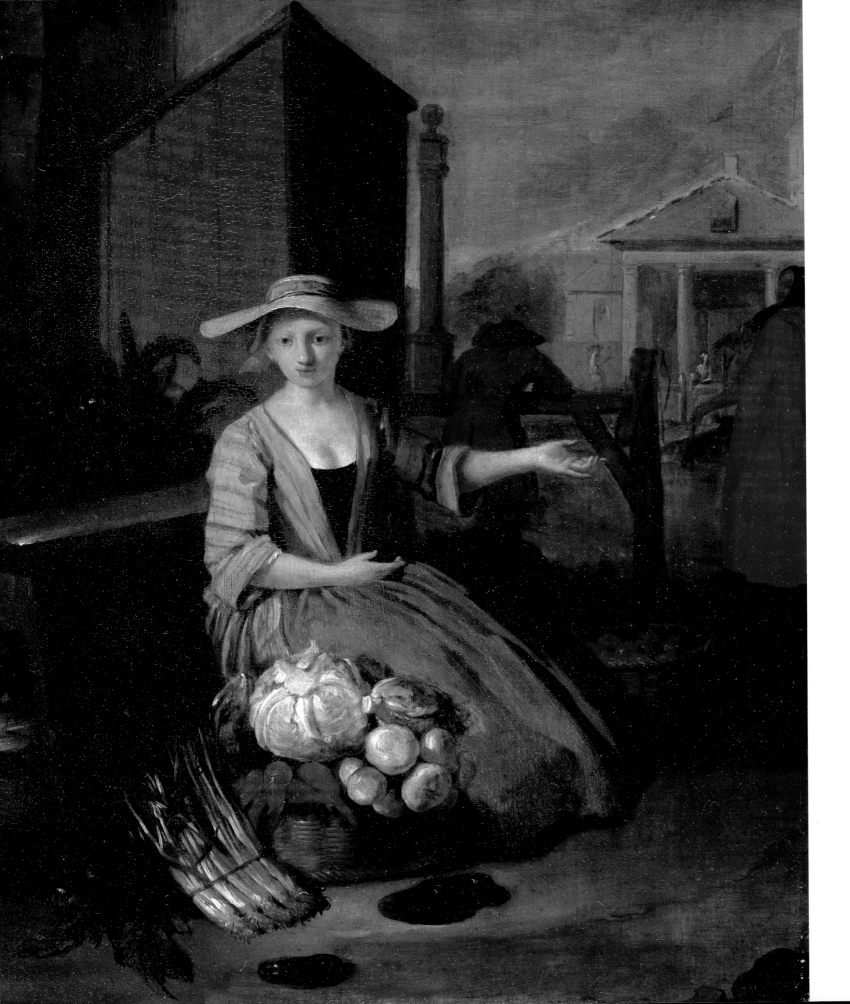

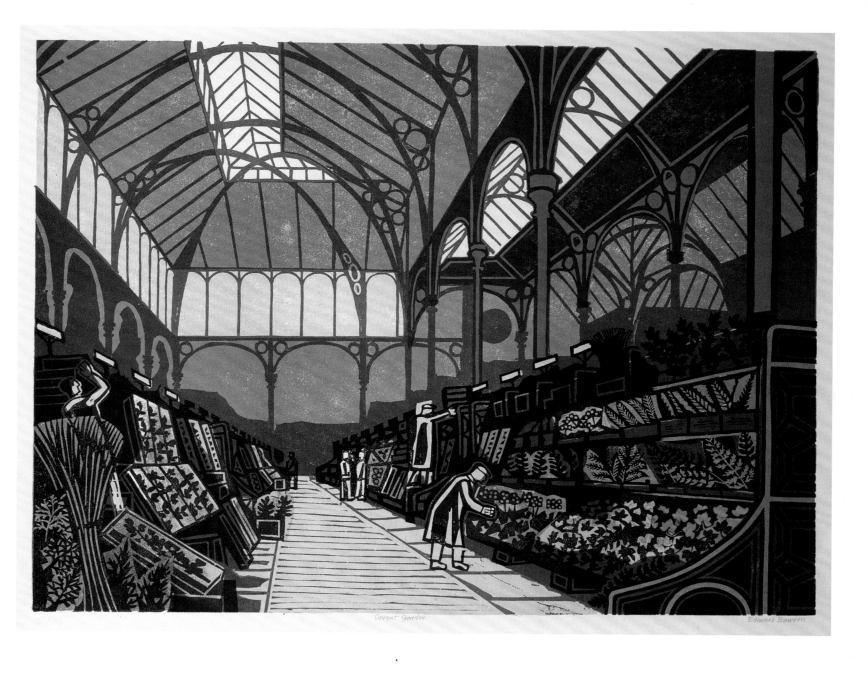

Covent Garden Edward Bawden

OPPOSITE:
86 Pieter Angellis,
Vegetable Seller, Covent Garden,
c.1726. Yale Center for British Art,
Paul Mellon Collection

ABOVE:
87 Edward Bawden,
The Floral Hall, Covent Garden,
1947. Fry Art Gallery,
Saffron Walden

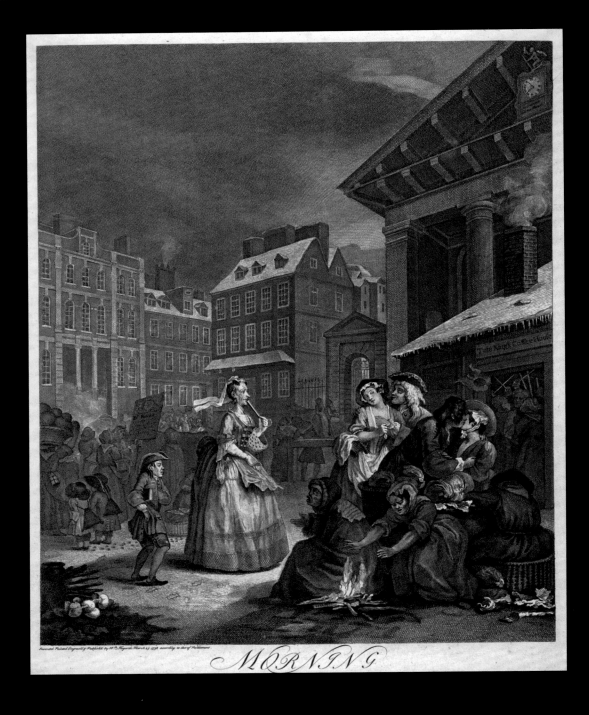

MORNING

Hogarth's 'Four Times of Day'

William Hogarth (1697–1764) was renowned for his darkly satirical paintings, often produced in series and reproduced in prints. They highlighted the moral failings of his day, with the protagonists of his work often succumbing to debauchery and disease.

'Four Times of Day' (1736) depicts different moments throughout the day in Covent Garden and beyond, drawing on pastoral mythological scenes by artists such as Nicolas Poussin, but replacing gods with character types found in London. The overall theme is perhaps that of hypocrisy, with the wealthy and ostensibly virtuous ignoring the poverty around them while indulging their own vices.

Morning (**88**) shows a lady in Covent Garden on her way to church, specifically St Paul's Church in the square itself. Revellers sprawl out of a coffee house, their night not yet over. A fight breaks out inside and someone's wig flies out the door. The virtuous woman, however, ignores the poverty around her.

Noon (**89**) takes place in St Giles, a slum area that has since been built over by the West End. While on one side of the picture Huguenots, French protestant refugees from Catholic France, leave their church in their Sunday best, on the other a couple engages in lascivious behaviour and an urchin eats a fallen pie off the ground. A cat that has been stoned to death separates the two groups.

In *Evening* (**90**), a family is on a trip out to Sadler's Wells, Islington, which at that time had not been absorbed by the metropolis and was still semi-rural. The bull's horns positioned behind the husband's head suggest that he is a cuckold, and that the children are not his.

Night (**91**) takes us to Charing Cross Road, where on the public holiday of Oak Apple Day, a festive bonfire has made a coach overturn. A barber shaves a customer drunkenly, while a similarly inebriated freemason finds a chamber pot emptied on his head from a window. A homeless family crouch under a window, among the taverns and brothels.

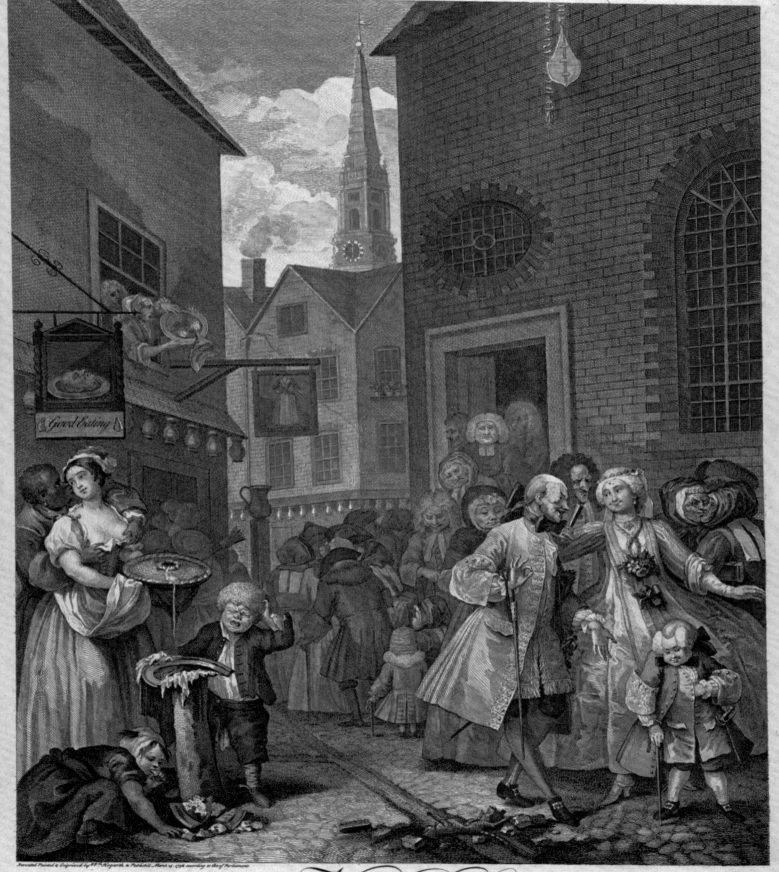

Invented Painted & Engraved by Wm. Hogarth & Publish'd March 25. 1738 according to Act of Parliament

Noon

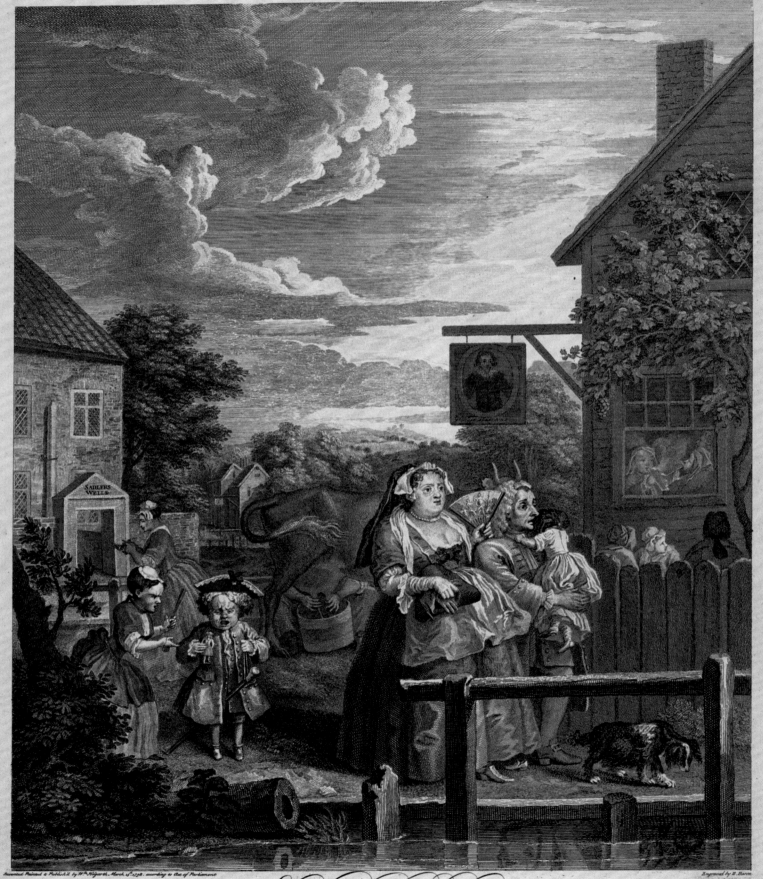

EVENING

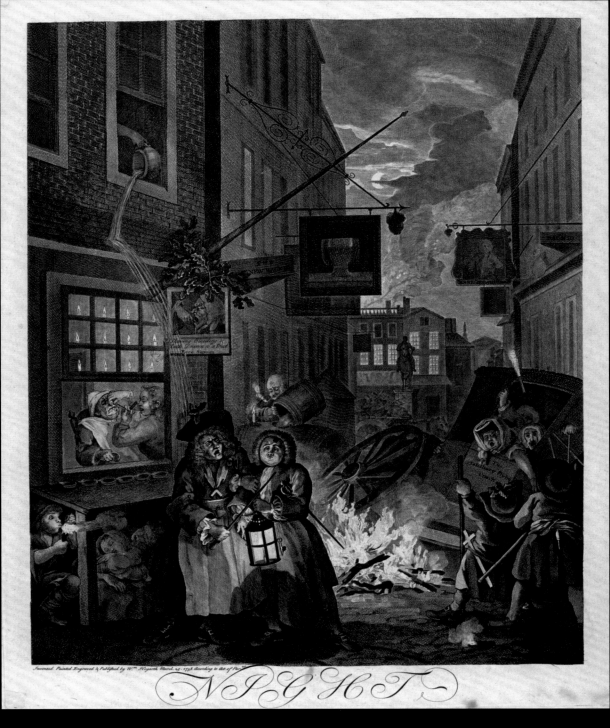

NIGHT

Criminal Covent Garden

In the years following the rise of the market in the mid-seventeenth century, Covent Garden was an area notorious for criminality, featuring in William Hogarth's series of paintings *A Rake's Progress* (1733) as the location in which the protagonist sinks into debauchery. In 1722, it was recorded that there were 22 gambling dens and 56 brothels. A guide to Covent Garden prostitutes was even published, called *Harris's Guide to Covent Garden Ladies*.

Covent Garden's shadier inhabitants finally met their match in 1749, when author and magistrate Henry Fielding set up the Bow Street Runners, considered Britain's first police force, on the edge of Covent Garden in Bow Street. The square became a more conventional working-class area until 1830, when the building of the market hall established a firm aura of respectability. Nevertheless, as we can see in Thomas Shepherd's watercolour of the renowned Dr Bossey (**92**), who sold 'quack' medicines of no worth from a stage complete with show in Covent Garden in the mid-nineteenth century, dubious activities still continued.

92 Thomas Hosmer Shepherd, *The Quack Doctor*, 1857. Private collection

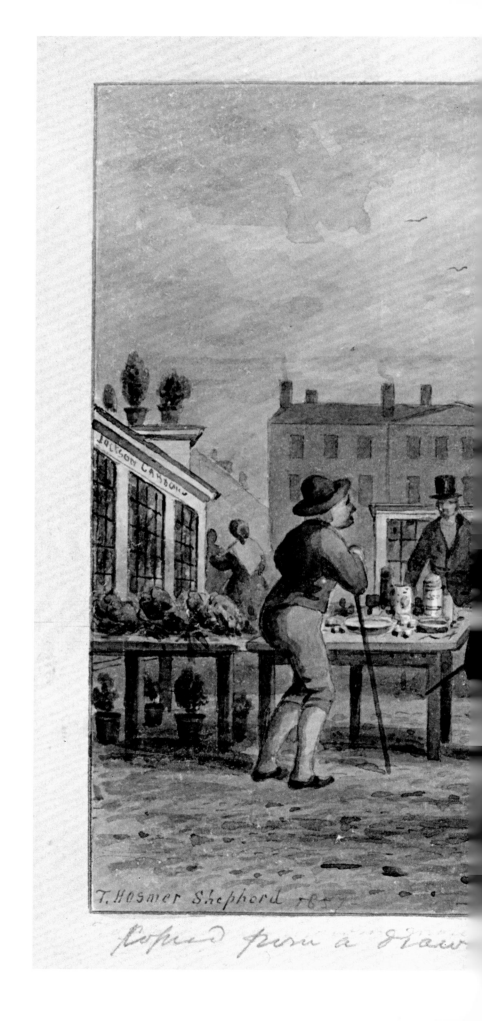

the time

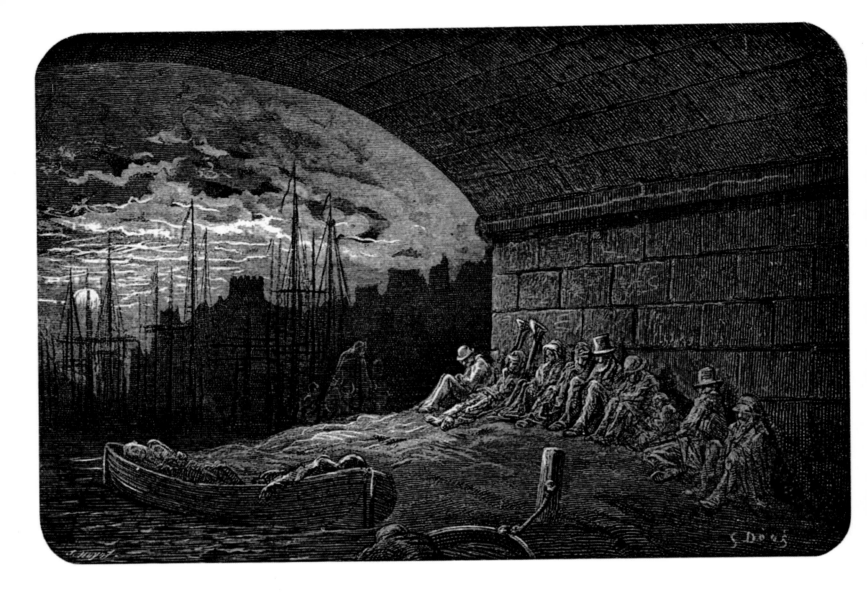

Doré's *London: A Pilgrimage*

French painter and engraver Gustave Doré (1832–83) was already established as a book illustrator, having produced landmark illustrations for Cervantes's *Don Quixote* and the English Bible, when he was commissioned in 1869 to work on a portrait of London, entitled *London: A Pilgrimage*, with text by Blanchard Jerrold.

Containing 180 engravings, the book was a commercial success on publication in 1872, although critics balked at the extent to which the images concentrated on the poverty found in the city, with *The Art Journal* accusing Doré of 'inventing, rather than copying'. As part of their research, however, Doré and Jerrold visited lodging houses, refuges and opium dens, often under the protection of plainclothes policemen.

The works here show the squalor of Orange Court, off Drury Lane and near Covent Garden (**94**), and the destitution that forced the homeless to seek shelter under the arches of London's bridges, here possibly Waterloo Bridge (**93**). Figures lie in moored boats, sleeping perhaps, but with the appearance of corpses.

ABOVE:
93 Gustave Doré,
Under the Arches, 1872

OPPOSITE:
94 Gustave Doré,
Orange Court, Drury Lane, 1872

'London is as complete a
solitude as the plains of Syria.'

CHARLES DICKENS,
NICHOLAS NICKLEBY (1838-39)

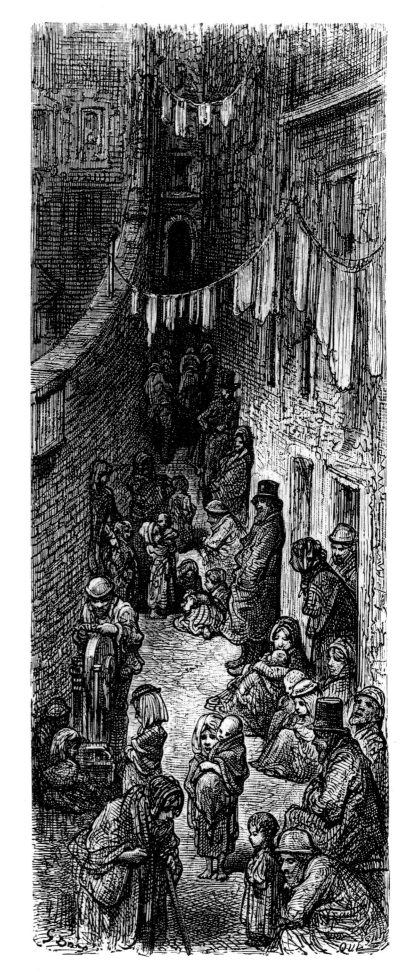

95 John O'Connor, *From Pentonville Road, Looking West, Evening*, 1884. Museum of London

Camden & Islington

KING'S CROSS, CAMDEN TOWN, REGENT'S PARK, LONDON ZOO,
PRIMROSE HILL, REGENT'S CANAL, HAMPSTEAD

North of central London, the sun sets on St Pancras railway station (**95**), a towering Victorian landmark in the borough of Camden. Once earmarked for demolition when such architecture was unfashionable, it was saved by a campaign spearheaded by the poet John Betjeman, whose statue now stands inside.

Camden itself is a curious but very cultural mix, containing both the bohemianism of Camden Town (**98**), where subcultures rub up against each other in the famous Camden Market, and King's Cross (**96**), shared with the neighbouring borough of Islington and once a thriving industrial area only recently emerging from a post-war slump that resulted in its becoming known as a red-light district.

Camden is not just where people live, however. It is also where they relax, notably in Regent's Park, where one can sail a model boat on the lake or just feed the ducks (**100**). Sit on Primrose Hill and admire the view (**102**), or visit the zoo, where you definitely won't be eaten by an angry lion (**101**).

And so to leafy Hampstead, where John Constable captured the view (**104**), and Ford Madox Brown painted a microcosm of society (**107**). Even here, the flags are out on Coronation Day (**111**). Hampstead might be its own little village, but it is still very much part of London.

OPPOSITE:
96 Charles Ginner,
The Fruit Stall, 1914.
Yale Center for British Art,
Paul Mellon Fund,
5020 - B1980.18

Kossoff and Auerbach's London

Painters Leon Kossoff (b. 1926) and Frank Auerbach (b. 1931) both studied under the great modernist artist David Bomberg, and are renowned for their use of applying paint very thickly (a technique known as 'impasto'). Kossoff is a lifelong resident of London, while Auerbach moved to the city as a Jewish refugee from Nazi Germany during World War II.

The two artists make frequent use of London locations in their art. Kossoff has painted such places as his former home in Mornington Crescent in Camden, King's Cross (**97**), the flower stalls at Embankment underground station and Christ Church, Spitalfields in the East End (**150**). Auerbach, meanwhile, a resident of Camden, has painted the area often (**98**), notably Mornington Crescent (**99**) and Primrose Hill.

Kossoff and Auerbach are considered among the finest British artists of their generation, each making their own significant contribution to the art of their time.

97 Leon Kossoff, *King's Cross, March Afternoon*, 1998

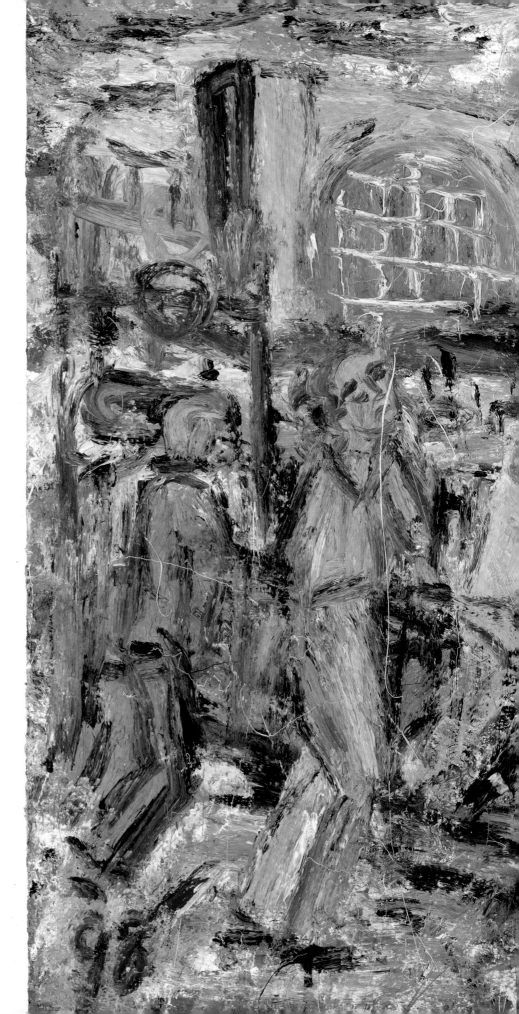

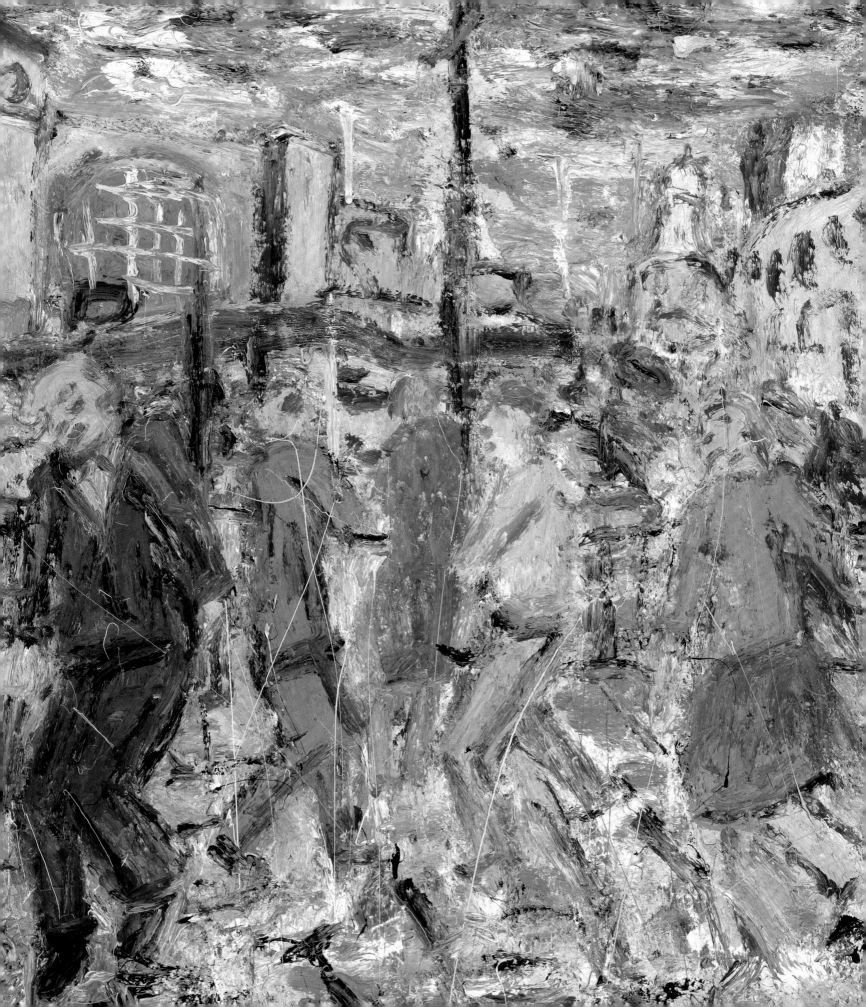

'Life itself, every moment of it, every drop of it, here, this instant, now, in the sun, in Regent's Park, was enough. Too much indeed.'

VIRGINIA WOOLF, *MRS DALLOWAY* (1925)

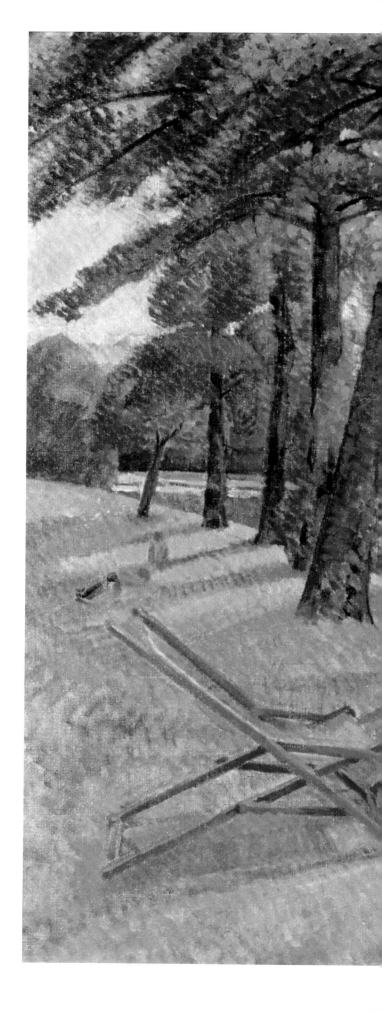

Regent's Park

Another of the Royal Parks, Regent's Park was land originally acquired by Henry VIII, known as Marylebone Park and used for hunting before being opened up to the public in 1835.

Within the park there can be found a lake (**100**), popular both for boating and waterfowl (although on a darker note around 200 skaters fell in and 41 drowned when the ice broke on the lake in 1867), and an open-air theatre, located near its centre within Queen Mary's Gardens. Towards the edge of the park are London Zoo (**101**) and London Central Mosque, with Regent's Canal running along the north end. Terraces in the Regency style designed by John Nash line the south, east and most of the west side, with a number of villas scattered throughout the park.

The park's bandstand was the target of an IRA bomb in 1982, killing seven soldiers.

100 Beryl Sinclair,
Regent's Park, 1934.
UK Government Art Collection

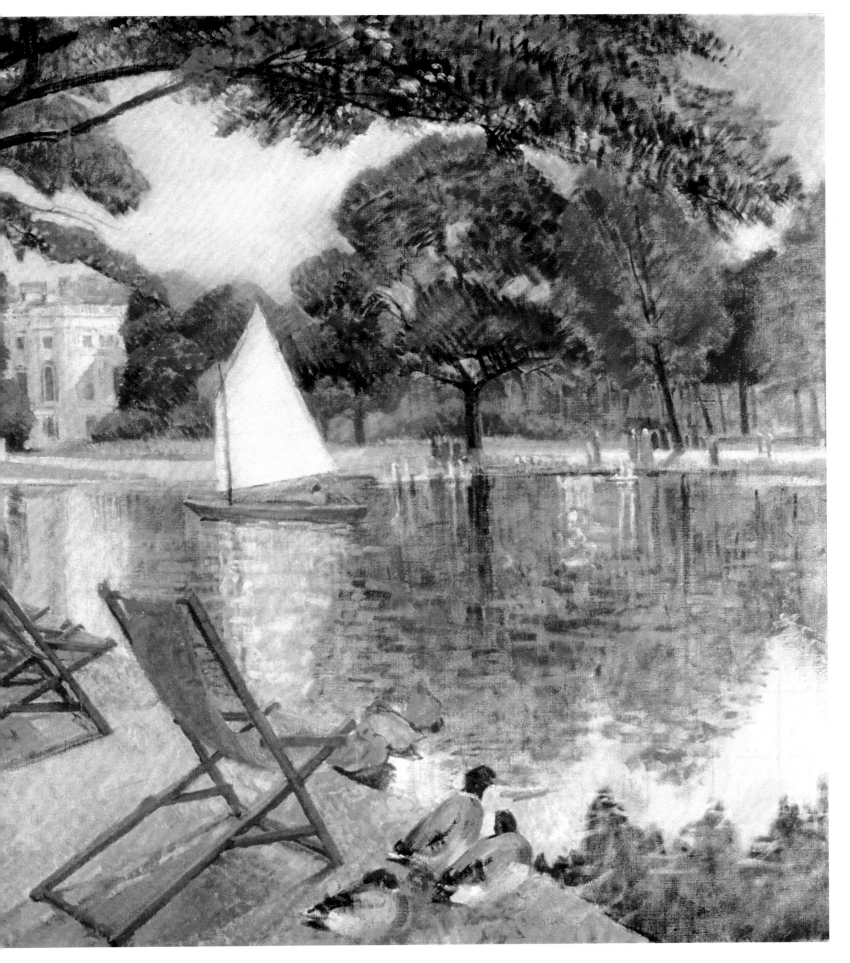

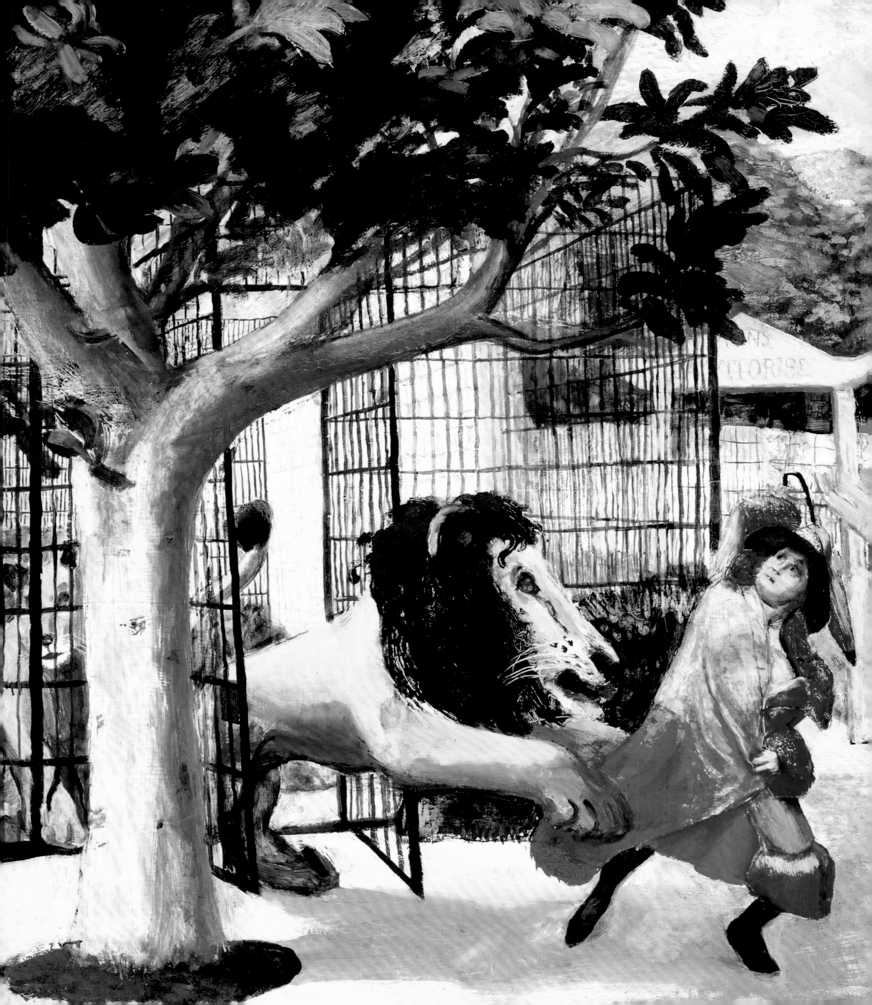

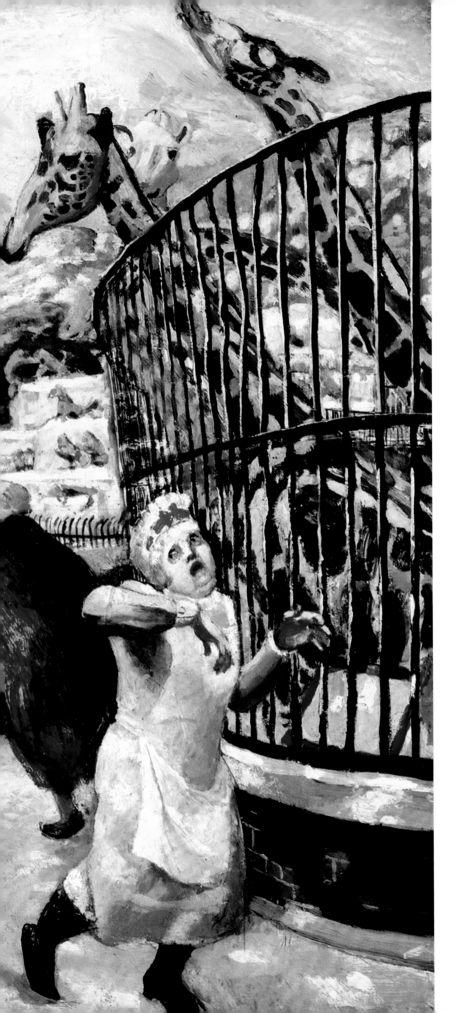

London Zoo

London Zoo is situated in Regent's Park and, having opened in 1828, is the oldest scientific zoo in the world. At first tropical animals were kept indoors, as it was thought they would not be able to survive in the British climate, before many were finally moved outside in 1902.

The zoo is particularly well known for its reptile house, and the modernist penguin pool and Round House, home to the gorillas. Both of the latter are considered excellent works of architecture and have Grade I listed status.

Over the years, many animals have been kept at the zoo, including examples of two species that are now extinct – the quagga, a subspecies of zebra, and the marsupial thylacine, or Tasmanian tiger. Other former residents of note include Jumbo the elephant, who arrived in 1865 and whose name was adopted as a word for anything of very large size, and Winnipeg the bear, or Winnie, a favourite of one Christopher Robin who named his own toy bear after him, about which his father A.A. Milne would write a rather famous book.

Carel Weight imagines an unlikely scene at the zoo (**101**), with a lion escaping from its cage and being fended off by a woman, based on a photograph of the artist's mother, brandishing an umbrella.

101 Carel Weight,
Allegro Strepitoso, 1932. Tate

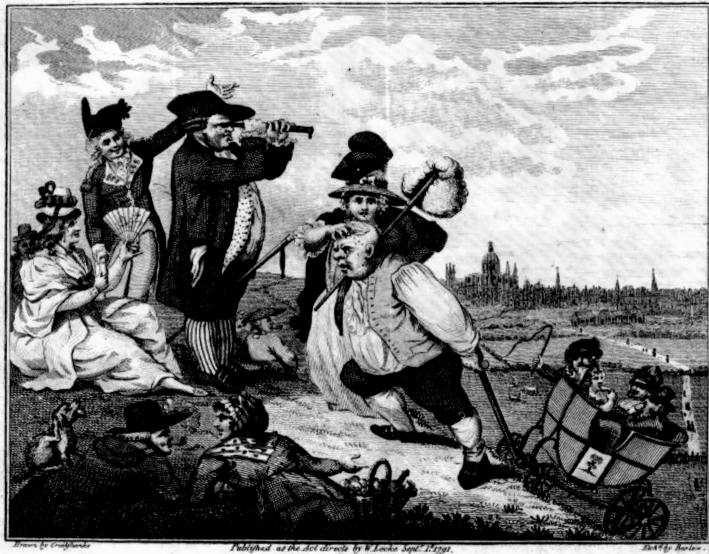

Drawn by Cruikshank Published as the Act directs by W. Locke Sept.r 1.1791. Etch'd by Barlow.

PASTIMES OF PRIMROSE HILL.

Primrose Hill

Primrose Hill, on the northern side of Regent's Park, offers one of the best views in the city, with central London to the south and Hampstead and Belsize Park to the north. The surrounding area is affluent, and the hill itself has long been a popular leisure spot.

The eighteenth-century caricaturist Isaac Cruikshank (1764–1811) presents a satirical take in his illustration *Pastimes of Primrose Hill* (**102**). Here a man struggles with pulling a pram loaded with children (one complete with whip) up the hill so much he breaks into a sweat and places his wig on a stick. Meanwhile, another man looks out at the view through a telescope, oblivious to the lady behind him, perhaps his wife, taking the card of an admirer.

ABOVE:
102 Isaac Cruikshank, *Pastimes of Primrose Hill*, 1791

OPPOSITE:
103 Algernon Newton, *The House by the Canal*, 1945. Harris Museum and Art Gallery, Preston

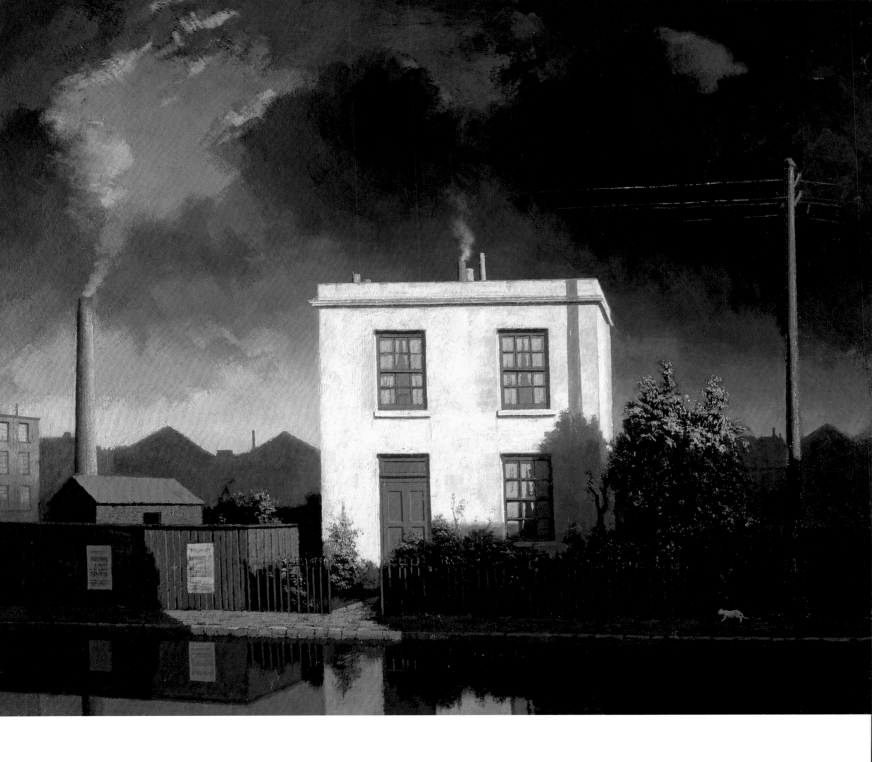

Regent's Canal

Supplementing the River Thames, London has a network of canals, once allowing for goods to be transported to many points across the country, and now used mainly for leisure. The Regent's Canal runs along the northern edge of central London, at a junction with the Grand Union Canal known as Little Venice in Maida Vale, before travelling through Regent's Park and to Camden. There it passes through Hampstead Road Locks, popularly known as Camden Lock, a local landmark adjacent to the famed Camden Lock Market. The canal continues through King's Cross and the Islington Tunnel, before turning south before the Limehouse Basin in the East End and heading towards its endpoint at the Thames.

The Regent's Canal and surrounding landscape was a major subject for the painter Algernon Newton (1880–1968), who gained the soubriquet 'the Canaletto of the canals'. His work is notable for its intense, almost uncomfortably dreamlike, stillness (**103**).

'The suburbs of London have a peculiar charm ... It can be so beautiful there.'

VINCENT VAN GOGH,
ARTIST (1853-90)

Hampstead

Within Camden is Hampstead, an affluent area that contains the large, hilly parkland of Hampstead Heath. Once a village outside London, Hampstead grew when it became a spa town in the eighteenth century, and still more when a railway link to London was built in the 1860s. Hampstead has been home to a large number of important cultural figures, including at various times the composers Edward Elgar and Frederick Delius, the authors H.G. Wells and Enid Blyton, poets Samuel Taylor Coleridge and John Keats, the founder of psychoanalysis Sigmund Freud (whose home is now the Freud Museum) and the artists John Constable (**104**) and Ford Madox Brown (**105**), among many others.

One of the highest points in the city, the view of London from the area of Hampstead Heath known as Parliament Hill, is protected by law.

104 John Constable,
Sir Richard Steele's Cottage, Hampstead, 1831–32.
Yale Center for British Art, Paul Mellon Collection

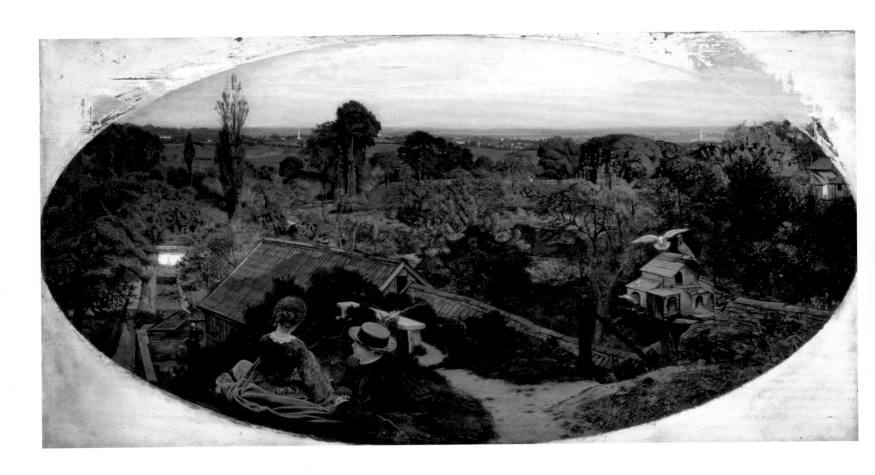

ABOVE:
105 Ford Madox Brown,
An English Autumn Afternoon,
1852–54. Birmingham Museum
and Art Gallery

OPPOSITE:
106 Ford Madox Brown,
Hampstead – A Sketch from Nature,
1857. Delaware Art Museum

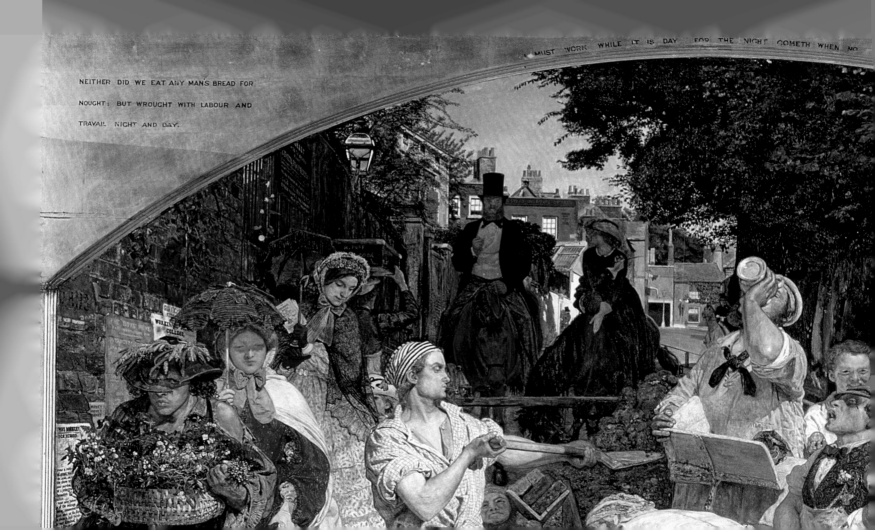

NEITHER DID WE EAT ANY MANS BREAD FOR
NOUGHT; BUT WROUGHT WITH LABOUR AND
TRAVAIL NIGHT AND DAY.

MUST WORK WHILE IT IS DAY FOR THE NIGHT COMETH WHEN NO

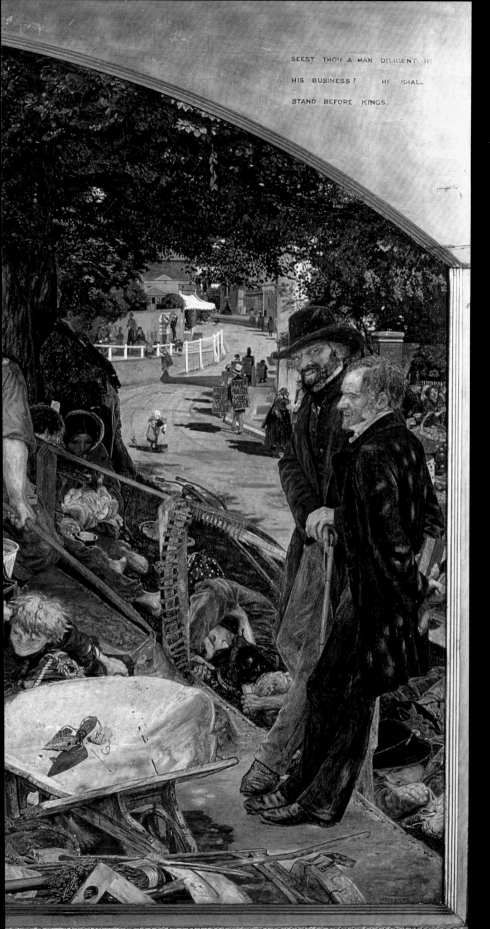

SEEST THOU A MAN DILIGENT IN
HIS BUSINESS? HE SHALL
STAND BEFORE KINGS.

Ford Madox Brown's *Work*

Ford Madox Brown, associated with but not a member of the Pre-Raphaelite Brotherhood, chose Hampstead as the location for his monumental allegorical painting *Work* (**107**). Painted partially on site, despite its size (nearly two metres wide), at the Mound, off Heath Street, Hampstead, it depicts the activity of 'navvies' digging the road, most probably in order to extend the sewerage system, an enterprise that was part of the fight against the spread of cholera and typhus.

Surrounding the workers are various types, representing different sections of society. A soberly dressed woman carries a Temperance Movement leaflet, while in front of her a glamorous lady shades herself from the sun with an umbrella. Also present are a ragged flower-seller, a man from the country wearing a rural smock, orphaned children and, lying on an embankment, unemployed labourers. A pair of intellectuals survey the scene.

Work contrasts productive and unproductive activity, with the resting unemployed sectioned off from the hard-working navvies in the composition by a scythe, and members of the leisured class pushed to the back and the side of the composition. With its displaced country dwellers and modernizing of leafy Hampstead, it also depicts the process of urbanization that characterized nineteenth-century Britain.

107 Ford Madox Brown, *Work*, 1852–65. Manchester Art Gallery

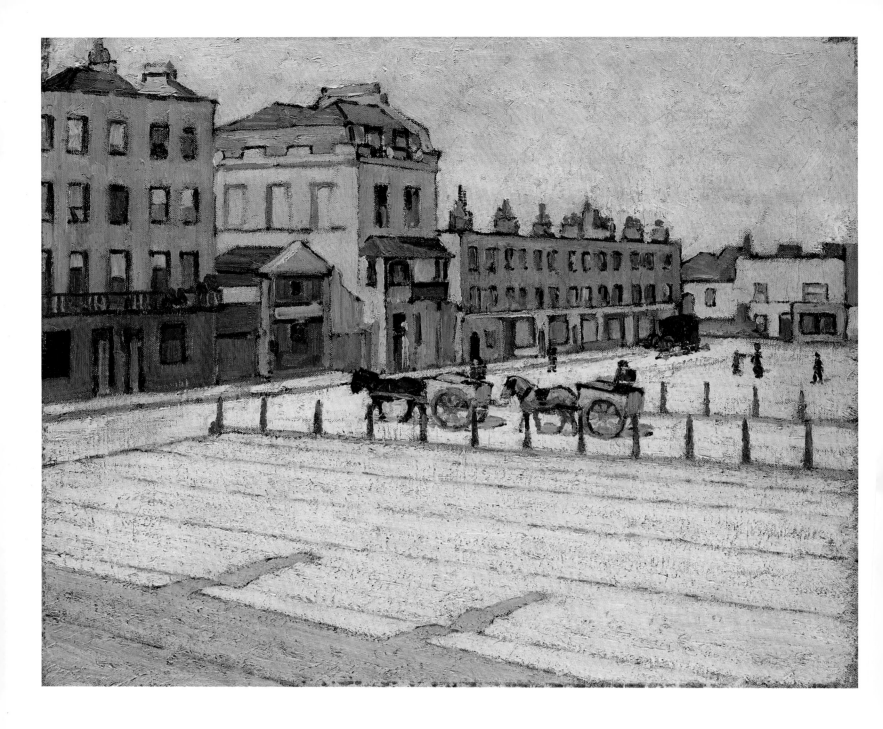

The Camden Town Group

The artists known as the Camden Town Group were so called because they met at the Camden home of senior member Walter Sickert in the years 1911–13. United by the influence of French post-Impressionist artists, the work of Camden Town Group artists such as Charles Ginner (**96**), Robert Bevan (**108**), William Ratcliffe (**109**), Malcolm Drummond (**52**), Spencer Frederick Gore and Harold Gilman, along with Sickert, is notable for its depiction of London locations, in Camden and beyond.

Members of the Camden Town Group also had their own particular interests. Walter Sickert was fascinated by the music halls, such as the Old Bedford Music Hall in Camden, while Robert Bevan often painted the horse sales at Cumberland Market (**108**), which once stood between Regent's Park and Euston railway station. Quite apart from its considerable artistic merit, the work of the Camden Town artists is an invaluable document of London as it was in the early years of the twentieth century.

'In fact when somebody from Hampstead is drowning, all their previous furniture passes in front of them.'

ALEXEI SAYLE, COMEDIAN (B.1952)

OPPOSITE:
110 Charles Ginner,
Flask Walk, Hampstead at Night,
1933. Fenton House, Hampstead

BELOW:
111 Charles Ginner,
*Flask Walk, Hampstead, on
Coronation Day*, 1937. Tate

157

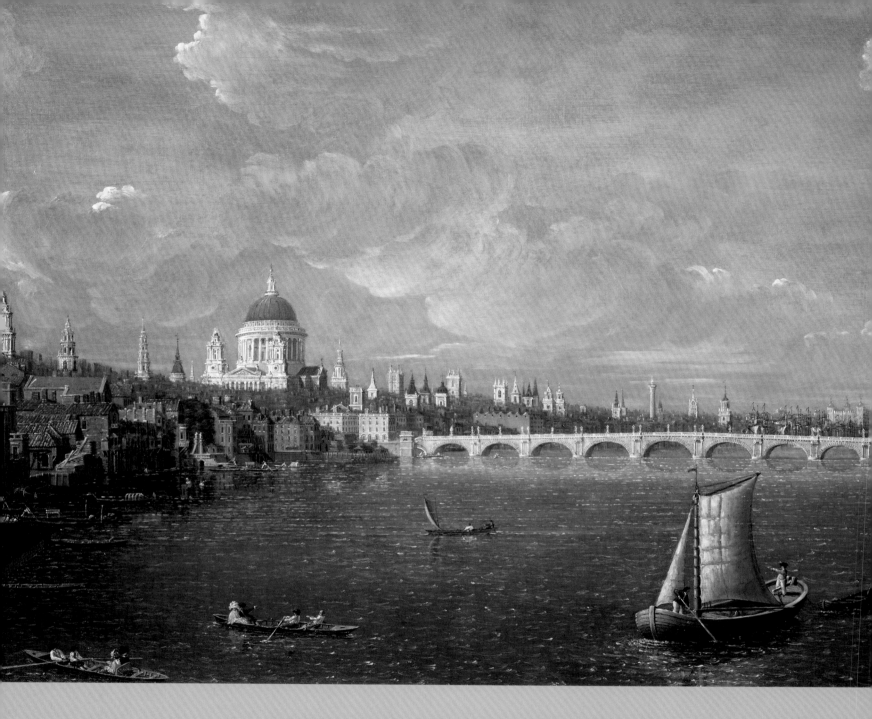

112 Daniel Turner, *View of St Paul's From the Thames*, c.1790. Tate

CHAPTER 7

St Paul's Cathedral
& The City

ST PAUL'S CATHEDRAL, THE CITY, FLEET STREET, MONUMENT,
SMITHFIELD MARKET AND BILLINGSGATE MARKET, LONDON BRIDGE

The dome of St Paul's Cathedral has a hint of blue echoing that of the sky as it stands, the tallest building in London, on a summer's day in the late eighteenth century (**112**). A still taller, very different cathedral had been on the spot less than a century and a half earlier (**114**), but the Great Fire of London of 1666 had consumed it, with Sir Christopher Wren's building taking its place and watching over London ever since (**115**), surviving the ravages of time and the Blitz (**122**). Art styles have come and gone, with St Paul's depicted in many of them, changing little, a constant presence in the lives of Londoners.

Surrounding St Paul's is the City of London (**126**), the area once contained within the old Roman walls, and now home to the capital's financial district. New skyscrapers rise up, taller than St Paul's, their arrival trumpeted on computer-generated images at ground level (**127**).

Elsewhere in the City is Fleet Street (**128**), where newspapers once came hot off the press, and the markets of Smithfield (**131**) and Billingsgate (**133**). Meanwhile, new developments rise from the ruins of Cripplegate, near-obliterated by the bombs of the Luftwaffe (**123**).

Back on the Thames, the seventeenth-century ice is frozen, and a 'frost fair' is there until the thaw (**134**). Ahead is London Bridge, for many centuries the city's only crossing point across the river – erected in Roman times, and reborn many times since. The medieval bridge proved the most durable, lasting for over 600 years. The current bridge may be nondescript and concrete, but the journey it enables is pivotal to the story of London, connecting it to farther fields, allowing it to grow.

St Paul's Cathedral

St Paul's Cathedral (**115**), designed by Sir Christopher Wren and consecrated for use in 1708, is a masterpiece of Baroque architecture, its dome a feat of structural engineering, as well as making it the tallest building in all of London until 1962.

Wren's is not the original St Paul's Cathedral, however. There has been a church dedicated to St Paul on the site since 604 AD, with a Saxon cathedral destroyed by fire in 1087 and replaced soon after. This Norman cathedral, already missing its spire following a lightning strike when painted by John Gipkyn (**114**), was itself severely damaged in the Great Fire of London in 1666. Wren's building, replacing it (gilded flames on top of the dome pointing in the direction the wind was blowing on the first day of the fire), has served ever since, surviving bomb damage in World War II (**121**), and left standing while whole areas in the vicinity such as Cripplegate were effectively flattened (**123**).

One of the most famous features of the cathedral is the Listening Gallery, which runs around the interior of the dome, 259 steps up. It has an unintentional aural quirk in that if you whisper into the wall at one point of the gallery, it can be heard by someone putting their ear up against the wall at another. Another sonic oddity of St Paul's is that a handclap will produce four echoes.

The funerals of venerated Britons such as Lord Nelson, the Duke of Wellington, Winston Churchill and Margaret Thatcher took place at the cathedral, as did the wedding of Charles, Prince of Wales, to Lady Diana Spencer in 1981. Perhaps only second to the Palace of Westminster, St Paul's defines the city of London in the eyes of the world.

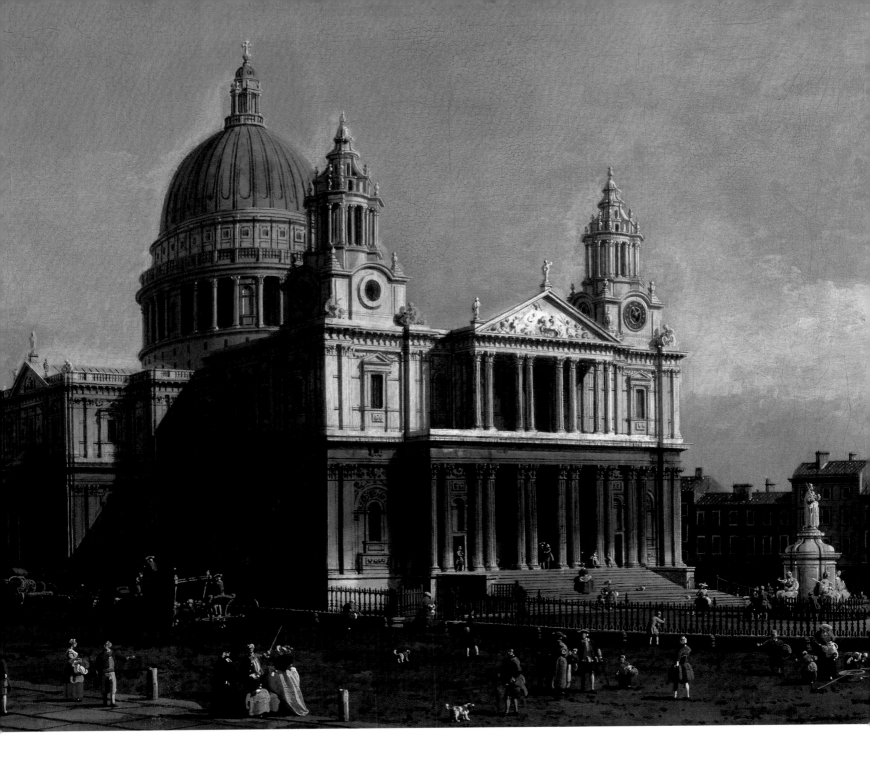

OPPOSITE:
114 John Gipkyn,
*Dr King Preaching Before Old
St Paul's Before James I*, 1616.
Society of Antiquaries of London

ABOVE:
115 Canaletto,
St Paul's Cathedral, c.1754.
Yale Center for British Art,
Paul Mellon Collection

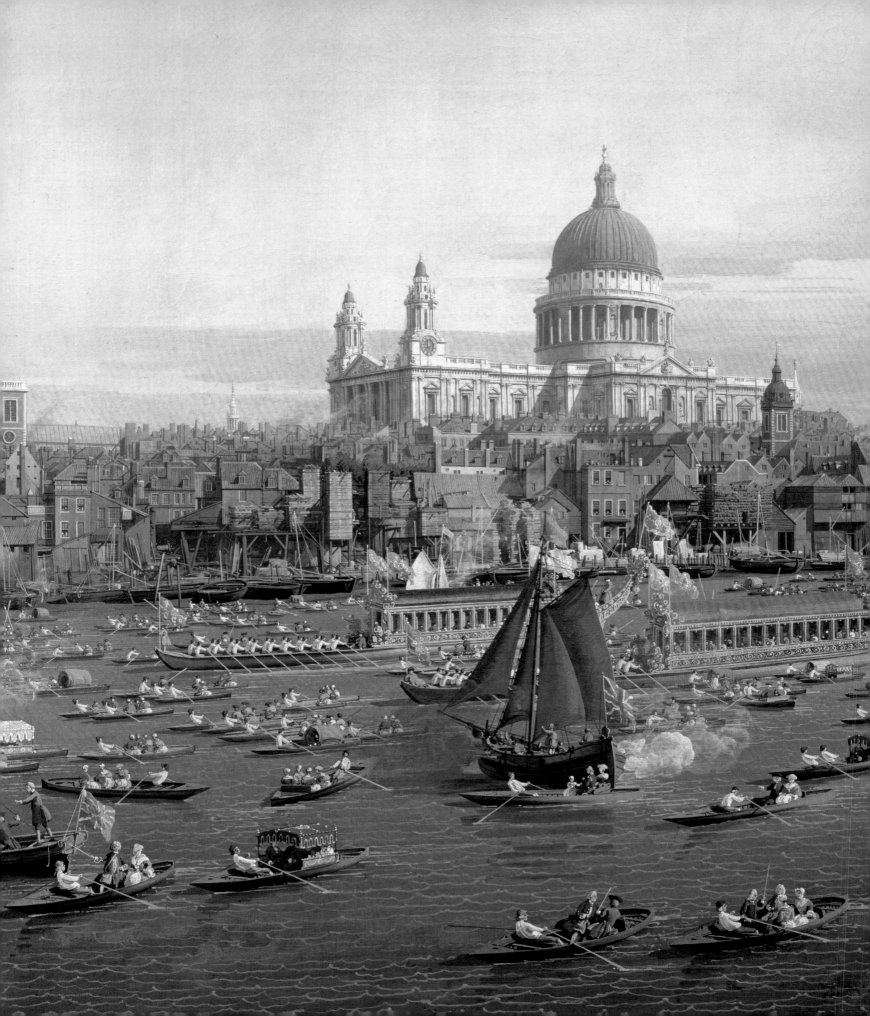

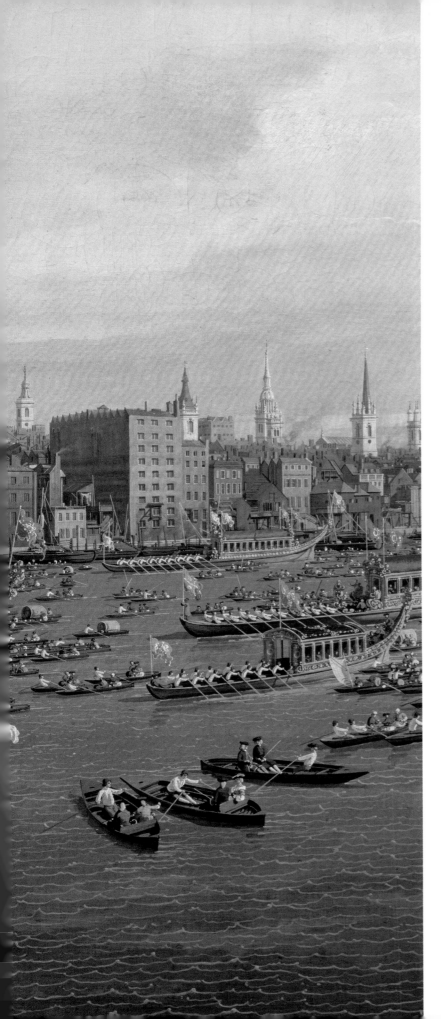

Wren and St Paul's

Although Sir Christopher Wren was given the task of replacing the old St Paul's Cathedral (114) after the Great Fire of London in 1666, along with many other churches in the City of London that had been lost, he had actually been working on designs for a severe modification of the old building since 1661, hoping to replace its tower with a dome. Even after the Great Fire, it was initially hoped that the old St Paul's could be saved, but this was not to be.

Wren drew up four plans for the new St Paul's before finally settling on the finished design. A first design, possibly inspired by the Pantheon in Rome and rejected by clerics as it 'was not stately enough', was followed by a second with the layout of a Greek cross. A third design added a nave to this plan. A large model of this (13 feet tall and 21 feet long) was made out of oak and plaster and has become known as the Great Model design. This third design was also rejected, however, as it was felt to be too different from other English churches. The model is now housed in the present St Paul's.

The fourth design gained royal approval, and is therefore known as the Warrant design. As the cathedral was being built, however, Wren made 'ornamental changes' that radically altered its appearance, dispensing with the planned steeple and replacing it with a dome inspired by that of St Peter's Basilica in Rome. This resulted in the St Paul's that we know today (115), a building nearly 70 feet shorter than Old St Paul's before it lost its spire following a lightning strike in 1561. Construction would begin in 1675, and continue until 1720, three years before Wren's death.

116 Canaletto,
The River Thames with St Paul's Cathedral on Lord Mayor's Day, c.1747–48.
Lobkowicz Palace, Prague Castle

London St Paul. C. Pissarro. 1890

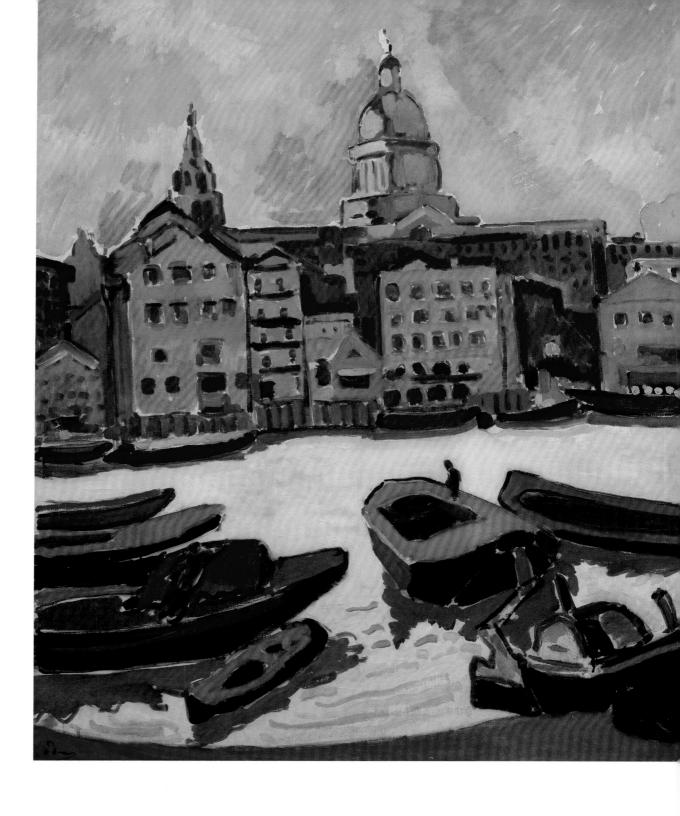

André Derain in London

French artist André Derain (1880–1954) co-founded the artistic movement of Fauvism alongside Henri Matisse. Noted for its use of vivid use of colour, often seemingly unrelated to that of its subject matter, Fauvism got its name from the critic Louis Vauxcelles, who sneeringly dubbed the artists '*les fauves*' ('the wild beasts').

In 1905 Derain's dealer, Ambroise Vollard, commissioned him to produce paintings of London, in the hope of recreating some of the success of Monet's paintings of the city. Derain made three trips to London in 1906–7, resulting in 30 canvases that imbued popular landmarks such as the Houses of Parliament, St Paul's Cathedral (**118**), Charing Cross Bridge (**75**) and Tower Bridge with the intense hues of the Fauves.

'Architecture aims
at eternity.'

SIR CHRISTOPHER WREN,
ARCHITECT (1632–1723)

119 Hannah Collins,
True Stories 8, 2000. Tate

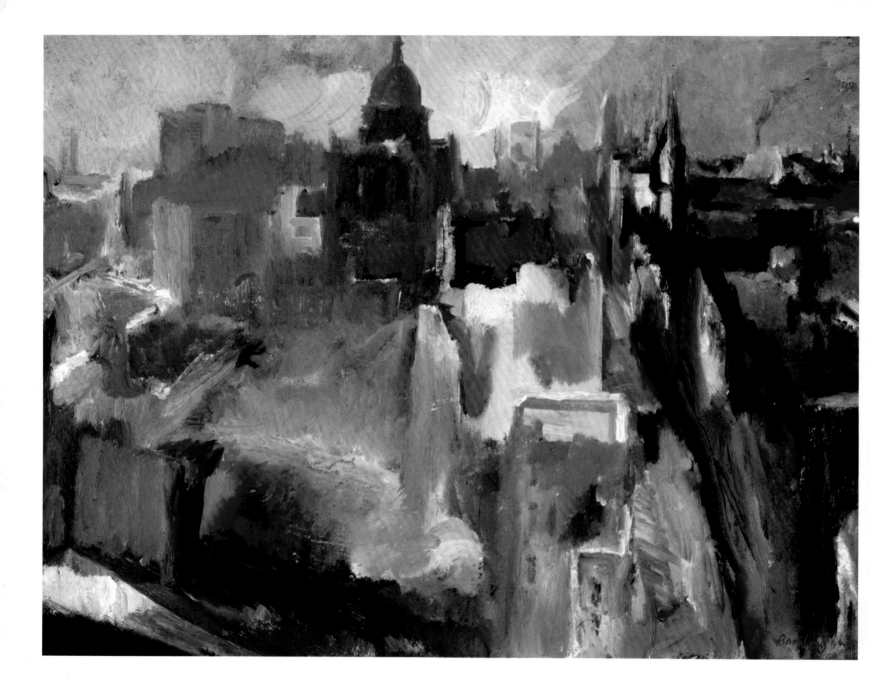

St Paul's Cathedral in World War II

During the aerial attacks on London during World War II known as the Blitz, St Paul's Cathedral was struck by bombs several times (**122**).

On 12 September 1940, a time-delay bomb that had landed under the cathedral was removed after three days and safely detonated at another location. If it had gone off, it would have destroyed St Paul's. A bomb dropped on 10 October the same year would destroy the high altar.

The attack on the City on 29 December 1940 was so devastating it was called 'the Second Fire of London', the same streets that burned in 1666 aflame again. Knowing the effect its loss would have on the nation's morale, Prime Minister Sir Winston Churchill ordered that St Paul's Cathedral should be protected at all costs. An incendiary device lodged in the roof, and began to melt the lead of the dome. St Paul's was saved, however, when the bomb fell down into the Stone Gallery, where it was smothered with sandbags.

A strike on 17 April 1941 resulted in a bomb detonating in the north transept, leaving a hole in the crypt. This blast is thought to have shifted the entire dome slightly sideways.

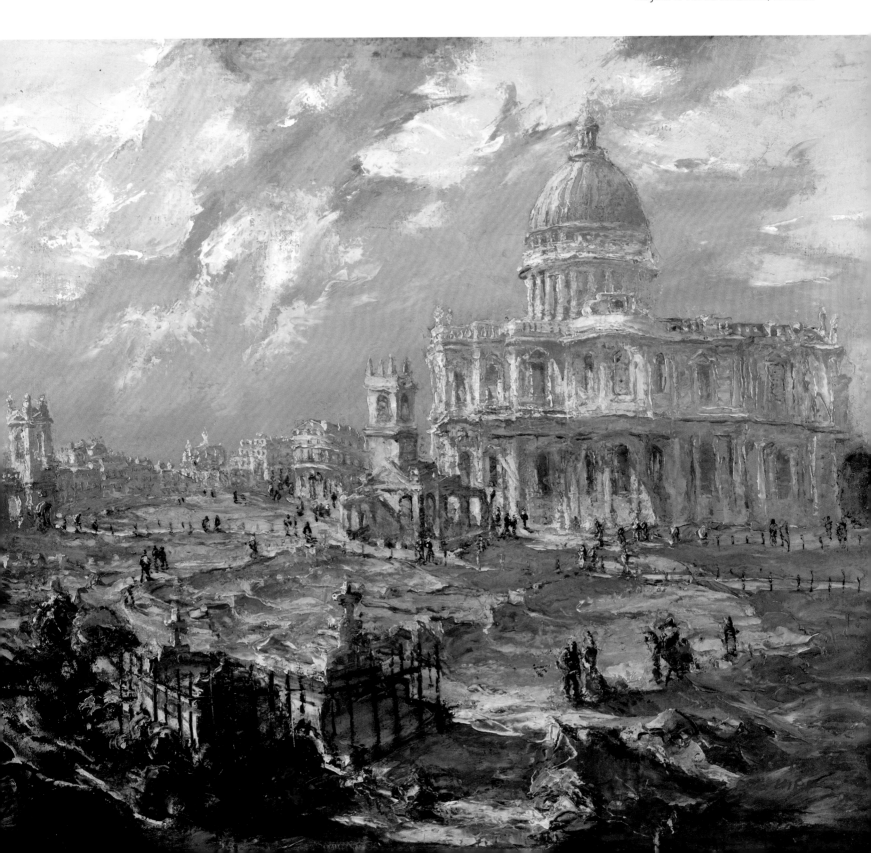

OPPOSITE:
120 David Bomberg,
Evening in the City of London,
1944. Museum of London

BELOW:
121 Eve Kirk,
St Paul's Cathedral, c.1940.
Royal Air Force Museum, London

'It is not the walls that make the city, but the people who live within them. The walls of London may be battered, but the spirit of the Londoner stands resolute and undismayed.'

KING GEORGE VI (1895–1952)

BELOW:
122 Charles Ernest Cundall, *St Paul's and London During the Blitz, seen from the Thames*, 1943. Private collection

OPPOSITE:
123 David Ghilchik, *Out of the Ruins at Cripplegate, London*, 1962. Guildhall Art Gallery, London

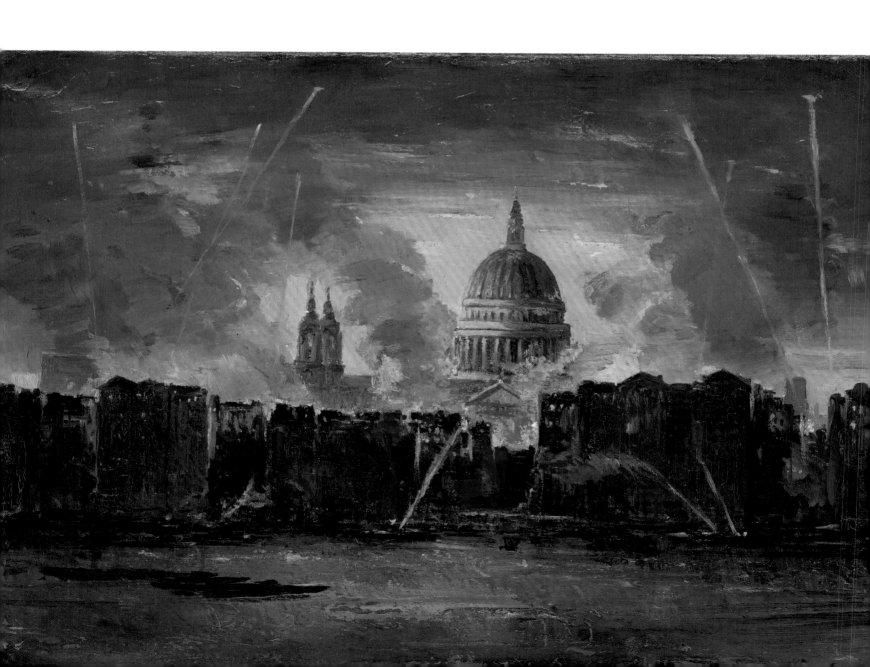

The Blitz

The Blitz (from the German *Blitzkrieg*, meaning 'lightning war') is the name given to the aerial bombing of the United Kingdom by Germany during World War II. From 7 September 1940 to 12 May 1941, London was targeted 71 times, 57 of these on consecutive nights. Nearly 20,000 people were killed.

In order to survive the bombing, the people of London (alerted by a two-minute wailing siren) hid in various shelters, such as the Anderson shelter, which was designed to be buried in the garden, and in Underground stations (**151**). Over 5,000 residents of the East End even made a temporary home for themselves in a network of caves in Chislehurst in south-east London, while the banqueting hall of the plush Savoy Hotel in the West End was partly used as a dormitory, with a special section for loud snorers.

Many were evacuated to other parts of the country, particularly children, with London's population depleted by almost 25 per cent. Civilians who were unable to join the armed forces enlisted in the Auxiliary Fire Service, the Air Raid Precautions Service and the Home Guard, which was to be Britain's second line of defence should it be invaded. During this time, Boy Scouts guided fire engines to where they were needed, and became known as 'Blitz Scouts'.

The area of the City known as Cripplegate was virtually demolished during the Blitz (**123**). After the War, the Barbican residential estate and arts centre was built on the site. The complex is in the modernist 'Brutalist' style, making a strange juxtaposition with the fragments of the Roman London Wall that survived the Blitz and stand on its grounds.

The City

The City of London (**126**), also known as 'the Square Mile' (actually 1.12 sq mi), is now primarily London's financial district, and is both a city and county in its own right. It was the site of Roman London in the first century AD, the boundaries of which were marked by a wall (of which small sections still survive), and still constituted much of the city until its rapid expansion during the Industrial Revolution.

Notable financial institutions to be found within the City include the London Stock Exchange, the Bank of England and the insurance market Lloyd's of London. In recent years, a number of skyscrapers have been erected (**127**), often with distinctive shapes that earned them nicknames, including 'the Walkie-Talkie' (20 Fenchurch St), 'the Gherkin' (30 St Mary Axe), and 'the Cheesegrater' (122 Leadenhall St).

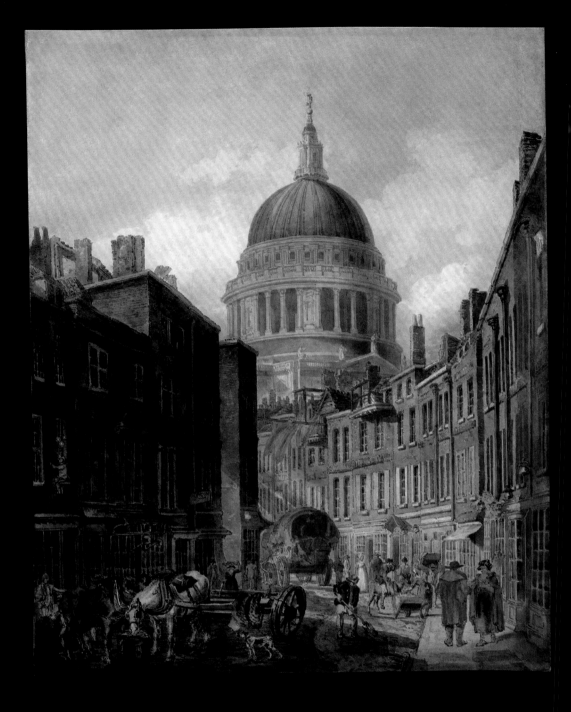

ABOVE:
124 Thomas Girtin,
St Paul's Cathedral from St Martin's le Grand, c.1795. Metropolitan Museum of Art, New York

OPPOSITE:
125 William Logsdail,
St Paul's and Ludgate Hill,
c.1887. Private collection

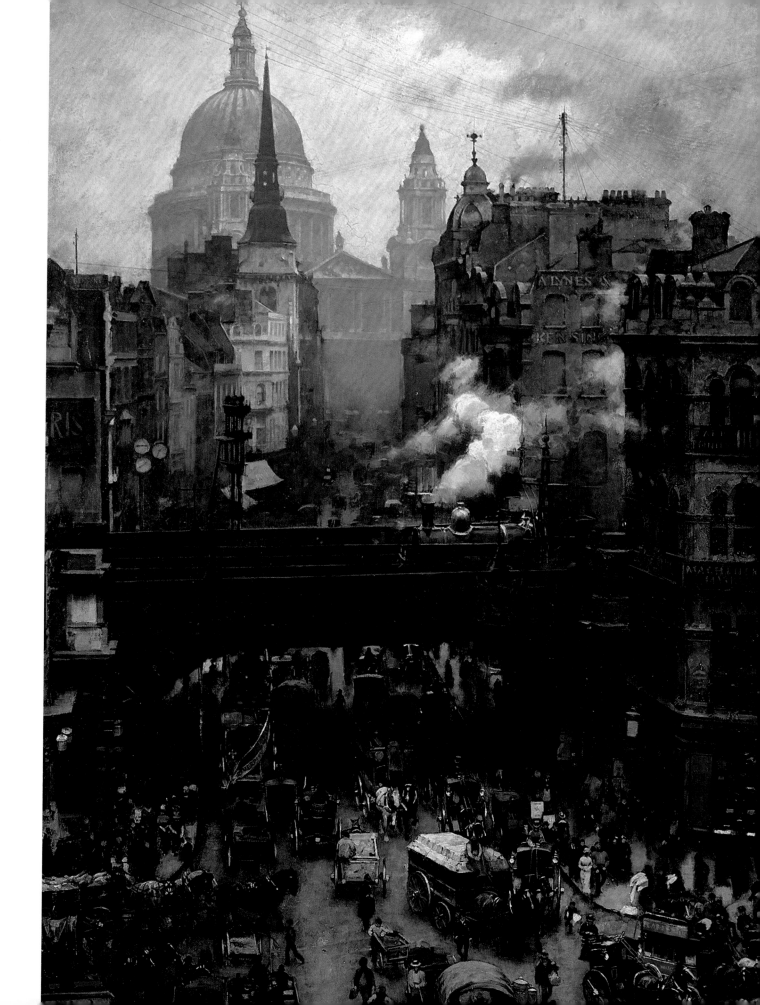

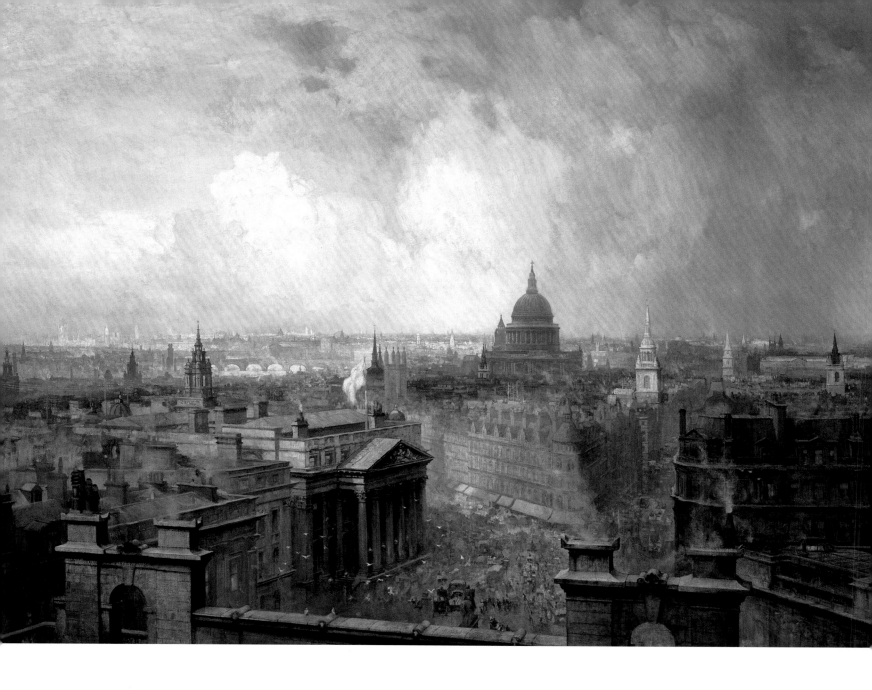

126 Niels Møller Lund,
The Heart of the Empire, 1904.
Guildhall Art Gallery, London

Rut Blees Luxemburg's 'London Dust'

Contemporary photographer Rut Blees Luxemburg is known for her images of cities at night. In her 'London Dust' series (**127**), Luxemburg sought to document the rapid changes that are occurring in central London, notably the erection of new skyscrapers. The images of these towering buildings, however, are not all that they initially appear to be. These are not photographs of the skyscrapers themselves, but of the computer-generated mock-ups of the skyline-to-come that appear on the perimeter fence of their building sites. The tallest skyscraper to be seen in these images, known as the Pinnacle, was, ironically, abandoned after just seven storeys were completed following the financial crash of 2008.

127 Rut Blees Luxemburg, *London Dust*, 2012

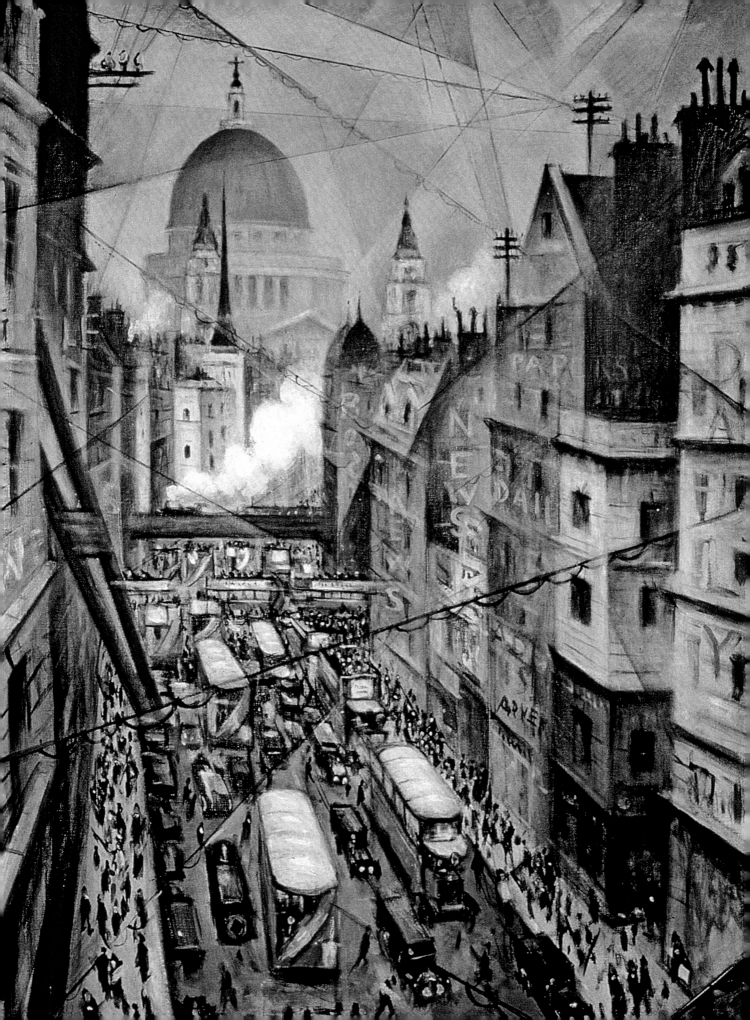

Fleet Street

Fleet Street (**128**) was until recently the home of British newspaper publishing. London's first daily paper, *The Daily Courant*, was published there in 1702, followed by *The Morning Chronicle*. By the twentieth century, Fleet Street was dominated by the newspaper publishing industry. The unknown artist who captured *Fleet Street in the 1930s* (**129**) gives particular attention to the Daily Express Building, an art deco masterpiece by Sir Owen Williams to which the paper relocated in 1931. Lord Beaverbrook, the newspaper's owner, can be seen smiling in the bottom right-hand corner.

Newspapers began to abandon Fleet Street in 1986, when News International owner Rupert Murdoch relocated *The Times* and *The Sun* to Wapping, where new computerized printing technology could be used, a move that triggered a bitter industrial dispute. Other publishers followed, and today one of the few publishing companies to still be found in Fleet Street is D.C. Thomson, responsible for cherished children's comic *The Beano*.

OPPOSITE:
128 C.R.W. Nevinson,
The Nerves of the World,
c.1930. Museum of London

ABOVE:
129 English School,
Fleet Street in the 1930s, 1930s.
Guildhall Art Gallery, London

The Great Fire of London and the Monument

On Sunday 2 September 1666, a fire started at a bakery in Pudding Lane. The fire spread quickly and, aided by the indecisiveness of the Lord Mayor of London when giving orders to fight the fire, would go on to consume much of the City of London contained within the old Roman Wall. 70,000 of 80,000 Londoners would lose their homes, and while only six deaths were recorded, the total may well have been much higher, the victims cremated to the point where they would have left no remains.

St Paul's Cathedral was destroyed, as were 87 parish churches. Architect Sir Christopher Wren was given the task of designing replacement buildings for St Paul's and many of the churches. Alongside this, Wren was responsible for the design of the Monument to the Great Fire of London (**130**), in collaboration with Robert Hooke, to be situated near the north end of London Bridge. A 202 foot (62 metre) tall Doric column (mirroring its distance of 202 feet from the site in Pudding Lane where the fire started), topped with a gilded fiery urn, the Monument can be climbed via a staircase of 311 steps. Text in Latin at the base tells the story of the Great Fire. Lines falsely blaming the fire on Catholics were removed in 1830.

The Monument was also designed to act as a scientific instrument for use in gravity and pendulum experiments, with its central shaft functioning as a zenith telescope.

130 Samuel Scott, attr., *Billingsgate and the Monument*, 1765–90. National Museums Liverpool

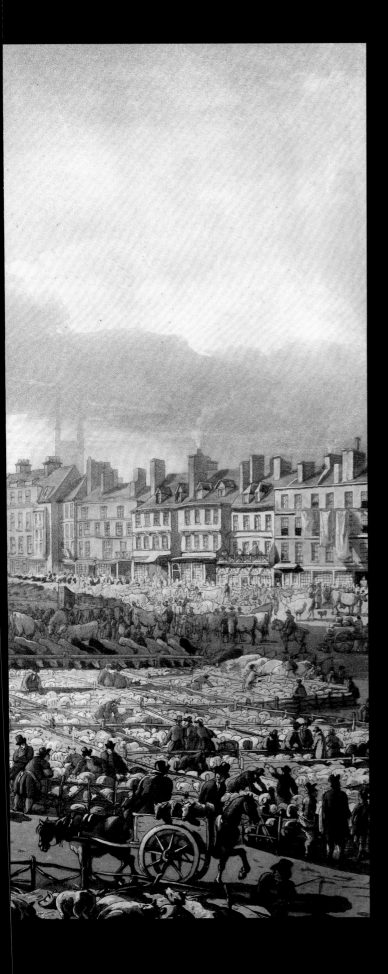

Smithfield Market and Billingsgate Fish Market

There are a number of markets associated with the City area, past and present. Smithfield Market is a wholesale meat, poultry and fish market, the origins of which date back 800 years. For centuries a place to sell livestock (**131**), hygiene concerns in the Victorian era (detailed by Charles Dickens in *Oliver Twist*, writing 'the ground was covered, nearly ankle-deep, with filth and mire') forced this trade out of the city, and in 1868 a new, specially built indoor market for meat was opened (**132**), with further blocks for poultry and fish opened in later years. The market is currently the only major wholesale market in central London not to be relocated. It has been under threat of demolition for some time, however, and there are currently plans to use one of the market blocks as the new home for the Museum of London.

Billingsgate Wharf has been the home of a fish market since the sixteenth century. In its earlier years, it was notorious for the foul language spoken there. A new market building was opened in 1877, which would be the largest fish market in the world at that time. In Clare Atwood's painting of the market (**133**), you can see the porters wearing their 'bobbin hats', protective leather headgear that enabled them to carry crates of fish on their heads. Figures of note to be employed in the fish market include author George Orwell and notorious gangsters the Kray twins. Billingsgate Market was relocated to the Isle of Dogs (although still retaining its name) in 1982.

131 Thomas Rowlandson,
Smithfield Market, 1811.
London Metropolitan Archives

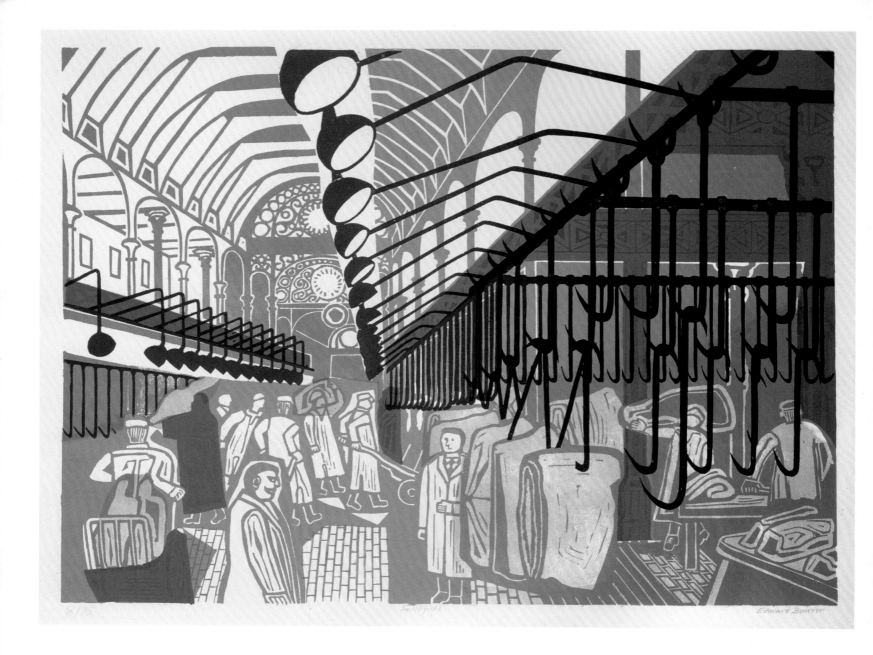

ABOVE:
132 Edward Bawden,
Smithfield Market, 1947.
Fry Art Gallery, Saffron Walden

OPPOSITE:
133 Clare Atwood,
Billingsgate Fish Market, 1936.
Smallhythe Place, Kent

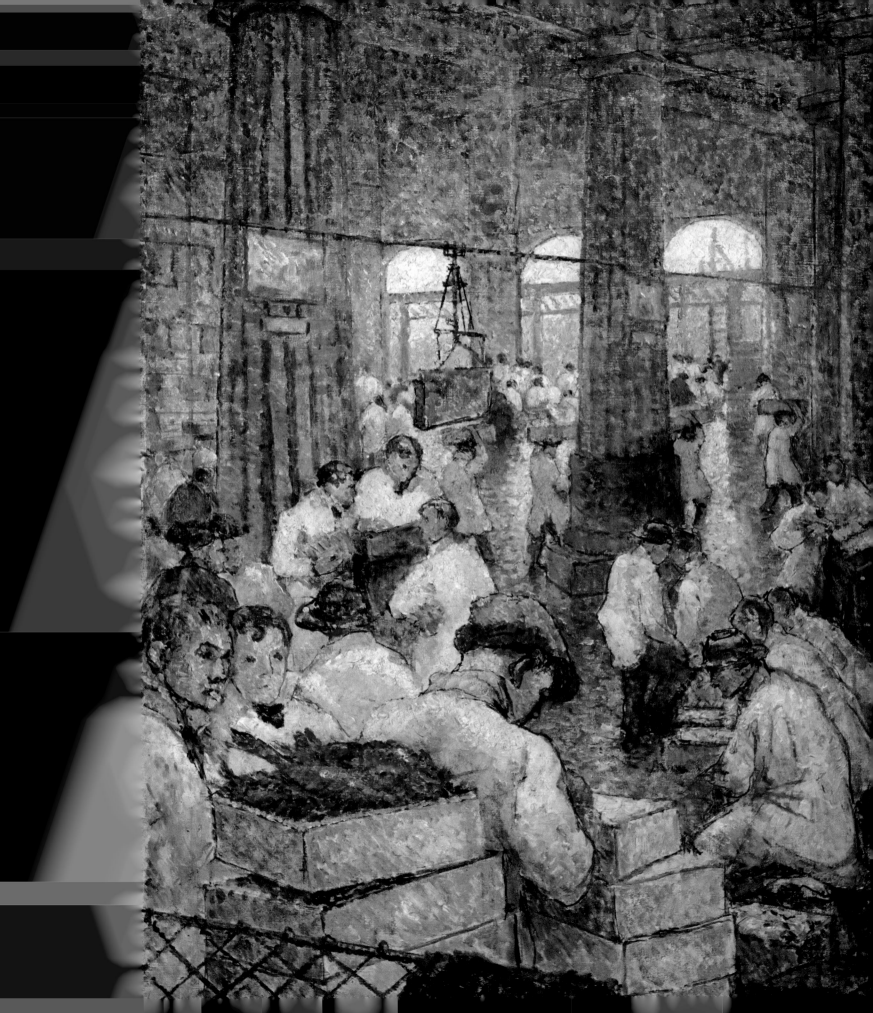

Frost Fairs

Following a warm period during the Middle Ages, between the thirteenth and nineteenth centuries the world entered what is known as 'the Little Ice Age'. With the British winter generally colder than now, the Thames froze over with greater regularity. From the seventeenth to the nineteenth centuries, Londoners took advantage of this by holding 'frost fairs' on the ice, with entertainments including archery, horse-and-coach races, bull-baiting, puppet shows and ox roasts, along with much sledging and skating (**134**).

A painting by an artist of the English school captures the fair of the Great Frost of 1683–84 (**135**), the worst recorded in England's history, when the Thames was frozen for two months. The fair marked the beginning of the famous Chipperfield's Circus, with James Chipperfield exhibiting performing animals on the ice.

Generally warmer winters and the slowing of the flow of the Thames by the construction of more bridges meant that the river now rarely freezes, and so the frost fairs are sadly no more.

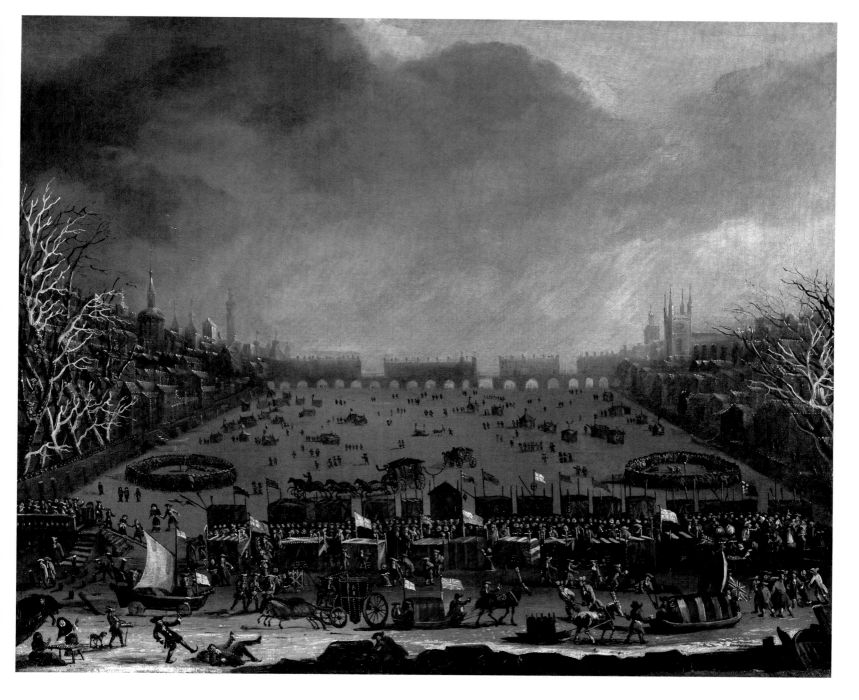

London Bridge

There has been a bridge crossing the Thames in the vicinity of the current London Bridge from the time of the Roman settlement of Londinium (c. AD 50). After being rebuilt or repaired a number of times over the next thousand years, a new stone bridge (**134**) was commissioned by King Henry II, with building beginning in 1176 and ending in 1209. This bridge would stand for 600 years, lined with shops, houses (some reaching up to seven storeys) and even public toilets, through which the waste would drop into the river below. For centuries, beginning with William Wallace ('Braveheart') in 1305, heads of traitors were impaled on pikes at the southern gatehouse.

The medieval bridge was finally replaced with a new stone bridge, designed by John Rennie, opening in 1831 (**138**). This would serve for over 130 years but, sinking under the weight of road traffic, it was itself replaced by a concrete bridge, completed in 1973. Rennie's bridge, meanwhile, was sold and reconstructed across the Atlantic, crossing the Bridgewater Channel Canal in Lake Havasu City, Arizona. A rumour that the buyer, entrepreneur Robert P. McCulloch, purchased it thinking it to be Tower Bridge was denied.

136 Charles Laurent Grevenbroeck, *View of Old London Bridge*, c.1740. Goodwood Collection

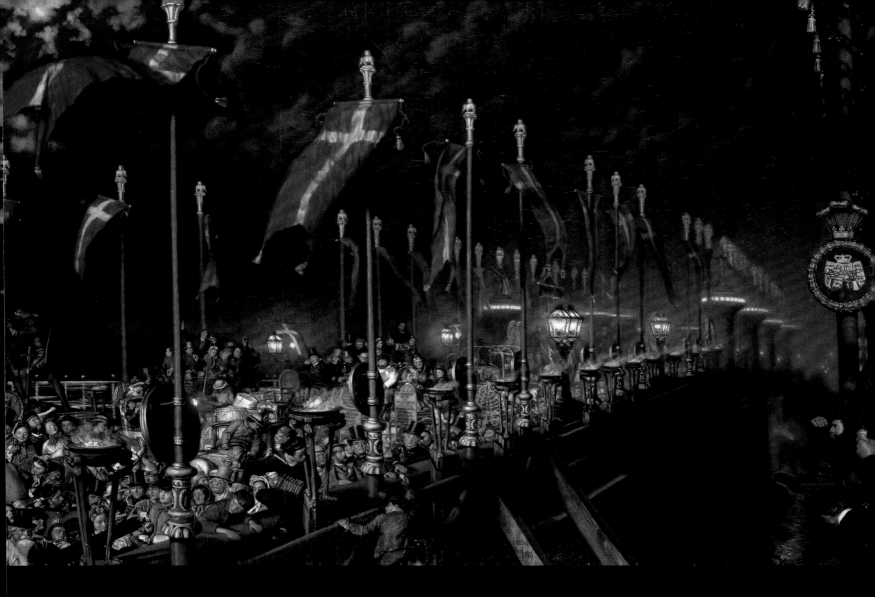

OPPOSITE:
137 Thomas Shotter Boys,
The Church of St Magnus the Martyr by London Bridge, with Monument in the Background, 1832. Yale Center for British Art

ABOVE:
138 William Holman Hunt,
London Bridge on the Night of the Marriage of the Prince of Wales and the Princess of Wales, 1863–66. Ashmolean Museum, Oxford

191

OPPOSITE:
139 Charles Ginner,
London Bridge, 1913.
Museum of London

ABOVE:
140 John Minton,
Bridge from Cannon Street, 1946.
Pembroke College, Oxford

141 Charles Edward Dixon, *Tower Bridge From Cherry Pier*, c.1900. Private collection

CHAPTER 8

The East End

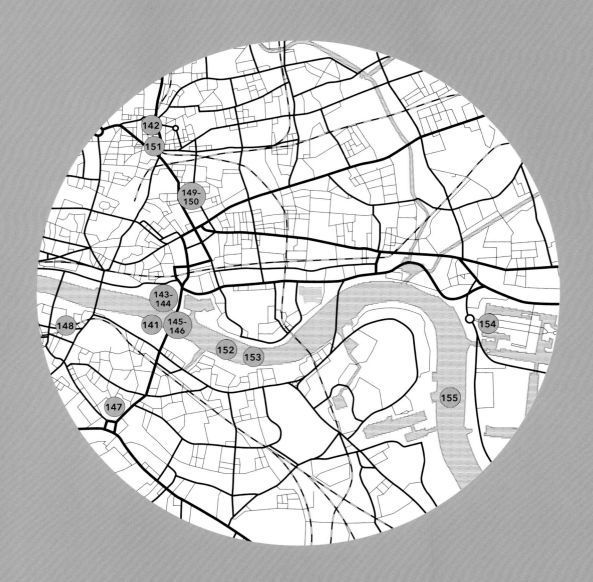

**THE TOWER OF LONDON, TOWER BRIDGE, SOUTHWARK,
CHRIST CHURCH SPITALFIELDS, THE POOL OF LONDON, CANARY WHARF**

Beyond the financial institutions of the City lies the East End, an area loosely contained within the borough of Tower Hamlets and often associated with poverty and the distinctive culture of 'cockneys'. Once including all Londoners, the term cockney is now said to be anyone born within earshot of the sound of 'Bow Bells', that is, the bells of the church of St Mary-le-Bow in the City. With their own distinctive accent (like that of actor Michael Caine), rhyming slang (for example, 'feet' rhymes with 'plates of meat' and so feet are known as 'plates') and local street traditions (the Pearly Kings and Queens, street traders who wear clothes covered in pearl buttons for charitable purposes), the residents of the East End probably possess the strongest local identity of all Londoners.

There is more to the East End than these obvious signifiers, however. Waves of immigration have left the area ethnically diverse, while contemporary artists such as Gilbert and George and the Young British Artists of the 1990s have lived there, and gentrification has led to the more affluent making it their home in recent years.

Our journey round the East End shows us some of the variety of this area. We start at the Tower of London (**143**), not often thought of as being part of the area, but built outside the old Roman Wall, and therefore outside the City of London, for William the Conqueror back in the eleventh century. A trip across Tower Bridge (**141**) takes us briefly to Southwark, another traditionally working-class area of London south of the river to see the fair of 1833, as depicted by William Hogarth (**147**), along with Borough Market (**148**), a food market that has existed in one form or other for a thousand years.

Back in the East End, we visit the architectural marvel of Christ Church, Spitalfields (**149**), and go down into the tunnels beneath Liverpool Street station, where Londoners hid from the bombs that rained down during the Blitz (**151**).

The towering luxurious skyscrapers of Canary Wharf (**154**), built on the site of the old West India Docks, show how land use is changing here, while the ships that once crowded the Pool of London (**152**) take us further down the river …

OPPOSITE:
142 Marjorie Sherlock,
Liverpool Street Station, 1917.
UK Government Art Collection

The Tower of London

Built for William the Conqueror following the Norman conquest, and expanded in later centuries, the Tower of London (**143**) has served a number of uses – among them a royal residence, the home of the Royal Mint, and a prison, its residents over the centuries including Sir Thomas More, Guy Fawkes and the Kray twins. Housing the Crown Jewels since the thirteenth century, for many years the tower also had its own menagerie, which at various times featured the first elephant in England, a pipe-smoking baboon, and a monkey who killed a clergyman with a cannonball. This only ended in 1835 after a soldier was bitten by a lion and the animals were transferred to London Zoo.

These days, the only wildlife looked after at the tower are ravens. At least six must have the tower as their home at any one time, or, it is said, the kingdom will fall. The ravens are cared for by the Ravenmaster, one of the Yeoman Warders, or 'Beefeaters' – retired officers of the armed forces who ceremonially guard the tower and act as tour guides.

Although a royal residence, the tower has been the site of bad fortune for several royals over the centuries. The boy king Edward V and his brother Richard were last seen in the tower, presumed murdered by their uncle, Richard III. Anne Boleyn, the second wife of Henry VIII, was held and executed there.

OPPOSITE:
143 David Roberts,
Tower of London, 19th century.
Newport Museum and Art Gallery

BELOW:
144 E.L. Laurie,
*The Coldstream Guards Marching
Out of the Tower of London, 3 April
1875*, 1875. Museum of London

Tower Bridge

Crossing the Thames near the Tower of London, Tower Bridge (**141**) is both a suspension bridge and a bascule bridge – that is, a bridge that is in two sections that can both be raised, allowing river traffic to pass through. The bridge, clad in a Neo-Gothic style so as to reflect the Tower of London's medieval architecture, has two towers either side housing the operating machinery, linked by a pair of walkways at their upper level.

Constructed from 1886 to 1894, the bridge ultimately replaced an underground foot tunnel underneath the Thames. The two upper-level walkways soon became frequented by prostitutes and pickpockets, and were closed to the public in 1910. They are now only accessible as part of the paid tour.

The original hydraulic machinery has been replaced, first by electrohydraulics in 1974, and by a computerized system in 2000, which at first proved unreliable, resulting in the bridge getting stuck halfway on a number of occasions. Although river traffic is much less frequent than when the bridge was opened, it is still raised about 1,000 times a year.

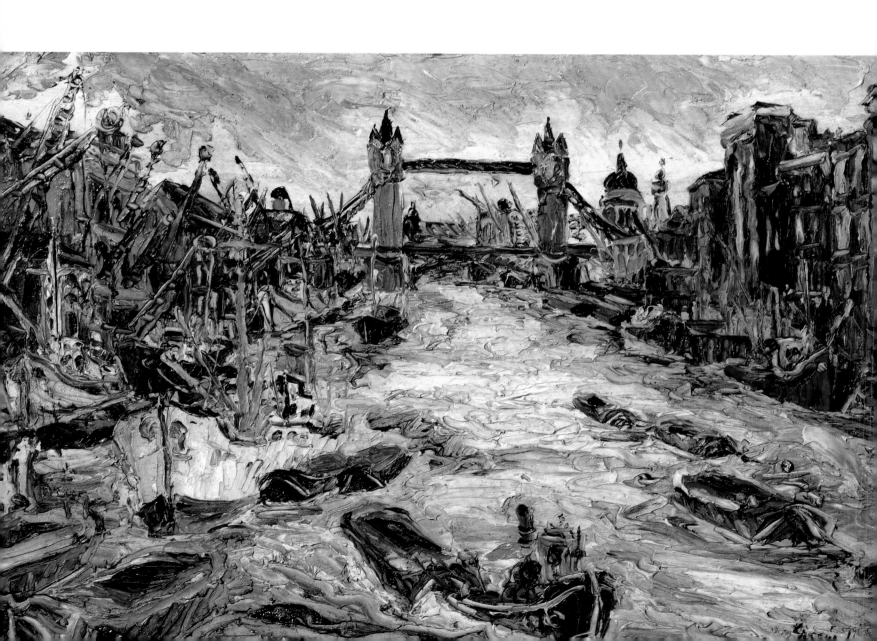

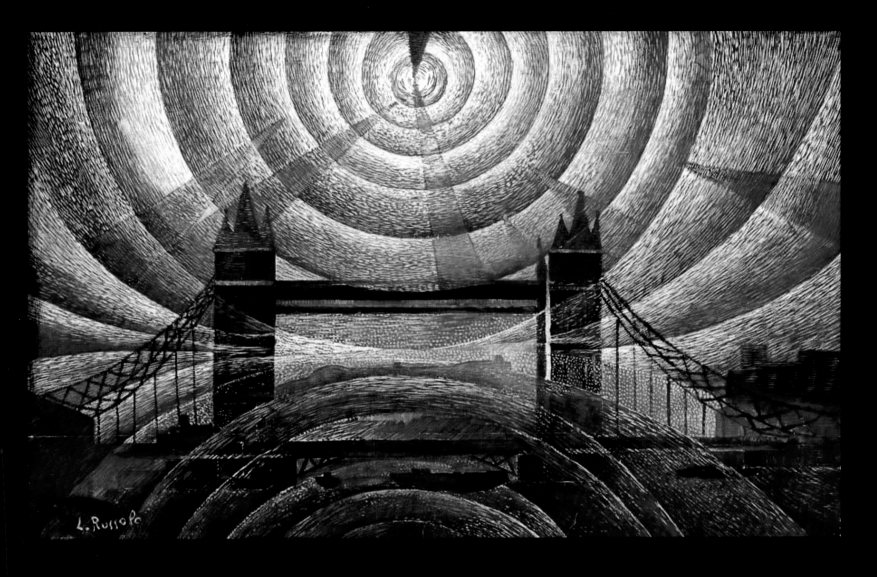

OPPOSITE:
145 George Hann,
Tower Bridge, 20th century.
University College
London Hospitals

ABOVE:
146 Luigi Russolo,
Tower Bridge, c.1910

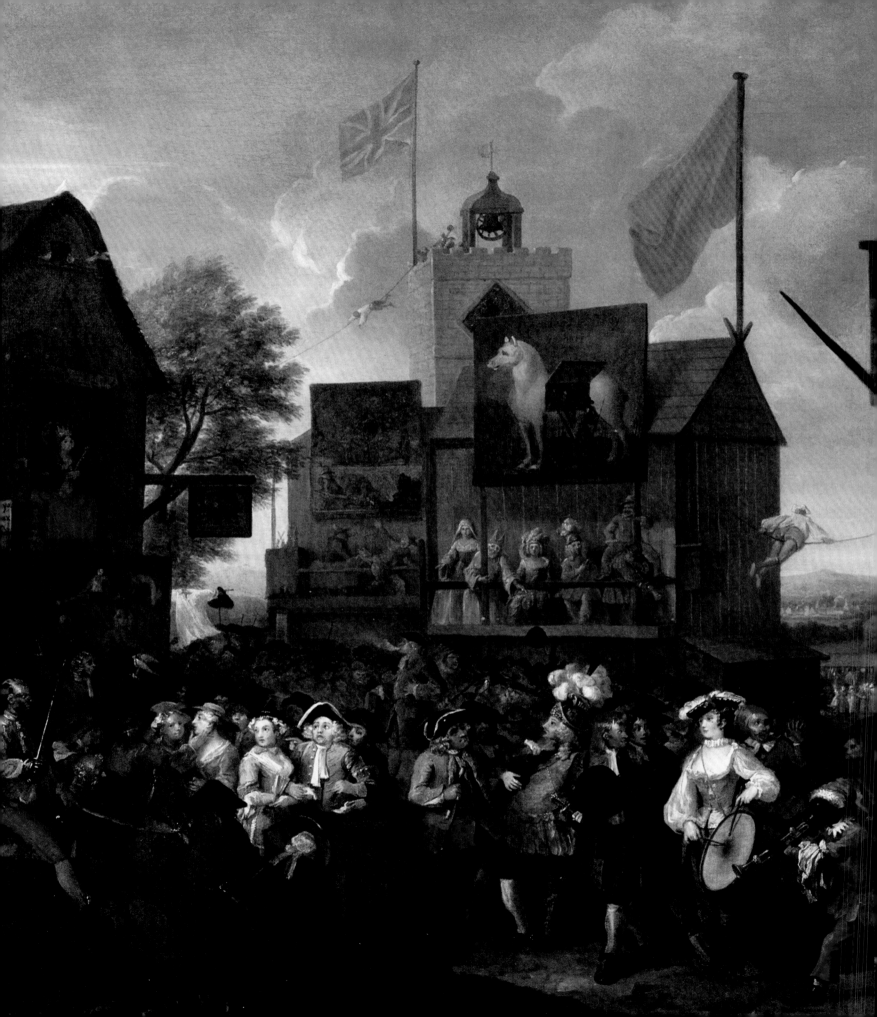

Hogarth's *Southwark Fair*

Southwark, south of the river opposite the City of London, was the site of an annual fair from the fifteenth to the eighteenth centuries. At its height, the fair would last a fortnight, with recorded attractions including weightlifters, puppet shows, and monkeys dancing on ropes.

William Hogarth's painting *Southwark Fair* (**147**) depicts many of the acts who appeared there in his day. The banner at the back shows the Trojan Horse and advertises a performance of Elkanah Settle's musical comedy *The Siege of Troy*. Other adverts show M. Christopher Miller, the German Giant; Isaac Fawkes, a conjurer famous for 'his curious Indian birds'; and a waxwork recreation of the French royal court. Swinging on a rope to the right of this is Robert Cadman, tightrope walker, while to the left, Violante, another acrobat, slides down from the church clock tower. Elsewhere in the crowd is a fire-eater, and on the far left, performing swordsman James Figg. The figures tumbling out onto the street on the right are part of a show ironically called 'The Fall of Bajazet', with an actor in armour from their company being arrested by a bailiff near the centre of the picture. In the foreground is a peep show – a box which contained a scene illuminated by a candle that could be viewed through a small hole. A gaming table to the left is perhaps a sign of the illicit activities that would lead to the fair being suppressed in 1763, 30 years after Hogarth painted it.

147 William Hogarth, *Southwark Fair*, 1733. Cincinnati Art Museum

'It is impossible to overestimate the thirst for spectacle among Londoners through many centuries.'

PETER ACKROYD, HISTORIAN (B.1949)

148 Edward Bawden,
Borough Market, 1947. Fry Art
Gallery, Saffron Walden

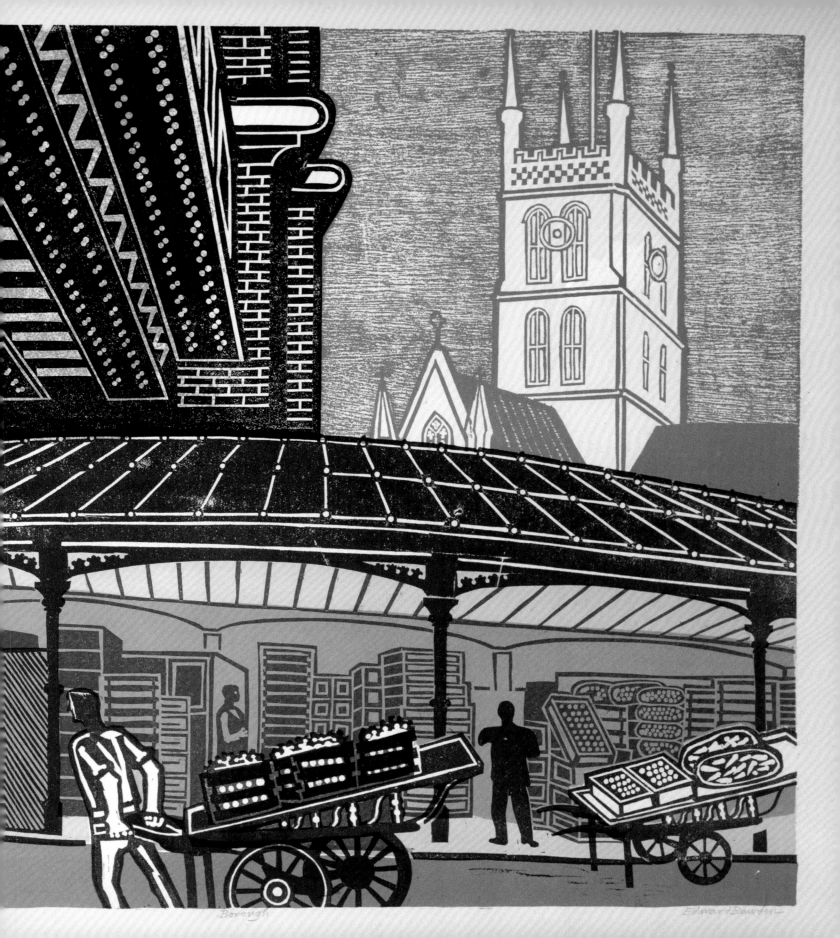

Borough Edward Bawden

Christard Church, Spitalfields

An Anglican church in the borough of Tower Hamlets, Christ Church, Spitalfields (**149**) was built in 1712-29, and is one of six London churches designed by architect Nicholas Hawksmoor. It features a near-Gothic spire atop a classically influenced building that seems quite plain when compared to the Baroque architecture of its age, perhaps to appeal to the tastes of the Huguenot protestant refugees who lived in the area having fled Catholic France.

Although serving the area over 200 years, the church was practically derelict by the 1960s, with services held elsewhere, and was threatened with demolition. A restoration led to the building coming back into use as a church in 1987.

Christ Church, Spitalfields has often been said to have a slightly unsettling atmosphere. Writers such as Peter Ackroyd, Iain Sinclair and Alan Moore have woven it into a fanciful reading of Hawksmoor's life, with his work tied in with occult practices. Pagan symbols are said to be built into the six London churches, which apparently form the shape of a pentagram when viewed on a map. Although these stories are fiction, the distinctive qualities of Hawksmoor's architecture that inspired them are undeniable.

149 John Piper,
Christ Church, Spitalfields,
1964. Tate

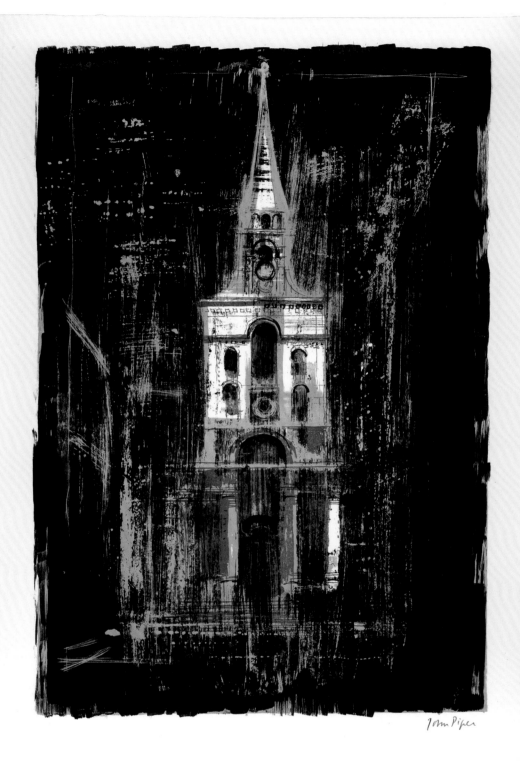

150 Leon Kossoff,
*Christ Church, Spitalfields,
Morning*, 1990. Tate

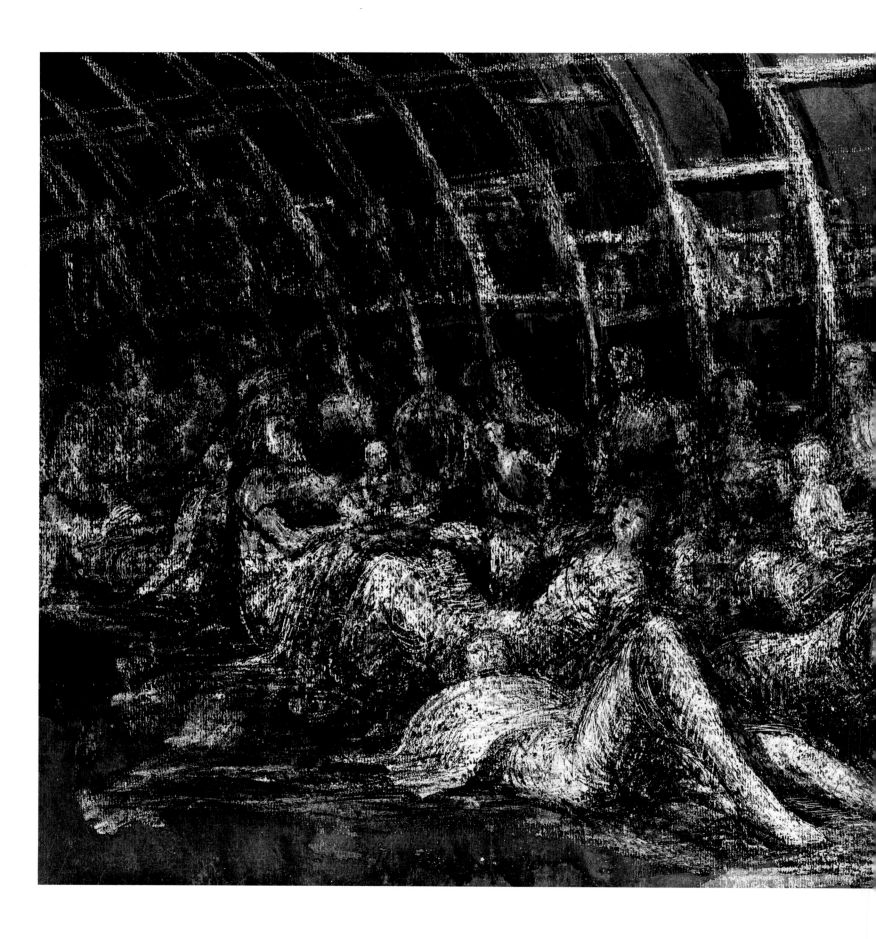

Henry Moore in the London Underground

Sculptor Henry Moore was already established as one of the most prominent and radical modern artists in Britain when World War II broke out. After his Hampstead home was bombed, Moore and his wife Irina moved out to Hertfordshire. When commuting into London, Moore's journey ended at Liverpool Street station, where underneath, a new extension of the Central Underground line, with tracks not yet laid, was being used as an air-raid shelter.

There Henry Moore drew many sketches of the figures huddled there, some of which he would then develop into full drawings. Here we see men and women and children, often given the heavy, monumental form of Moore's sculptures (151), lining the tunnels in the darkness, anxiety evident on their faces despite Moore's economy of detail, as bombs fell on the city above.

151 Henry Moore, *Shelterers in the Tube*, 1941

The Pool of London

Running from London Bridge to below Limehouse in the East End, the Pool of London (**152**) is a stretch of the River Thames where ships would moor and unload at the near-continuous run of wharfs along the bank. Always a major part of the success of London as a trading city (the Venerable Bede wrote that the Pool was the reason for London's existence back in the seventh century), the Pool reached its peak in the eighteenth and nineteenth centuries, to the point that it was said you could cross the Thames simply by jumping from ship to ship.

This overcrowding led to the building of off-river docks, such as the West India Docks at the Isle of Dogs, in the early nineteenth century, although the Pool continued to thrive long after. A move towards shipping containers and deep water ports on the coast in the 1960s, however, led to the drying-up of shipping traffic down the Thames. The wharfs were closed, and the area significantly redeveloped for commercial and residential purposes.

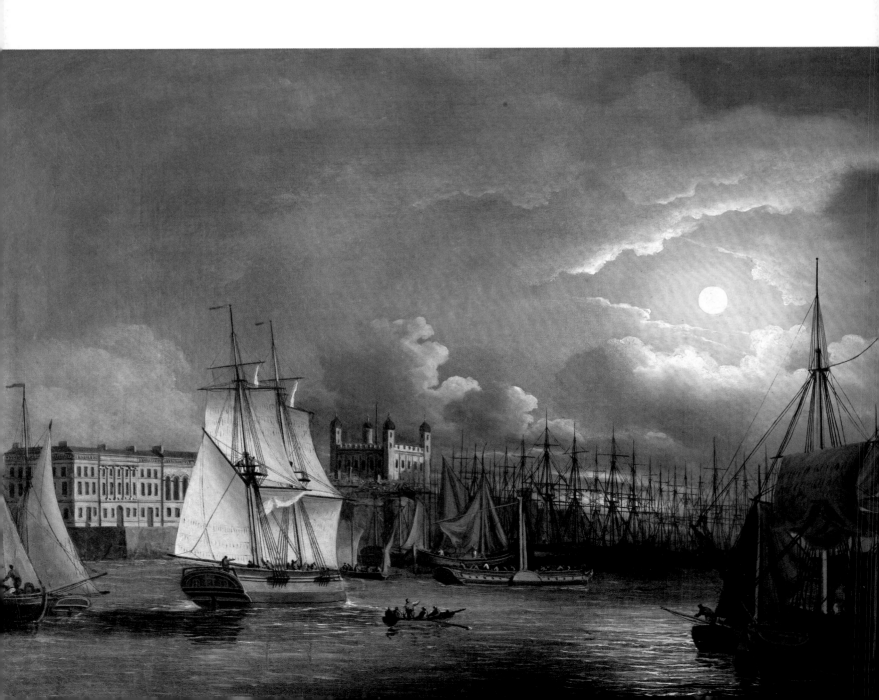

Canary Wharf

The West India Docks, located on the Isle of Dogs in the Tower Hamlets area of London, were among the busiest docks in the world in the nineteenth century. The London docks went into rapid decline during the 1960s as shipping containers and coastal deep water ports rendered them obsolete, and the West India Docks were closed in 1980.

Taking its name from one of the docks' berths, Canary Wharf is a business district built upon the old dock site, its first buildings completed in 1991 (**154**). Although initially running into financial trouble, the Canary Wharf development recovered, and continues to grow. Already containing a number of skyscrapers, including what was formerly the tallest building in the United Kingdom, One Canada Square, 30 new buildings are planned for the future. A studio flat in the new 30 Casson Square residential building will cost at least £750,000.

In 1996, Canary Wharf was bombed by the IRA, resulting in the loss of two lives and £150 million worth of damage.

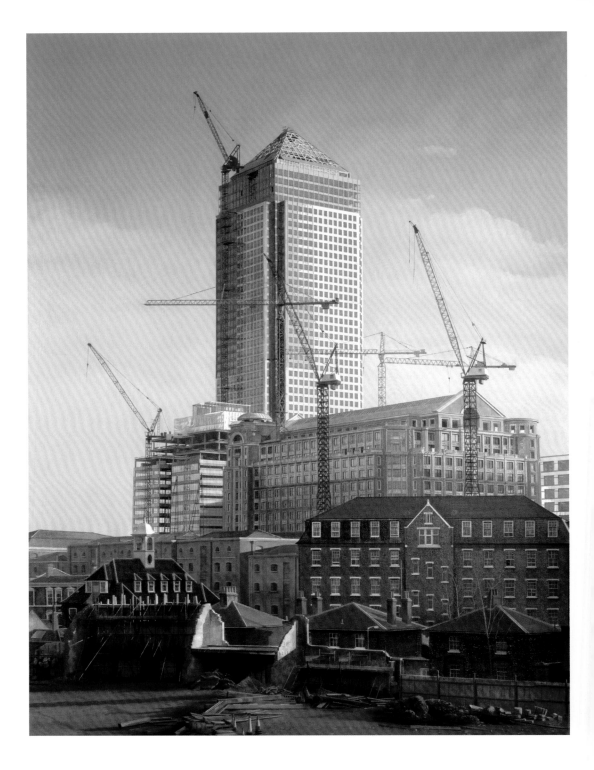

'Thames, the most loved of all the ocean's sons,
By his old sire, to his embraces runs,
Hasting to pay his tribute to the sea,
Like mortal life to meet eternity.'

JOHN DENHAM, 'COOPER'S HILL' (1642)

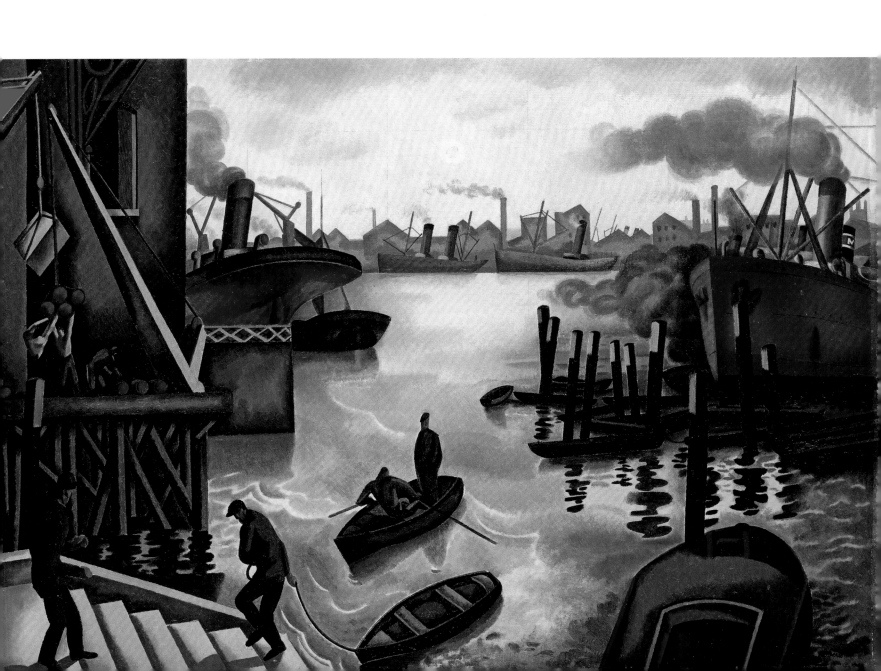

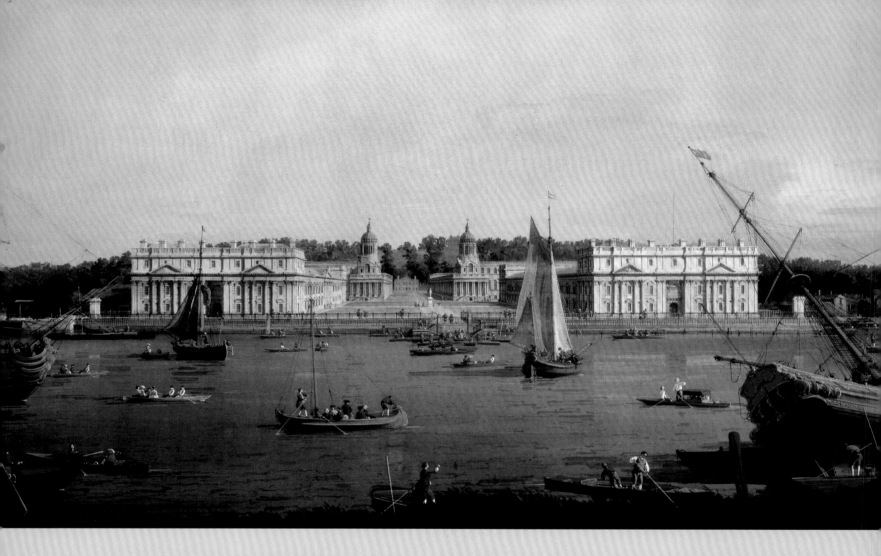

156 Canaletto, *London: Greenwich Hospital from the North Bank of the Thames*, 1750–52. National Maritime Museum, London

Greenwich

GREENWICH HOSPITAL, THE ROYAL OBSERVATORY, GREENWICH PARK

And so the Thames takes us out of central London, and to Greenwich on the south bank. A town famous for its maritime history and its observatory (**157**), it was absorbed into Greater London in the late nineteenth century.

Here we can look back with Turner from Greenwich Park (**158**), past the two towers of the Greenwich Hospital for Seamen, and upriver towards London. St Paul's is just a shape on the horizon now, and the city indistinct under low cloud.

The Thames will carry on, down into the Thames Estuary and out to sea, while London will also continue – to grow, change and inspire.

Greenwich Hospital

The Royal Hospital For Seamen at Greenwich ('hospital' used in its older sense of providing hospitality) was established on the orders of Queen Mary II after seeing the wounded returning from the Battle of La Hogue in 1692 (**156**). Architects Sir Christopher Wren and Nicholas Hawksmoor gave their services for free, building on the site of royal residence Greenwich Palace, which had fallen into disrepair. The Queen's House, however, still stood, and so the hospital was split into two so as not to obscure the view of the river.

The hospital was in use until 1869, housing retired seamen, including some who had fought at the Battle of Trafalgar. The building was used as the Royal Naval College from 1873 to 1998, and is now the Maritime Greenwich visitor's attraction.

OPPOSITE:
157 Eric Ravilious,
Observatory, c.1937.
London Transport Museum

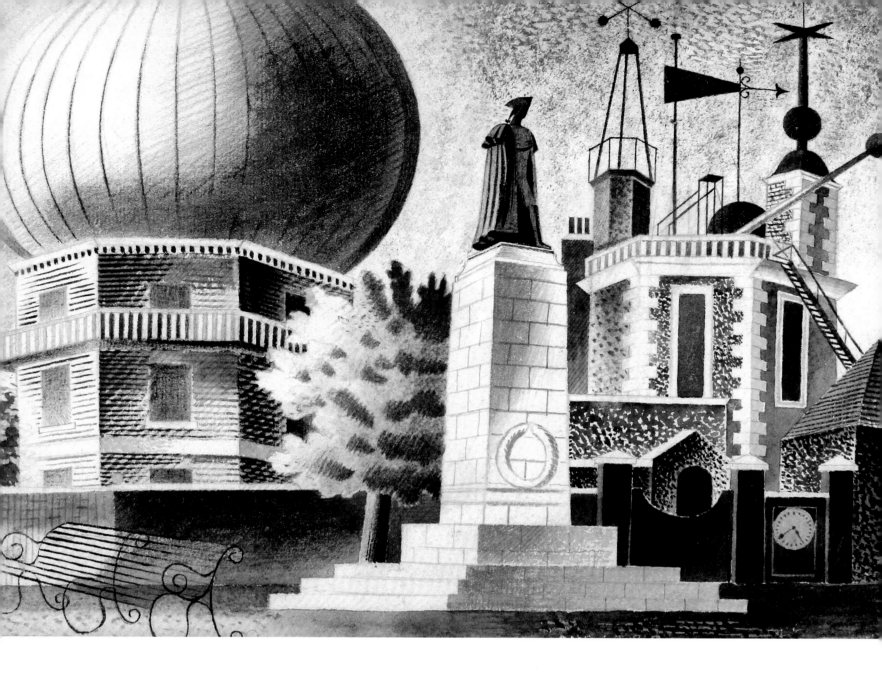

The Royal Observatory, Greenwich

The Royal Observatory (**157**), commissioned by Charles II in 1675, and with an original building designed by Sir Christopher Wren, has great significance for international timekeeping. The Greenwich Meridian, the line of longitude that was marked by a brass (now stainless steel) strip, became the standard for mapping and timekeeping across the world, and known as the Prime Meridian.

What the time was calculated to be at Greenwich, known as Greenwich Mean Time, determined what the time was considered to be around the globe.

Although the observatory is no longer operational and is now a museum, and Greenwich Mean Time has been superseded by Coordinated Universal Time, calculated with atomic clocks, the observatory's place in history is assured.

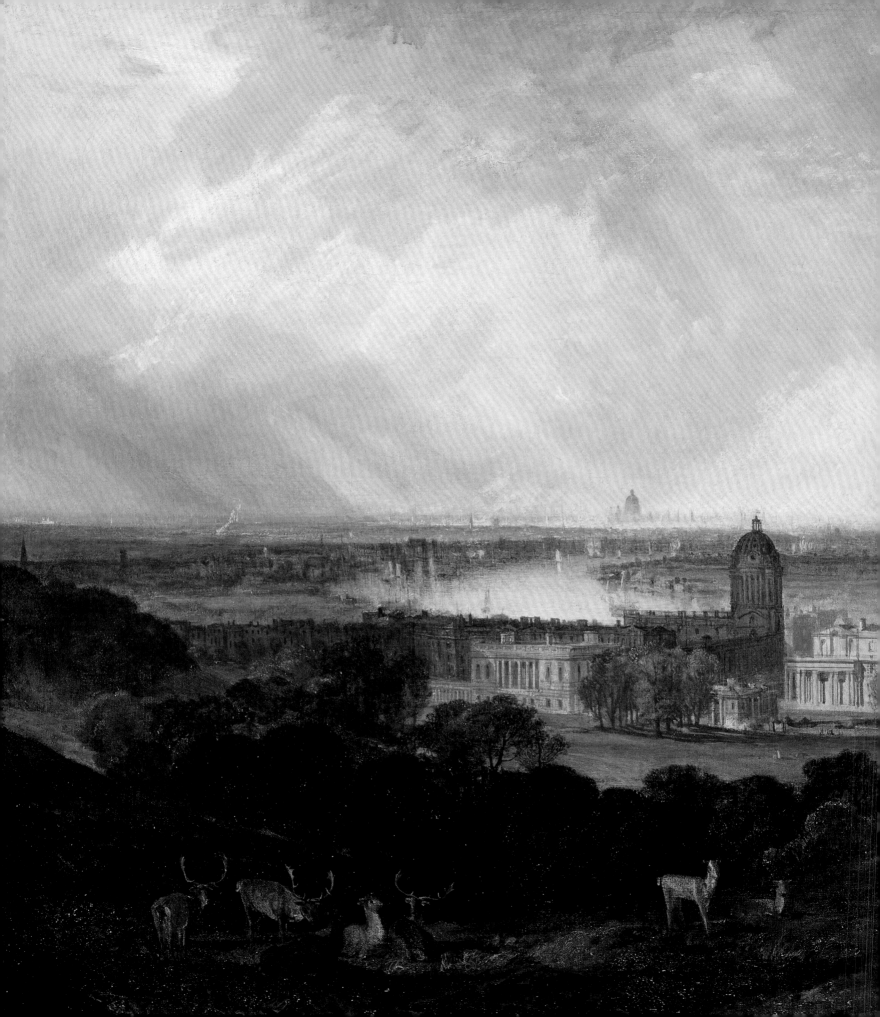

158 J.M.W. Turner,
London from Greenwich Park,
1809. Tate

Index

Image credits

Unless specified otherwise, image credits are listed by figure number

Page 4 © Tate London 2017 / © Teresa Topolski
Page 6 top Library of Congress
Page 6 bottom © Robin Reynolds (robinreynolds.co.uk)
Page 8 © Museum of London
Pages 9, 10, 11 © TfL from the London Transport Museum collection

1 © Tate London 2017
2 Compton Verney, Warwickshire, UK/ Bridgeman Images
3 Private Collection/Bridgeman Images
4, 5 © Tate London 2017
6 Los Angeles County Museum of Art (LACMA). Watercolour on light blue paper. Sheet: 10 × 13^{13}/$_{16}$ in. (25.4 × 35 cm); framed: 17^5/$_{16}$ × 21^1/$_{16}$ in. (44 × 53.5 cm). Mr and Mrs William Preston Harrison Collection (31.12.18). © 2016. Digital Image Museum Associates/LACMA/Open Access
7 Image by Public Catalogue Foundation. Courtesy National Museums Liverpool
8 Dorset County Museum/Dorset Natural History and Archaeological Society
9 Photo © Christie's Images/Bridgeman Images
10 Compton Verney, Warwickshire, UK/ Bridgeman Images
11 Photo © Historic Royal Palaces/Robin Forster/Bridgeman Images
12 National Gallery of Victoria, Melbourne. Felton Bequest, 1962 (1093-5). © DACS 2017
13 Private Collection, London
14 Private Collection / Photo © Moore-Gwyn Fine Art / Bridgeman Images
15 Private Collection/Photo © Christie's Images/Bridgeman Images
16 Greys Court, Henley-on-Thames, Oxfordshire, UK/National Trust Photographic Library/John Hammond/ Bridgeman Images /© The Piper Estate/ DACS 2017
17 Musée d'Art Moderne, Troyes, France/ Bridgeman Images/© ADAGP, Paris and DACS, London 2017
18 Private Collection/Photo © Chris Beetles Ltd, London/Bridgeman Images
19 Image courtesy Museum of London
20 © Museum of London, UK/Bridgeman Images
21 Private Collection/Photo © Christie's Images/Bridgeman Images/© Estate of the Artist
22 Gift of Paul Mellon. Accession No. 1987.82 Courtesy National Gallery of Art, Washington/Open Access
23 Yale Center for British Art, Paul Mellon Collection
24 Private Collection/Photo © Rafael Valls Gallery, London, UK/Bridgeman Images
25, 26 Yale Center for British Art, Paul Mellon Collection
27 By courtesy of Dean & Chapter of Westminster Abbey, UK/Bridgeman Images
28 © Guildhall Art Gallery, City of London/Bridgeman Images

29 Louis Pierre Spindler: *Intérieur Londonien*. 1834-36. Strasbourg, Musée des Beaux-Arts. Photo Musées de Strasbourg, M. Bertola
30 Private collection, London
31 The Clark Art Institute/Wikimedia Commons
32 Philadelphia Museum of Art. Oil on canvas, 36 1/4 x 48 1/2 inches (92.1 x 123.2cm). The John Howard McFadden Collection, 1928. © 2016. Photo The Philadelphia Museum of Art/Art Resource/ Scala,Florence
33 Cleveland Museum of Art, Cleveland. © 2016. Photo Fine Art Images/Heritage Images/Scala, Florence
34 City Club, London, UK/Bridgeman Images
35 © Museum of London
36 Hirshhorn Museum and Sculpture Garden. Gift of the Joseph H. Hirshhorn Foundation, 1966. 66.2488
37 Chester Dale Collection. Courtesy National Gallery of Art, Washington
38 Image © UK Government Art Collection/©The Sir William Coldstream Trust/Bridgeman Images
39 Peter Blake 'Thames Regatta', 2012, copyright the artist, courtesy Paul Stolper Gallery/© Peter Blake. All rights reserved, DACS 2017
40 Image courtesy the artist
41 Mary Evans Picture Library/Alamy
42 Private Collection/© Look and Learn/ Bridgeman Images
43 © Imperial War Museums (Art. IWM ART LD 3911)/©The Estate of Charles Cundall/Bridgeman Images
44, 45, 46 Royal Collection Trust © Her Majesty Queen Elizabeth II, 2016/ Bridgeman Images
47 Museum of London/Heritage Image Partnership Ltd/Alamy
48, 49, 50 © UK Government Art Collection
51 Photo Fine Art Images/Heritage Images/Scala, Florence
52 Southampton City Art Gallery, Hampshire, UK/Bridgeman Images
53 © Museum of London
54 Copyright Royal Academy of Arts, London
55 © UK Government Art Collection
56 Private Collection/Bourne Gallery, Reigate, Surrey/Bridgeman Images
57 © Museum of London
58 © The Estate of L.S. Lowry. All Rights Reserved, DACS 2017
59 © Tate London 2017-
60 Private Collection/Bridgeman Images
61 National Railway Museum/Science & Society Picture Library
62 Image courtesy Museum of London
63 © TfL from the London Transport Museum
64 © Museum of London
65 Fitzwilliam Museum, University of Cambridge, UK/Bridgeman Images
66 Private Collection/© Julian Simon Fine Art Ltd/Bridgeman Images
67 York Museums Trust (York Art Gallery)
68 Digital Image © Tate London 2014/©Estate of Ceri Richards. All rights reserved, DACS 2017
69 'History Painting' 1993/4, oil on canvas, 9 x 12ft. Collection of the Museum of London. Image courtesy the artist
70 © Tate London 2017
71 Private Collection/Photo © Christie's Images/Bridgeman Images

72 © The Sullivan Collection/Bridgeman Images
73 Royal Pavilion & Museums, Brighton & Hove
74 Collection of Mr. and Mrs. Paul Mellon. Courtesy National Gallery of Art, Washington/Open Access
75 National Gallery of Art, Washington DC, USA/Bridgeman Images/© ADAGP, Paris and DACS, London 2017
76 Collection of David and Anita Atterbury Thomas. Image courtesy the artist
77 Private Collection/Photo © Christie's Images/Bridgeman Images
78 Private Collection/Bourne Gallery, Reigate, Surrey/Bridgeman Images
79 © Tate London 2017
80 © Royal West of England Academy, Bristol, UK/Bridgeman Images
81 Private collection, London
82 © Museum of London
83 Private collection, London
84 © Museum of London
85 Tullie House Museum and Art Gallery
86 Yale Center for British Art, Paul Mellon Collection
87 © Fry Art Gallery, Saffron Walden, Essex, UK/Bridgeman Images
88, 89, 90, 91 Private collection, London
92 Private Collection/Bridgeman Images
93, 94 Private collection, London
95 © Museum of London
96 Yale Center for British Art, Paul Mellon Fund
97 Copyright the Artist, courtesy Annely Juda Fine Art
98, 99 © Frank Auerbach, courtesy Marlborough Fine Art
100 Image © UK Government Art Collection/Estate of the artist
101 Image © Tate London 2017/ The Estate of Carel Weight, Bridgeman Images
102 Private collection, London
103 Harris Museum and Art Gallery, Preston, Lancashire, UK/Bridgeman Images/© The Estate of the Artist
104 Yale Center for British Art, Paul Mellon Collection
105 Birmingham Museums and Art Gallery/Bridgeman Images
106 Delaware Art Museum, Wilmington, USA/Samuel and Mary R. Bancroft Memorial/Bridgeman Images
107 Manchester Art Gallery, UK/ Bridgeman Images
108 Southampton City Art Gallery/ Bridgeman Images
109 © Tate London 2017
110 Fenton House, Hampstead, London, UK/National Trust Photographic Library/ Bridgeman Images
111, 112, 113 © Tate London 2017
114 Society of Antiquaries of London, UK/Bridgeman Images
115 Yale Center for British Art, Paul Mellon Collection
116 Lobkowicz Palace, Prague Castle, Czech Republic/Bridgeman Images
117 Private Collection/Photo © Christie's Images/Bridgeman Images
118 Minneapolis Institute of Arts, MN, USA/Bequest of Putnam Dana McMillan/ Bridgeman Images/© ADAGP, Paris and DACS, London 2017
119 © Tate London 2017
120 © Museum of London
121 Image courtesy Royal Air Force Museum London

122 Private Collection/© Liss Fine Art/ Bridgeman Images
123 London Metropolitan Archives, City of London/Bridgeman Images
124 Metropolitan Museum of Art. Watercolour, pen, black ink over graphite, sheet: 19^3/$_{16}$ × 14^7/$_8$ in. (48.8 × 37.8 cm). Purchase, Sir Edwin Manton Gift, 2002 (2002.435).© 2016. Image copyright The Metropolitan Museum of Art/Art Resource/Scala, Florence
125 Private Collection/Photo © Christie's Images/Bridgeman Images
126 © Guildhall Art Gallery, City of London/Bridgeman Images
127 Image courtesy and © the artist
128 © Museum of London, UK/ Bridgeman Images/©The Estate of CRW Nevinson/Bridgeman Images
129 © Guildhall Art Gallery, City of London/Bridgeman Images
130 Image by Public Catalogue Foundation. Courtesy National Museums Liverpool
131 Private collection, London
132 © Fry Art Gallery, Saffron Walden, Essex, UK/Bridgeman Images
133 Smallhythe Place, Kent, UK/National Trust Photographic Library/Bridgeman Images
134 © Museum of London
135 Yale Center for British Art, Paul Mellon Collection
136 The Trustees of the Goodwood Collection/Bridgeman Images
137 Yale Center for British Art, Paul Mellon Collection
138 Ashmolean Museum, University of Oxford, UK/Bridgeman Images
139 © Museum of London, UK/ Bridgeman Images
140 © Royal College of Art, London
141 Private Collection/Bourne Gallery, Reigate, Surrey/Bridgeman Images
142 Image © UK Government Art Collection
143 © Newport Museum and Art Gallery, South Wales/Bridgeman Images
144 © Museum of London
145 Image courtesy University College London Hospitals/© Estate of the Artist
146 © Estate of the Artist
147 Cincinnati Art Museum, Ohio, USA/ The Edwin and Virginia Irwin Memorial/ Bridgeman Images
148 © Fry Art Gallery, Saffron Walden, Essex, UK/Bridgeman Images
149 © Tate London 2017/© The Piper Estate/DACS 2017
150 Copyright the Artist/© Tate London 2017
151 Image courtesy Henry Moore Foundation
152 Anglesey Abbey, Cambridgeshire, UK/National Trust Photographic Library/ Bridgeman Images
153 Image courtesy RIBA Collections
154 Image Museum of London/ © the Artist
155 © Tate London 2017/© Estate of the Artist
156 © National Maritime Museum, Greenwich, London
157 © TfL from the London Transport Museum
158 © Tate London 2017

Acknowledgements

Thanks to Robert Shore, Kara Hattersley-Smith and Laurence King for bringing me on-board this project.

This book is dedicated to my partner Emily and our daughter Ella.